DESERTS

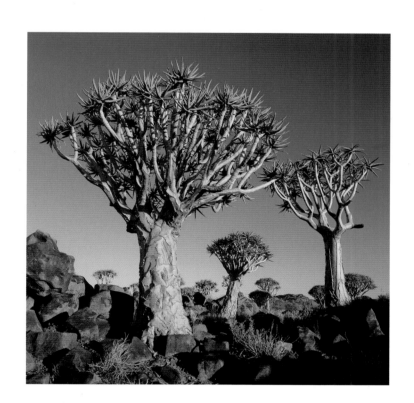

DESERTS

THE LIVING DRYLANDS

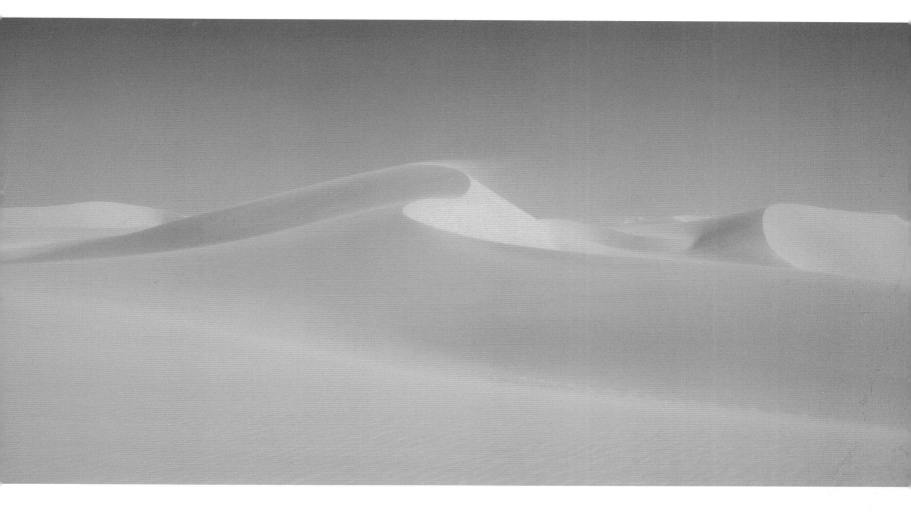

SARA OLDFIELD

PHOTOGRAPHY BY BRUCE COLEMAN COLLECTION
FOREWORD BY MARK ROSE, EXECUTIVE DIRECTOR OF
FAUNA & FLORA INTERNATIONAL

NEW
HOLLAND

First published in 2004 by
New Holland Publishers (UK) Ltd
London • Cape Town • Sydney • Auckland

www.newhollandpublishers.com

Garfield House
86–88 Edgware Road
London W2 2EA
United Kingdom

80 McKenzie Street
Cape Town 8001
South Africa

14 Aquatic Drive
Frenchs Forest, NSW 2086
Australia

218 Lake Road
Northcote
Auckland
New Zealand

10 9 8 7 6 5 4 3 2 1

ISBN 1 84330 728 6

Publishing Manager: Jo Hemmings
Senior Editor: Jane Morrow
Designer: Becky Willis, poddesign
Production: Joan Woodroffe
Cartographer: Bill Smuts

Front cover: Namib Desert, Sossusvlei, Namibia
Back cover: Ostriches running on a salt pan, Etosha National Park, Namibia
Page 1: Joshua tree
Page 3: Gobi Desert dunes
Page 4–5: The Hidden Valley, Joshua National Park, California
Pages 6–7 (clockwise from top left): quiver tree; elephant feeding on Ana
tree, Kaokoland, Namibia; Namib Desert dunes; secretary birds building a
nest; web-footed gecko, Namibia; bat-eared fox, Kalahari; Berber with two
camels; saguaro cactus and ocotillo; giant hairy scorpion, Arizona;
Aboriginal art, Arnhem Land, Australia.
Page 8: Oryx in dune landscape, Sossusvlei, Namibia

Reproduction by Pica Digital (Pte) Ltd, Singapore
Printed and bound by Tien Wah Press (Pte) Ltd, Singapore

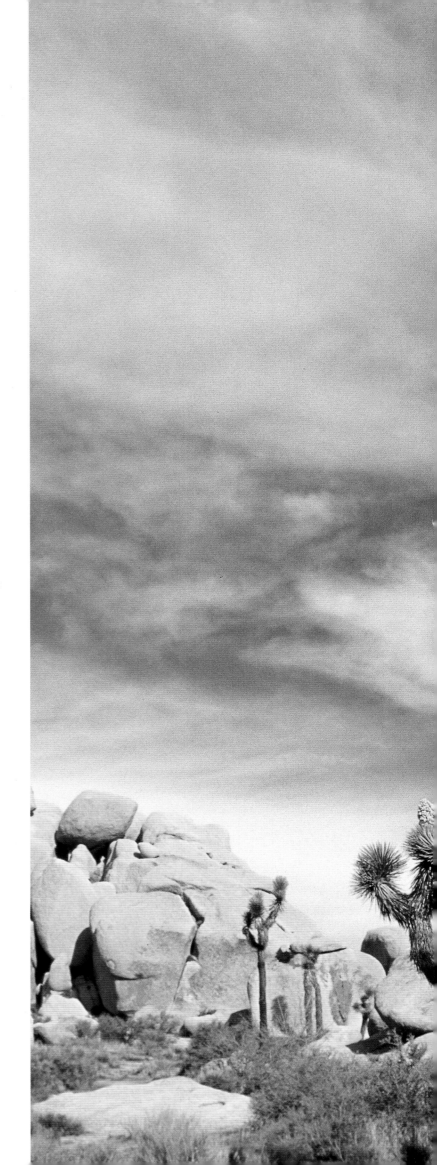

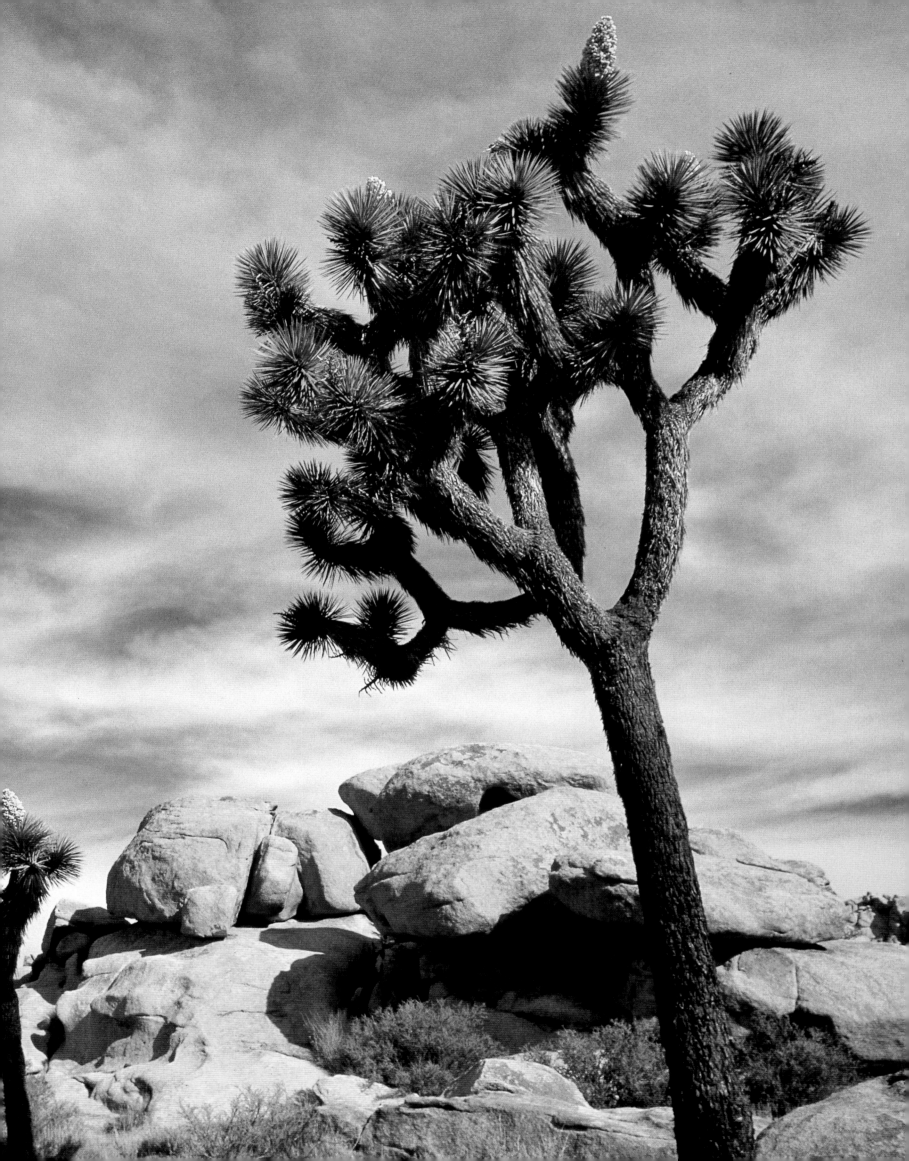

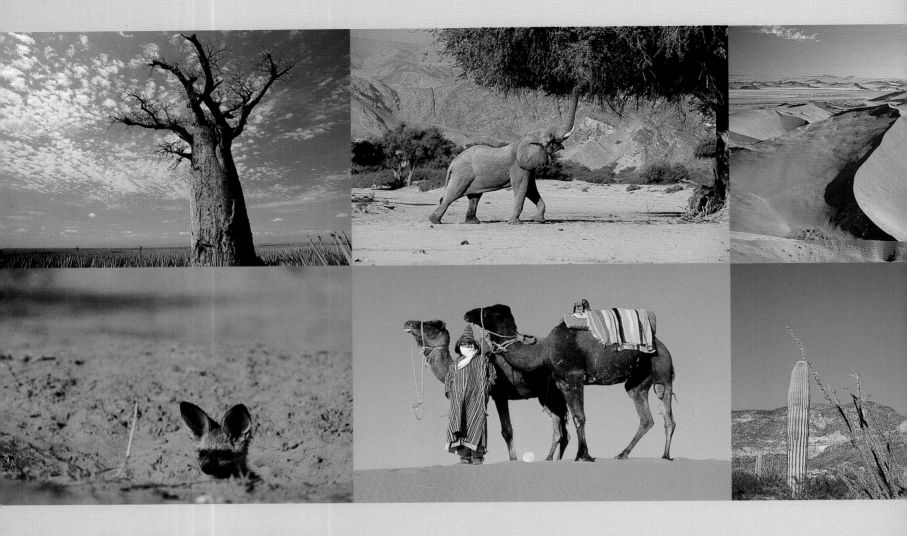

CONTENTS

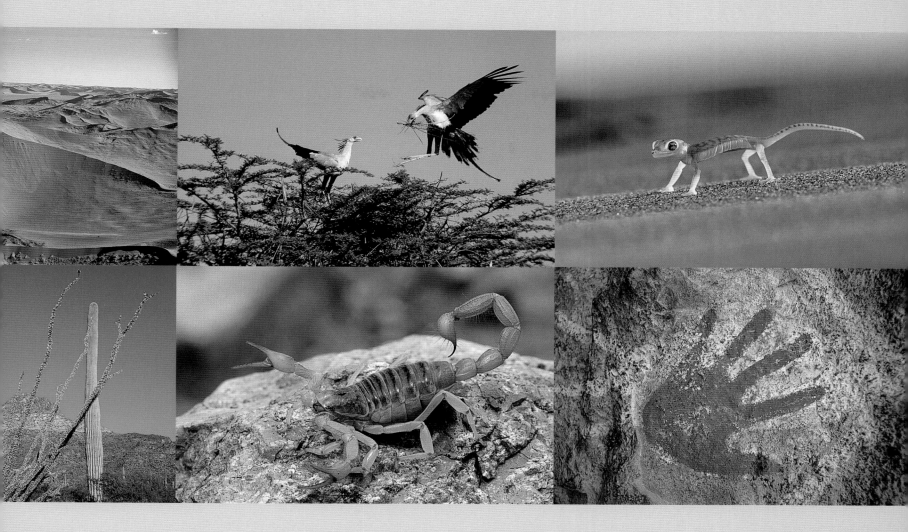

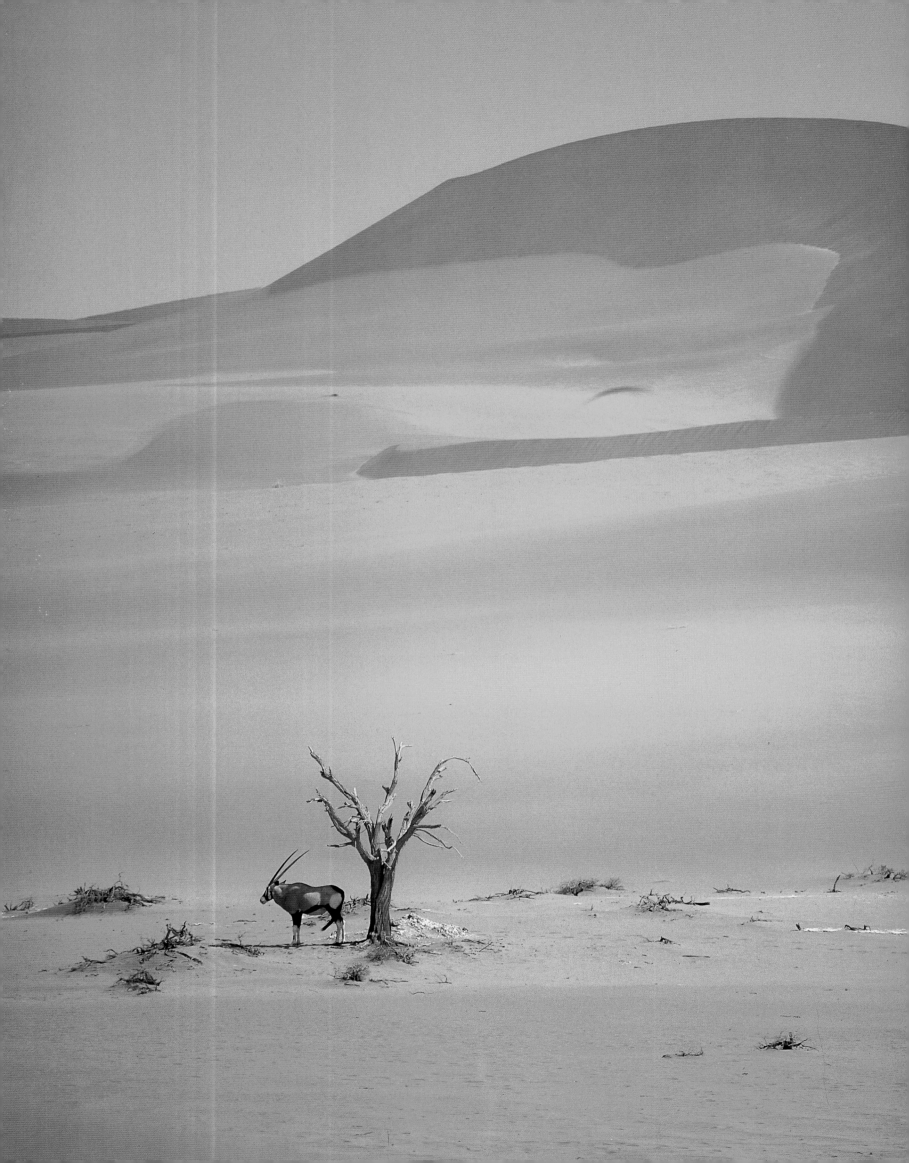

Foreword

Fauna & Flora International is proud to be associated with this attractive and authoritative book which highlights the stunning landscapes and highly adapted biodiversity of desert regions. Since its formation 100 years ago FFI has strived to conserve threatened species and ecosystems around the world, often caring for the less popular plants and animals and their habitats. Many of these – the snakes, lizards and spiny succulent trees – are found in desert regions, which have not always received the conservation attention they deserve.

The symbol of FFI is the Arabian oryx, one of the more charismatic desert species, and one that is Endangered in the wild. Hunting and loss of habitats have placed huge pressures on this species, but nevertheless the Arabian oryx is a symbol of conservation success. Back in the 1960s, FFI led the way in developing conservation action for this magnificent animal. Faced with heavy poaching along the southern edge of the Rub-al-Khali, FFI decided, with local agreement, to transfer a few wild oryx to captive breeding facilities. An international captive breeding programme was established using additional oryx from zoos and private collections. By 1977 the captive herd had increased to 100 individuals, and carefully planned reintroductions to the wild commenced in 1982. The Arabian oryx was the first species to be successfully reintroduced to its natural habitat.

As Executive Director of FFI, I have visited deserts and semi-arid regions in various parts of the world and I have witnessed the rapid changes taking place to dryland ecosystems in even the remotest regions. The vital role local people play in traditional land management has deeply impressed me. Faced with scarce natural resources, the importance of each and every component of biodiversity is appreciated by local people. We need to ensure that the traditional skills of utilizing and conserving dryland biodiversity are not lost as the pace of change intensifies.

Trees assume a special importance in the sparsely vegetated lands, providing food, shelter, timber, firewood and a host of other products. They also provide important habitat for associated animal species. Unfortunately tree species in dryland regions are facing increasing threats to their survival. Royalties from *Deserts* will help to directly support the Global Trees Campaign, a joint initiative of FFI and the United Nations Environment Programme – World Conservation Monitoring Centre (UNEP-WCMC) to save the world's most threatened tree species from extinction. Through the campaign, experts are documenting the status of trees around the world and working with local people to ensure their survival. With your help the campaign will grow. Please do all that you can to help us conserve endangered species and their habitats.

Mark Rose
Executive Director
Fauna & Flora International

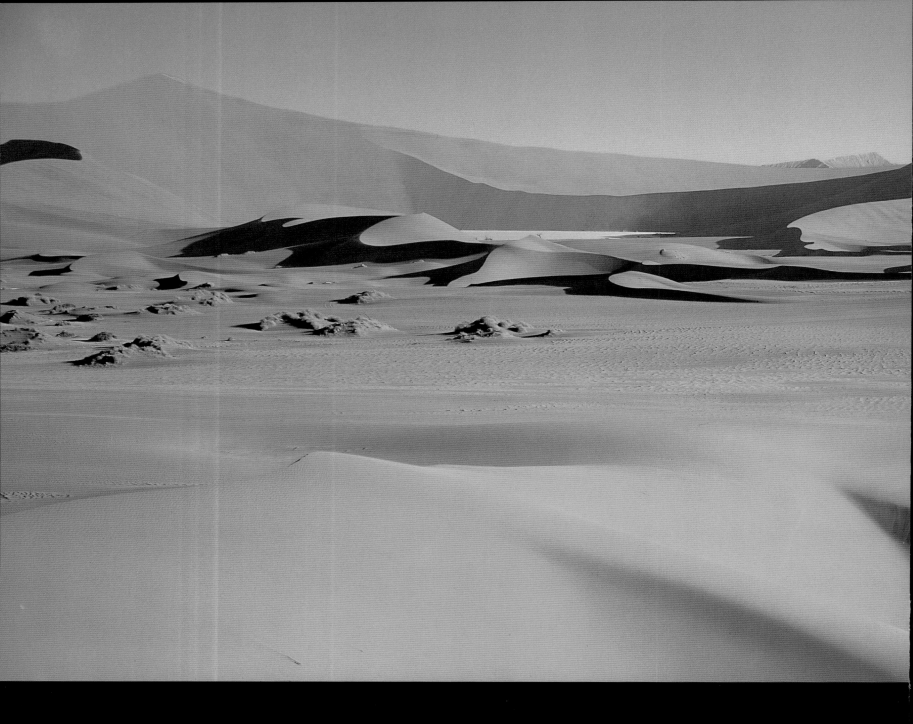

CHAPTER ONE

Deserts of the world

Unique species and ancient civilizations

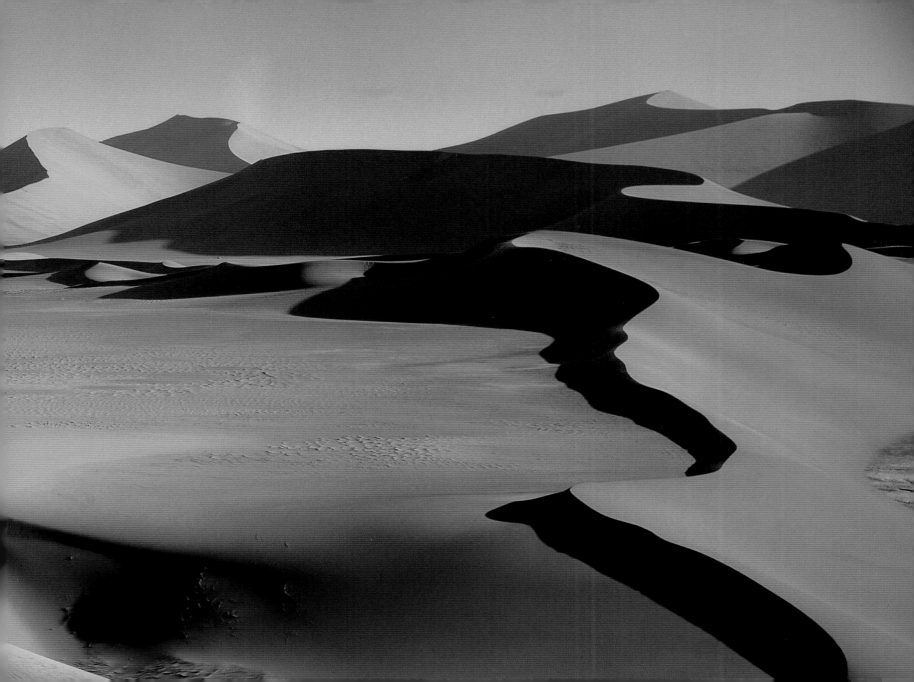

Centuries of exploration

The desert regions of the world have attracted the attention of legendary explorers for thousands of years. These include the Greek historian Herodotus, who travelled through Egypt and Central Asia nearly 2,500 years ago, and Alexander the Great of Macedonia who, shortly after, led a huge army from Central Europe to India, founded over 70 cities, and for a while was Pharaoh of Egypt.

In the 14th century the great Muslim explorer Ibn Battuta set out to explore the known Muslim world, undertaking numerous journeys from his native Morocco across the Sahara to Timbuktu, throughout Arabia, India, and as far afield as China. In the Victorian era, desert explorers included women such as Gertrude Bell, who embarked on her lifelong travels in the Middle East to recover from an unhappy love affair. Yet some deserts remained virtually unknown to the outside world well into the 20th century. The Rub Al Khali, or Empty Quarter, of the Arabian Peninsula was first traversed by Europeans in the 1930s; Australia's Simpson Desert was not crossed by motorized vehicles until the 1960s.

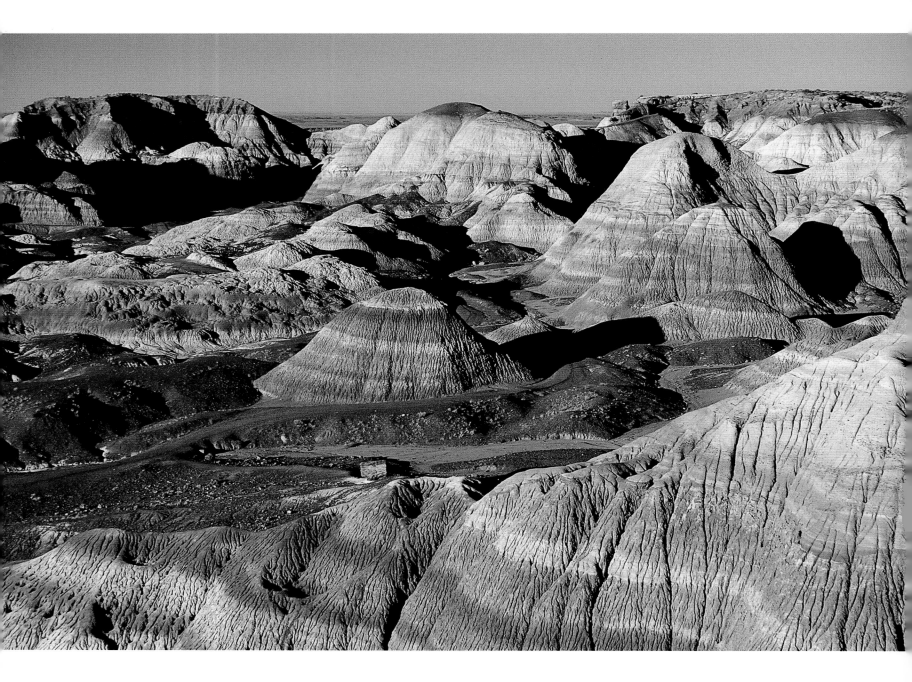

Desert distribution and diversity

True deserts are found in the very driest places on earth. Around their margins, where the rainfall is a little higher, lie the drylands, the 'semi-deserts' or semi-arid lands. There is no universally accepted definition of drylands, but generally these are considered to be areas where rainfall is less than 600 millimetres (23 inches) each year, and where other climatic factors, such as temperature, contribute to aridity. Arid lands – deserts – are those where annual rainfall does not exceed 200 millimetres (8 inches). In some of the world's deserts the average rainfall is much less, with no rain at all recorded for years on end.

However, rainfall values cannot be used to delineate desert areas alone because temperature and other factors play an important role in determining the dryness of the land. In Australia, for example, parts of the hot tropical northwest with around 500 millimetres (20 inches) of rain each year lie within the country's arid zone, whereas in the cooler southern parts of the country, the boundary of the desert is where the rainfall is around 250 millimetres (10 inches).

Along with very low rainfall, irregular patterns of rainfall and extremes of temperature also help to define deserts. The lack of cloud cover in desert areas prevents the retention of heat close to the earth as night falls and so deserts tend to be very cold when the sun is no longer out. Daily temperature variations are commonly around 20°C (68°F) and can be much greater. Strong desiccating winds are also common in these regions.

Arid and semi-arid areas comprise over 30 per cent of the surface of the earth. The cold polar deserts of the Arctic and Antarctic cover a further 10 per cent, but are not included in this book as they are such a different sort of environment. The vast, dry and sparsely vegetated expanses of land, natural ecosystems of extreme climatic conditions, are among our planet's last great wilderness regions. From the rolling sand dunes of the Empty Quarter of the Arabian Peninsula to the expansive dry steppes and deserts of Central Asia, the forces of nature have worked for millennia to produce landscapes of stark beauty and amazing ecology.

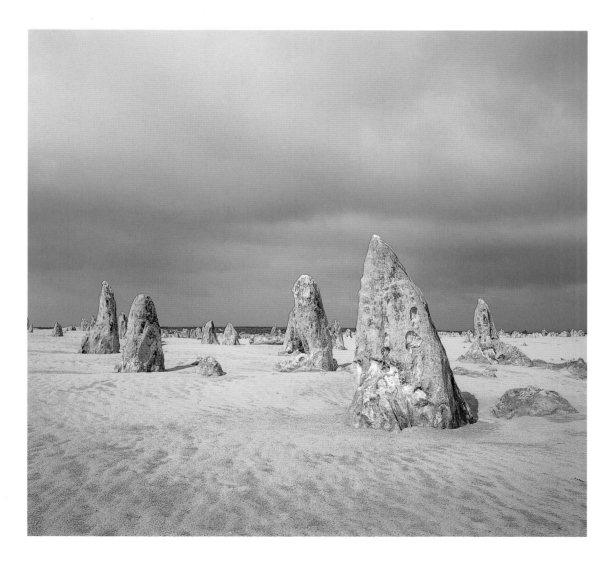

PAGES 10–11: Sand dunes in the Namib Desert portray the classic desert image of landscape devoid of life.

OPPOSITE: Badlands scenery of the Painted Desert forms part of the Petrified Forest National Park in northeast Arizona. The hills are made up of layers of different coloured sandstone and mudstone.

LEFT: The limestone pinnacles of Nambung National Park, Western Australia, are the petrified skeletal remains of ancient trees which rise above the sandy desert.

Ancient and evolving landscapes

Desert landscapes appear broadly similar in different parts of the world, and explorers since Victorian times have been impressed by their unusual natural features – dunes, rock sculptures and bare rock hills rising from flat gravel plains. The effects of erosion by ancient river torrents, millennia of high daytime temperatures under the baking sun, cold nights and strong winds, are laid bare – without the softening effect of vegetation. Despite these common features, each of the world's

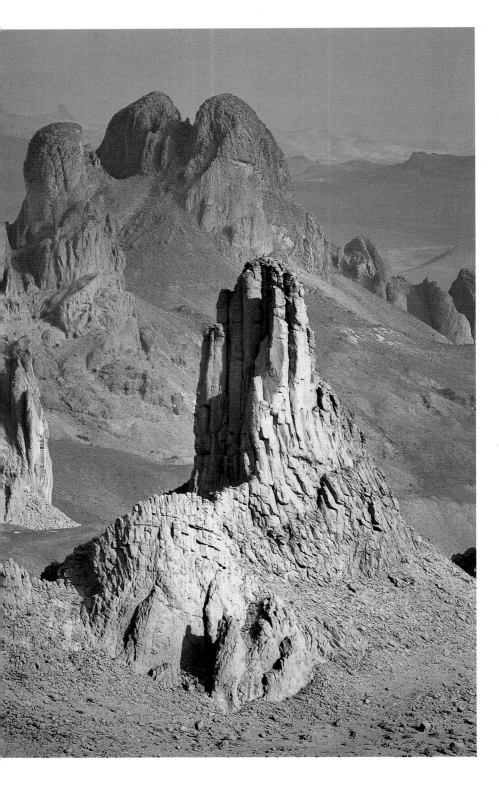

major deserts has unique landforms. Although it is still not fully understood how these have been developed, one common factor which has helped to shape the appearance of arid lands is climatic change over millions of years, with wetter conditions in the relatively recent geological past.

Current desert environments reflect a combination of erosional and depositional forces, which have sculptured the landscape over the millennia. Patterns of land use also influence the shape of deserts to an increasing extent. It is thought that the scenery of the North American drylands results mainly from the impact of erosion and deposition by rivers and other forms of surface water, the Grand Canyon being the supreme example of river erosion. The badlands of the Great Plains and Colorado Plateau, with their deep-sided gullies and rills, are rapidly eroded as surface water impacts on the soft shale rock. In other areas, for example in the eastern Sahara, wind erosion has been the most significant factor in shaping the landscape. In the Atacama Desert of South America, chemical erosion resulting from high salinity, and local movements of the earth's crust, have helped to shape unique landforms.

Sand dunes

The great seas of sand with rolling dunes make up about 20 per cent of the world's deserts. Sand dunes cover close to 50 per cent of the Australian desert region, a higher proportion than anywhere else on the planet. Approximately 20 per cent of the vast Sahara and Arabian deserts is covered by sand dunes; much of the remainder is comprised of gravel deserts – 'regs' – and rocky plateaux – 'hammadas'. The largest single sand sea in the world is the Rub Al Khali (Empty Quarter) of the Arabian Peninsula, which covers an area larger than France.

Sand dunes are formed by the deposition of wind-borne material which has been eroded from solid rock by various mechanical and chemical processes. Over millennia, the matter combines to form sand seas in basins bordered by mountain ranges. Some of the great dune systems of the world are now largely fixed and inactive. These include the dunes of the Sahel region of Africa, the deserts of Australia, the Kalahari Desert of southern Africa and the Thar Desert of India and Pakistan. In contrast, the dune systems of the Sahara, Arabian and Namib Deserts, and the Taklimakan Desert of China, are in an active stage of formation.

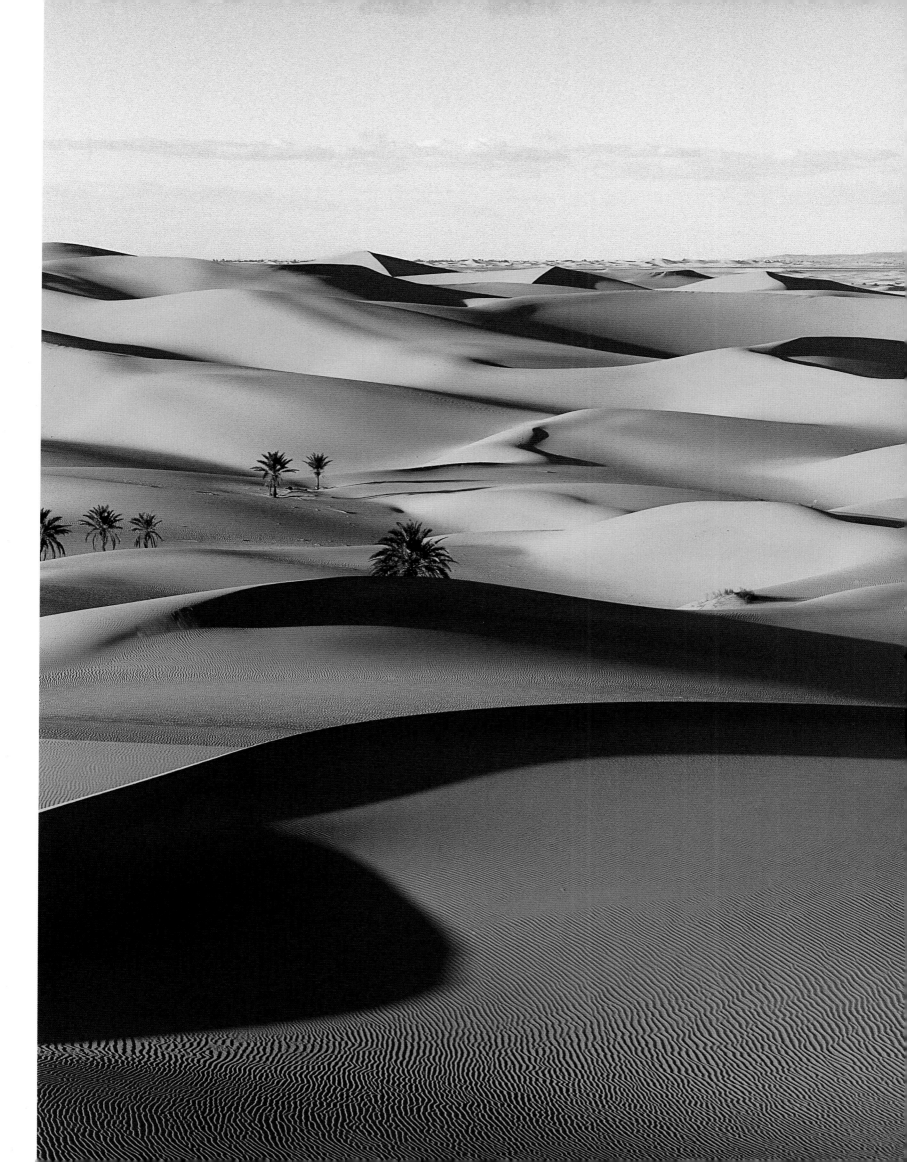

Differences in annual wind patterns and in the supply of sand produce various types of dune systems. The most commonly found dunes are linear, forming parallel, straight dunes. Longitudinal sand ridges of this type are typical in the Australian deserts, where they are normally under 30 metres (98 feet) high, averaging 13 metres (43 feet) in the Simpson Desert, and up to 300 kilometres (186 miles) in length. The single crests of these dunes may remain active with the deposition of new wind-blown sand, but frequently the dune flanks of the Australian deserts are static and support grasses or shrubs, giving a striped pattern of vegetation. Dunes of the Namib Desert of southern Africa are also linear but are much higher, forming some of the largest dunes of the world, with crests rising close to 300 metres (984 feet).

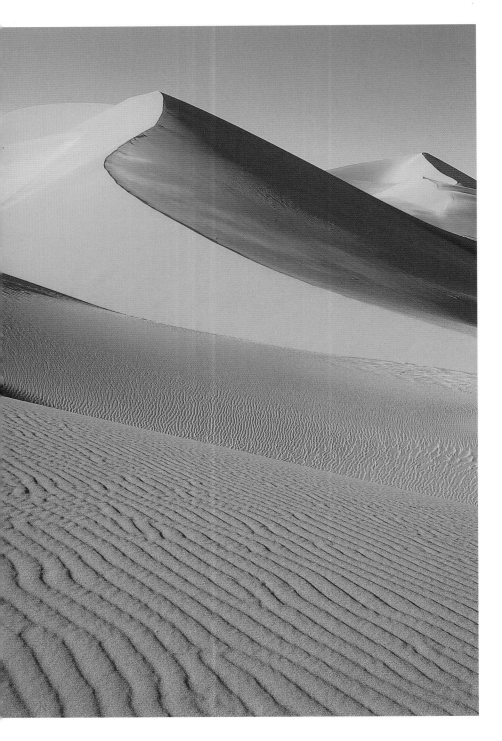

There are also crescent or horseshoe-shaped dunes, known as 'barchans', which are fairly uncommon and relatively short-lived, and star-shaped dunes which are also quite rare and form in areas with complex wind patterns. Huge star-shaped dunes over 360 metres (1,180 feet) high and 800 metres (2,625 feet) across, for example, are found in the deserts of Algeria and China.

Rock erosion

The sand and dust carried by the strong winds of desert regions contributes to the erosional impact of the wind on the dryland landscape. Rocks on the desert surface are shaped by the wind to form features known as 'ventifacts'; rock pillars are carved by wind and other weathering processes; depressions are scoured out of the land surface; a peculiar form of hills or hillocks known as 'yardangs' develop. Yardangs were first described from the Taklimakan Desert, and the name is derived from the Turkestani word *yar*, meaning ridge or steep bank. These streamlined, aero-dynamically shaped hills are found in the deserts of every continent except Australia. They are restricted to extremely arid areas where vegetation and soil development is minimal.

In Iran, yardangs occur in the Dasht-e Lut Desert, a region of intense wind erosion and less than 50 millimetres (2 inches) rainfall per year. Hot, dry, southerly winds dominate in the summer months, and the *bad kessif* or 'dirty wind' blows from the south in summer, carrying large amounts of sand and dust. The yardangs in this region are said to resemble buildings, and are known to Iranians as *shahr lut* or 'desert cities'.

Desert crusts

Another desert landscape feature is the sun-baked desert crust or 'duricrust', where consolidation and cementation of loose debris protects the underlying sediments from erosion. Various processes are thought to contribute to the formation of desert crusts, including the precipitation of minerals from evaporating water bodies, leaching of other more soluble materials; accumulation of minerals by upward movement of ground water, and lateral movement of minerals carried by surface water in valleys or large basins. Various different types occur. Calcretes (desert crusts composed of calcium carbonate) are the most common form. Silcrete duricrusts (which are not restricted to desert areas) are formed by the cementation of various forms of silica, including precious opals, and are found in the deserts of Australia and South Africa. Gypsum and sodium chloride crusts also occur in the Sahara, Namib and Australian deserts.

Water in the desert

An oasis is any area in the desert that contains enough water to support plant life. Wherever water is found, it acts as a magnet, attracting wildlife and people alike. Oases have sustained travellers for centuries and their locations have influenced the ancient trade routes used by camel caravans throughout North Africa, the Middle East and Asia. Where cultivation is possible around an oasis, settlements have frequently developed. Oases usually occur where groundwater stored in the underlying rocks – the 'aquifer' – seeps to the surface in the form of springs. The storage of water underground in arid lands depends largely on the type of rock and on past climatic conditions. Some water is stored deep in the ground in 'fossil' aquifers, derived from rainfall thousands of years ago.

Mighty rivers, rising in distant mountains, meander through some of the world's desert regions and are another important source of water. Some of the world's largest river systems – the Nile, the Tigris and Euphrates, the Rio Grande of North America and the Murray-Darling in Australia – flow for much of their length through otherwise parched land.

PAGE 14: The wind-carved sandstone pillars of the Tassili are found in southern Algeria in an area now protected as a World Heritage site. The rugged scenery includes massive gorges formed by rivers in the ancient past.

PAGE 15: The sand dunes of the Sahara Desert are in an active stage of formation. In total about 20 per cent of the desert consists of sand-dune formations.

OPPOSITE: Towering sand dunes of the Namib Desert showing single crests and rippled surfaces.

LEFT: The date palm has been in cultivation for around 6,000 years and is commonly associated with oases. The leaves provide a splash of green against the arid desert background.

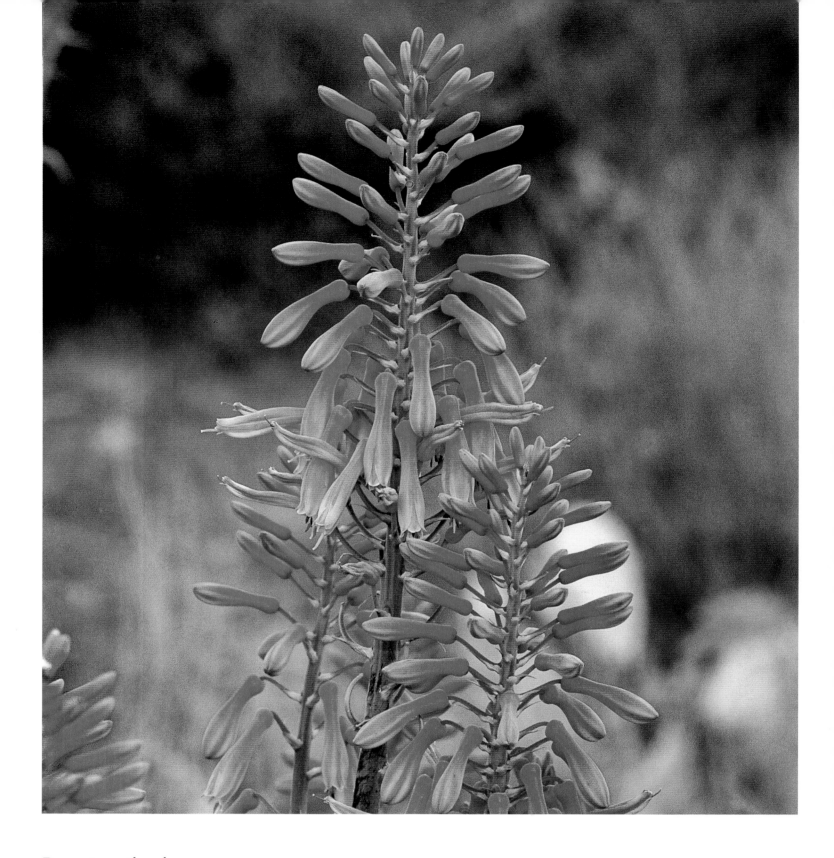

Desert wetlands

'Desert wetlands' appears to be a contradiction in terms, but there are areas where ancient climatic conditions, or current geology and landforms, give rise to shallow lakes, inland deltas and marshes in otherwise arid desert regions. The Okavango Delta in Botswana, lying close to the northern margins of the Kalahari Desert, is one of the largest inland deltas in the world. This area of permanent marshland, waterways and seasonal flooding is located in a dryland region where rainfall is generally between 400–600 millimetres (16–23 inches) each year.

Likewise the marshes of southern Iraq, although now on the most part drained, appear in an area with punishing summer temperatures and extremely low rainfall.

In Mali, the vast inland delta of the Niger river is comprised of permanent lakes with seasonal flooding. The extent of flooding varies from year to year depending on monsoon rainfall in the highlands of Guinea, the source of the Niger. When the rainfall is low, the flood is poor; in the 1970s this knock-on effect contributed to the severe Sahelian droughts.

Desert ecology and adaptations

Readily available water is, of course, the exception in desert areas, and desert plants and animals have adapted to cope with some of the most extreme conditions on earth. Fierce daytime sun, low night-time temperatures, strong winds and lack of water all contribute to the hostile prevailing conditions. Yet most deserts harbour a surprising diversity of plants and animals, with very few, if any, being devoid of wildlife.

Hardy desert vegetation

Vegetation in desert areas is typically sparse, with widely spaced plants that have adapted various survival strategies. Desert mosses and ferns – groups of plants more usually associated with moist conditions – have developed a tolerance to drought. These specially adapted species are able to dry up until apparently lifeless and then quickly resume growth when water is

OPPOSITE: Aloe vera seen here in bloom has succulent leaves which are an adaptation to arid conditions. Now an important crop cultivated for its medicinal and cosmetic properties, the wild origin of this plant is uncertain.

LEFT: Creosote bushes (*Larrea divaricata*) are characteristic of the North American deserts and are superbly adapted to arid conditions.

BELOW: Mesems have attractive, brightly coloured flowers that carpet the drylands of South Africa and Namibia following rainfall. The leaves are succulent.

PAGE 18: The horned lizard (*Phyrnosoma platyrhinos*) of the Mojave Desert feeds almost exclusively on ants. This well-camouflaged desert creature can squirt blood from its eye sockets as a form of defence.

PAGE 21 TOP: The shovel-snouted lizard (*Aporosaura anchietae*) raises two of its feet alternately in a form of dance designed to reduce heat intake from the burning sand. The shape of its nose helps the lizard burrow to find cooler conditions.

PAGE 21 BOTTOM: The sidewinder (*Bitis peringueyi*) of southern African deserts reduces contact with the hot sand by its peculiar and characteristic sideways movement.

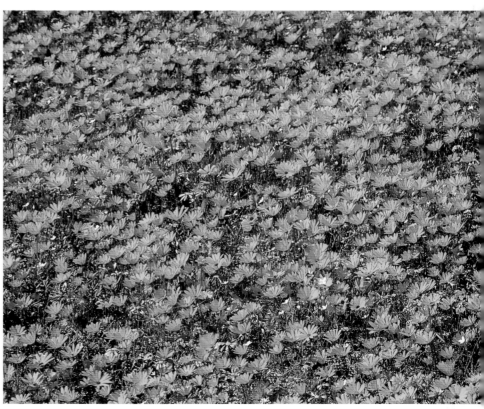

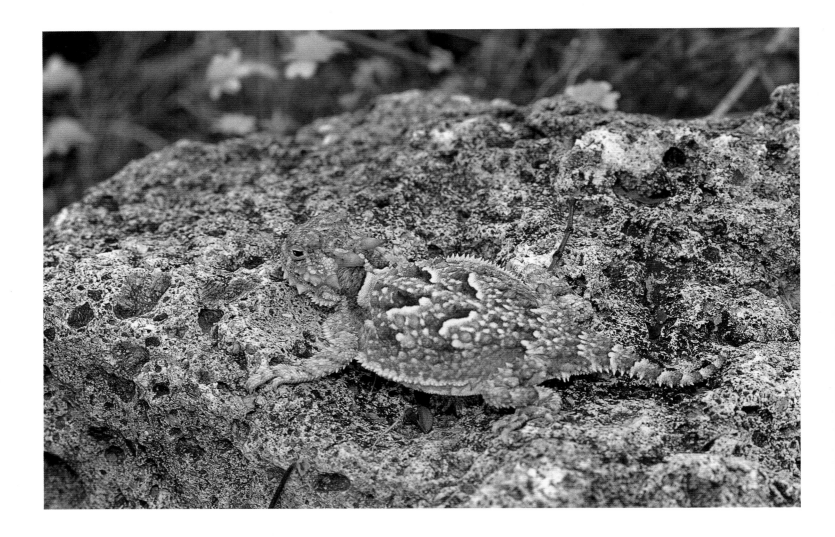

available. The creosote bush (*Larrea divaricata*), a characteristic plant of the deserts of North America, is also remarkably tolerant. The lower leaves dry up and die in periods of extreme drought, whereas the small leaves in the bud rapidly resume growth after rain. The resins contained within its leaves also help to limit water loss from the leaf surfaces and to prevent overheating of the internal leaf cells.

The leaves of desert plants are typically small, often with a waxy cuticle to reduce water loss. Larger leaves, such as those of desert palms, often have highly dissected margins resulting in effectively smaller leaves. Cacti and many other succulent plants have greatly reduced leaves or highly modified leaves in the form of spines. The amount of valuable water lost through the leaf pores is thus reduced, and waxy coatings further aid the process. Cacti typically also have shallow, widely spreading roots to maximize access to available moisture in the frequently parched soils. Other plants, such as palms and the creosote bush, have very deep roots, which can tap into the water table.

Another method by which plants survive arid desert conditions is evasion: plants either have a very short life cycle (coinciding with periods of available moisture) or survive much of the year in the form of underground storage organs such as bulbs or tubers. The desert bloom following periods of rain is one of the most spectacular sights in arid areas, notably in the Californian Desert and the Namaqualand region of southern Africa. Namaqualand has very low, sporadic winter rainfall, and in spring the desert is carpeted with bright orange, yellow and white flowers (see page 19). Short-lived desert plants are often prolific producers of seed that is highly tolerant of environmentally exacting conditions and can survive years of drought buried beneath the arid soils. Ephemeral desert plants are quick to grow when scarce rain falls and many complete their life cycle within just a few weeks.

The adaptability of desert reptiles

Animals, as well as plants, display a marvellous range of desert adaptations. Reptiles have probably been the most successful of vertebrate groups in exploiting desert environments. Each desert region of the world has its own reptile fauna, and over half the reptile families are represented in these areas. The thick skins of lizards, snakes and tortoises help these creatures to retain water. They are cold-blooded, or ectothermic: they cannot produce heat internally and rely on warmth primarily from the sun. Since reptiles do not

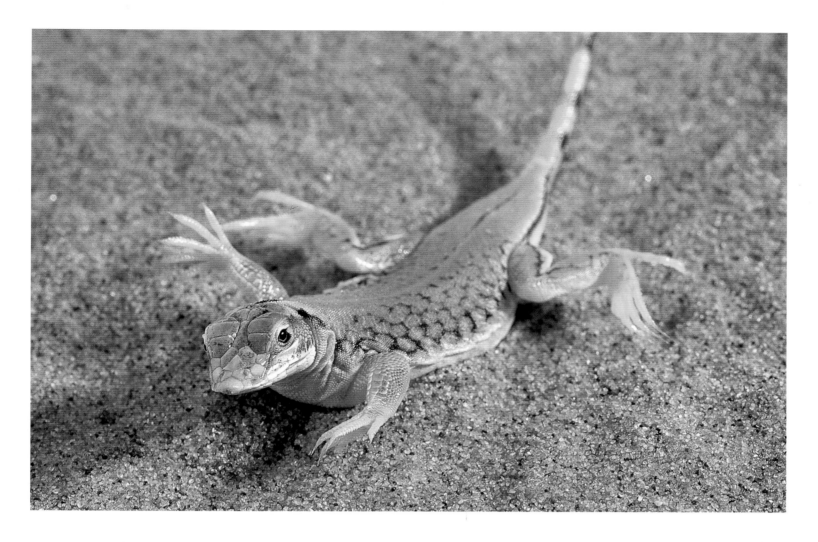

need to rely on food intake to maintain body temperature, they require a relatively limited food supply, and are thus able to survive on the sparse vegetation and prey species offered by the desert environment.

The horned lizards (*Phrynosoma*) of the USA and Mexico show numerous behavioural adaptations to the desert environment. They regulate their body temperature by burrowing into the sand or soil in order to avoid temperature extremes. In the morning the head emerges first so that the brain temperature is raised and heat then transferred to other parts of the body. Basking in the sun usually involves tilting the body to the east to maximize the effects of the early morning sun.

Snakes also exhibit various desert survival mechanisms. The sidewinder, or Peringuey's viper (*Bitis peringueyi*), found in the deserts of South Africa and Namibia, has a peculiar twisting form of movement which minimizes body contact with the burning sands. In this way the snake avoids overheating. Generally this 25-centimetre (10-inch) long snake hides its body in the sand with just its eyes and tail tip above the surface. When a prey species such as a lizard or desert rodent approaches, the snake's tail twitches, luring the prey within striking range.

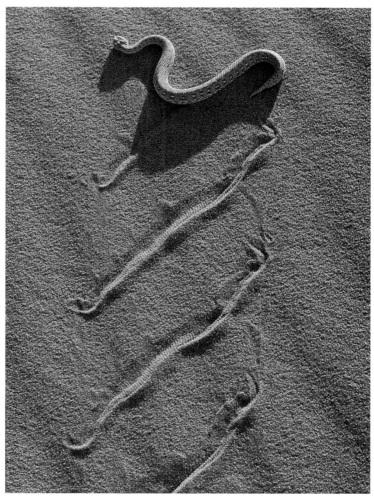

Clever frogs and fish

The thin-skinned amphibians are at an obvious disadvantage in dryland environments, and yet a considerable number of frog and toad species are able to survive in deserts. In Australia, for example, there are at least 20 species of burrowing frogs in the arid interior of the country. Specially adapted spade-like structures on the undersurface of their feet facilitate digging into the sand. They can also develop an external cocoon formed from dead skin, which helps to retain a layer of moisture next to the body. As the scarce rain percolates through the sand, the frogs dig down, often to a considerable depth. Puddles on the surface are generally essential for breeding to take place, but the tiny sandhill frog (*Arenophryne rotunda*) of Western Australia remains underground for at least five months each year, and eggs are laid in the moist conditions below the surface of the sandhills.

Even fish have adapted to desert conditions, making the most of any available water. Some desert fish are equipped with a lung so that when desert pools dry out they are able to breathe air. Others, such as the so-called annual fish, die when there is insufficient water, having first laid eggs which are able to survive until the next year's rains.

Desert birds

Desert birds, too, have adapted to arid conditions. Some species display nomadic behaviour, making the most of water availability in a given area of dryland; some vary their breeding patterns, avoiding breeding in particularly arid years and with concentrated breeding after periods of rain; some have mechanisms to restrict water loss, and the ability to survive on limited or semi-saline water. Coursers, sandgrouse, bustards and larks are among the groups of birds

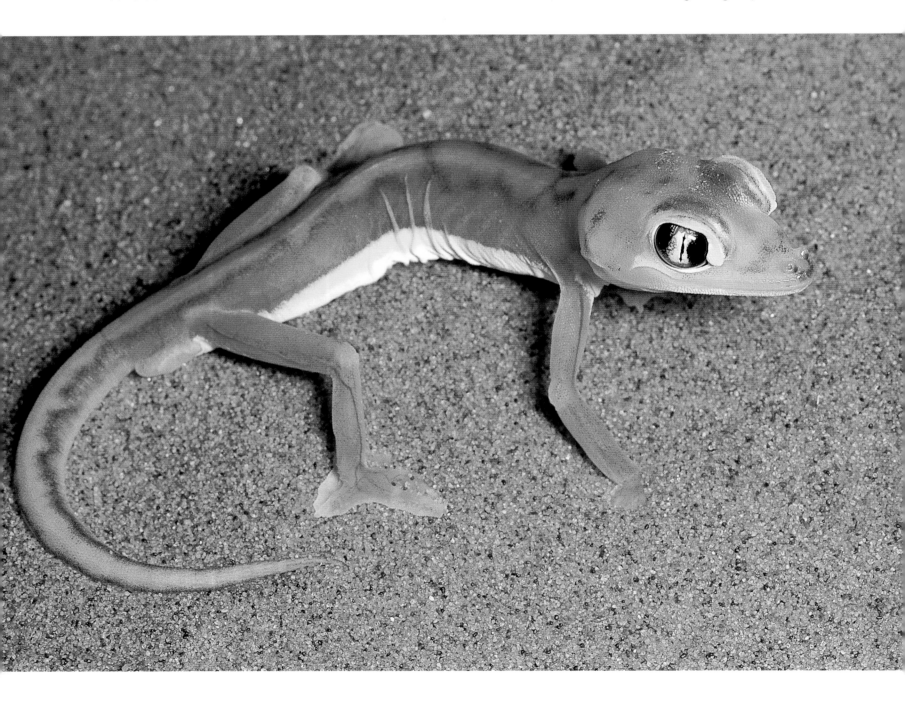

associated with desert conditions. Larks feed and nest on the ground and do not require the presence of trees, and in hot deserts have adapted patterns of behaviour to avoid the hottest temperatures. The Karroo lark (*Certhilauda albescens*), a common bird of southern Africa, is inactive during the midday sun when it rests in the shade. Another species, the spike-heeled lark (*Certhilauda albofasciata*) – also of southern Africa – is able to remain inactive throughout the day as its foraging behaviour takes place in partial shade provided by denser vegetation.

Most sandgrouse live in arid and semi-arid regions, including the main African and Asian deserts. They feed largely on small, hard seeds and other dry food, and need to drink regularly. The amount of rainfall and subsequent availability of food largely determines the breeding season. The male birds supply water to the young birds in their nests on the ground in a unique way. When the male travels to drink he also ensures that his belly feathers are soaked in water before he returns to the nest. These feathers have microscopic filaments on the inside surface which help to prevent loss of water by evaporation during flight. In this way the young birds are able to survive some distance from the water sources.

Desert mammals

Mammal adaptations to the desert environment include the ability to survive without drinking any water by relying on moisture digested from prey species. Small seed-eating mammals, such as desert rodents, use seeds stored in their burrow as a form of water storage. As the mammals breathe, they exhale water vapour; the condensed water is absorbed by the seeds and can then be consumed when the seeds are eaten.

Various desert mammals have extraordinarily large ears. The fennec fox (*Fennecus zerda*) of North Africa and the Middle East (see page 41) and the jackrabbits of North America, for example, have ears that appear disproportionate to the size of their bodies. One of the reasons for this is that the ears act as a temperature safety valve. The dense network of blood vessels close to the surface helps to radiate away excess heat from the animal's body.

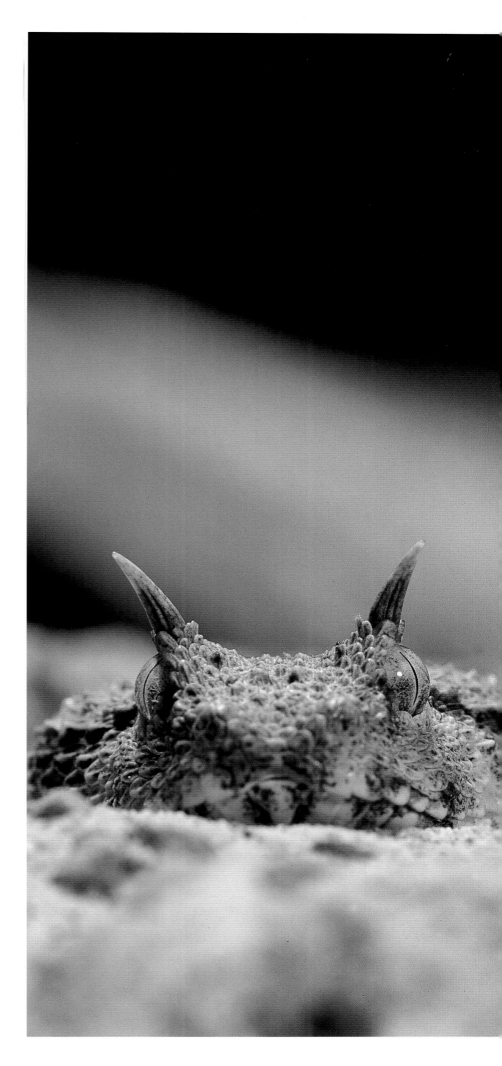

LEFT: The web-footed gecko is a nocturnal and mainly solitary species. During the day it rests in deep burrows, emerging at night to hunt for insects. The males of this species commonly fight one another.

RIGHT: The horned viper is an extremely venomous African snake. It moves in a side-winding manner to reduce contact with the hot sand and burrows to escape from the heat. The prey of the horned viper is small desert mammals.

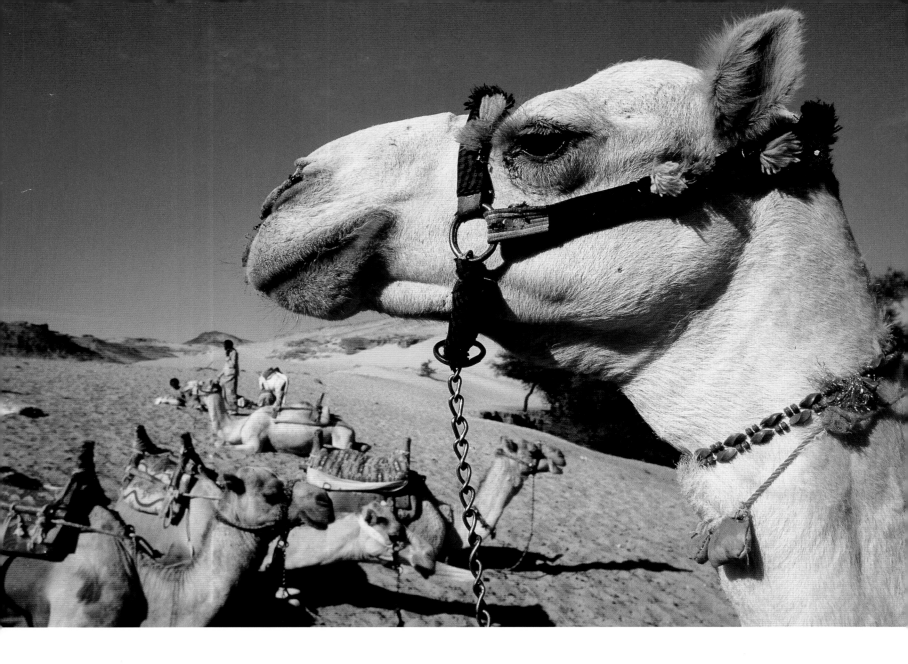

The king of desert animals

The camel must be the most characteristic desert animal, and is superbly adapted to withstand the harsh, arid conditions. There are two species of camel: the one-humped camel, or dromedary (*Camelus dromedarius*), and the two-humped or bactrian camel (*C. bactrianus*).

Closely related to the camel are four species found in the South American steppes and arid lands: the llama (*Lama glama*), alpaca (*Ama pacos*), guanaco (*Lama guanicoe*) and vicuña (*Vicugna vicugna*). The close relationship between the true camels and their relatives in South America was recently confirmed by the artificial production in Dubai of a cross between a camel and a llama – the 'camma'.

Dromedaries and bactrian camels are able to survive for long periods – up to ten months if they are not being worked and they have access to plenty of food – without drinking any water, after which they can rapidly consume around 130 litres (29 gallons)! They also conserve water by producing little urine and dry faeces. Camels have specially adapted sweat glands, eyelids

that can wipe away sand, and nostrils that can be closed to keep out sand and dust. They can survive on a diet of sparse, dry thorny vegetation and can store energy-rich fats in their humps, as well as having thick coats, which help protect them against the extreme temperatures.

It is not known exactly when the dromedary was first domesticated, but it is thought that this took place in Arabia well before the birth of Christ. From there the one-humped camel was transported to North Africa, and later to East Africa and India. Today there are around 12 million dromedaries in the world, all of which are domesticated – the dromedary has long been extinct in the wild – the majority of which live in Africa.

The bactrian camel was domesticated independently probably around 4,500 years ago. The natural range of the bactrian camel extended from Asia Minor through to Northern China, and wild animals were common in the early part of the 20th century. Now less than a thousand wild bactrian camels remain in the arid upland areas of the Gobi Desert (see page 89).

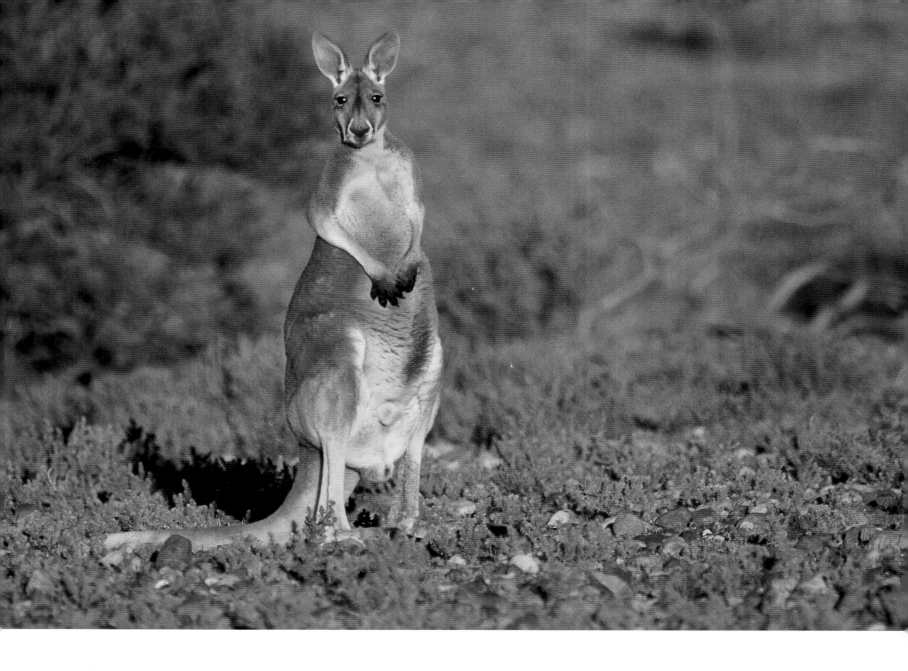

Camels are immensely valuable as beasts of burden and as a source of milk and meat in traditional desert societies. Even where modern vehicles have replaced transport by camel, these superbly adapted creatures retain a special place in the customs and rituals of the Arab and Asian world.

Camel racing is a hugely popular sport in the Arabian Peninsula, where racing camels are as highly prized as top racehorses are in the West. Traditionally camel racing took place at weddings and other festivals. Now customized race tracks have been built for the sport. Slender breeds of camel such as the pale-coloured 'Anafi' or dark 'Boushari' are favoured for racing.

Camel racing also takes place in the Australian outback! Camels were first introduced into the country in 1840 and they played an important role in aiding desert exploration. Now there are about 150–200,000 feral camels living throughout the arid interior of Australia. Every year people meet in the small outback town of Boulia to watch the camel-racing event.

OPPOSITE: Camels are prized possessions of the nomadic people of desert regions.

ABOVE: The red kangaroo (*Macropus rufus*) is a characteristic mammal of the Australian drylands. Unlike other desert mammals of Australia, this species has thrived since European settlement, benefiting from the provision of pasture and water for domestic livestock.

Desert people

Throughout the drylands of the world people have developed ingenious strategies to cope with the harsh conditions. Traditional hunter-gatherer societies in dryland regions are now extremely rare. The San Bushmen of the Kalahari and Namib Deserts have been all but forced to give up their traditional existence based on collecting roots and tubers, berries and fruit, and hunting antelope and small desert mammals with poison-tipped arrows. The Aborigines of Australia's arid lands have largely dropped their traditional nomadic ways. In the past, the Aborigines travelled through the desert with few possessions, hunting wild animals with spears and boomerangs and collecting desert plants. Their way of life was finely tuned to the desert environment and remained a sustainable form of land use for millennia.

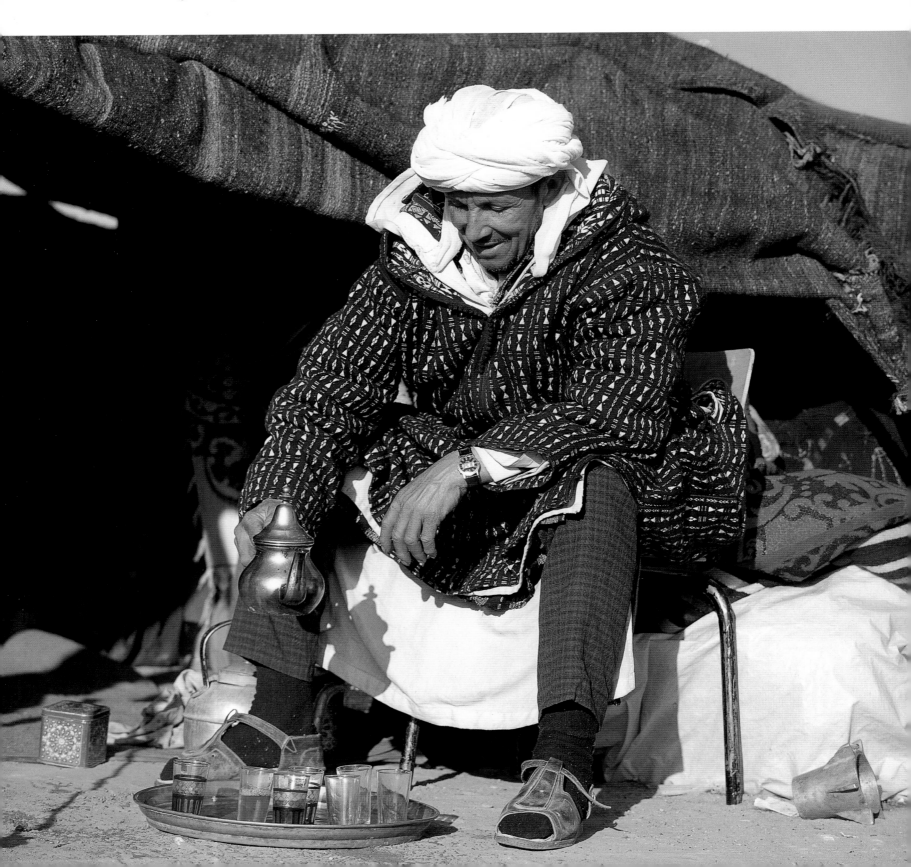

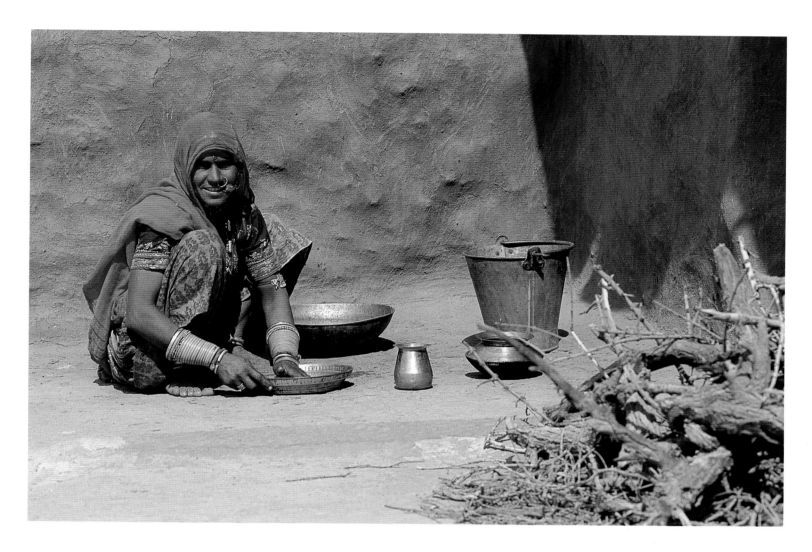

Pastoralists

The tending of domestic animals in various forms of pastoralism is a much more widespread way of life in desert areas. The pastoralists are usually nomadic, travelling with their herds to find new sources of grazing in response to seasonal changes in temperature and rainfall. The domestic animals provide food, clothing, transport and often a measure of wealth for traditional desert nomads. Where wood is scarce in arid regions, shelter is often provided by tents, which are easy to transport; cultures which are constantly on the move tend to have few possessions. In the Gobi Desert the traditional yurts are made from yak wool; the Bedouin of the deserts of Arabia traditionally inhabit tents made from black cloth of woven goat and camel hair; and the Afar or Danakil people of Eritrea and Djibouti live in portable shelters made from animal skins.

Traditional use of desert plants

Making use of scarce native plants has helped traditional cultures to survive in arid regions. Gathering of plants for food continues to supplement the diets of nomadic peoples, and the traditional use of wild plants as medicines is of major importance in most dryland parts of the world. For example, over 70 plant species in Central Australia have been used medicinally by

LEFT: The Bedouin of the Arabian Desert are pastoralists with livelihoods based on tending camels, goats and sheep. Here, a Bedouin man prepares mint tea.

ABOVE: A Thar woman cleans pots in preparation for cooking. Life is a struggle in this, one of the most inhospitable landscapes on earth. The people of the Thar Desert are nomadic, moving from place to place in search of water and grazing lands, and returning only on occasion to their ancient villages.

Aborigines. The use of plants as narcotics has also played a part in desert society; the hallucinogenic peyote cactus (*Lophophora williamsii*) – and several other species of cacti – is ritually consumed by the native people of the American Southwest and Mexico. *Khat* or *qat* is a stimulant derived from *Catha edulis*, an evergreen shrub which grows wild in East Africa and is now cultivated in Ethiopia, Somalia and Yemen. In Australia, four wild species of *Nicotiana*, the plant genus of commercial tobacco, are used by Aborigines to produce a mild drug called *pituri*, which is important in traditional trade.

One of the major traditional uses of plants in dryland areas is to provide fuel for cooking and heating. Trees, being such a rare resource, are of immense importance to local people in arid environments.

Agriculture in arid lands

Agriculture in desert areas has usually been associated with the major river valleys, mountain massifs or oases. Various forms of irrigation have made cultivation possible in otherwise arid and barren regions. In the Nile Valley, traditional irrigation made use of the late summer flood. Various mechanisms such as waterwheels (powered by donkeys) and the *shaduf* (a counterpoised pole and bucket) have been used since Roman times to lift water into the irrigation channels.

Elsewhere in the arid lands of the world different strategies have been employed to guarantee water for the cultivation of crops. Ancient engineering exploited groundwater supplies in parts of North Africa and Asia with underground tunnels and water-lifting devices, known in Iran as *ganat*. For thousands of years dams have been built in arid regions as a means of controlling water supplies and providing water for agriculture.

In total around 850 million people inhabit arid and semi-arid lands, with over 80 per cent living in poor rural areas dependent on agriculture and pastoralism. Modern desert cities such as Palm Springs and Las Vegas in the USA are home to only a small fraction of the people who live in the driest parts of the world.

BELOW: Aboriginal men from the desert area of Arnhem Land in Australia. Arnhem Land is a large Aboriginal reserve in the far north of the Northern Territory, and outsiders may only visit by permission of the indigenous owners.

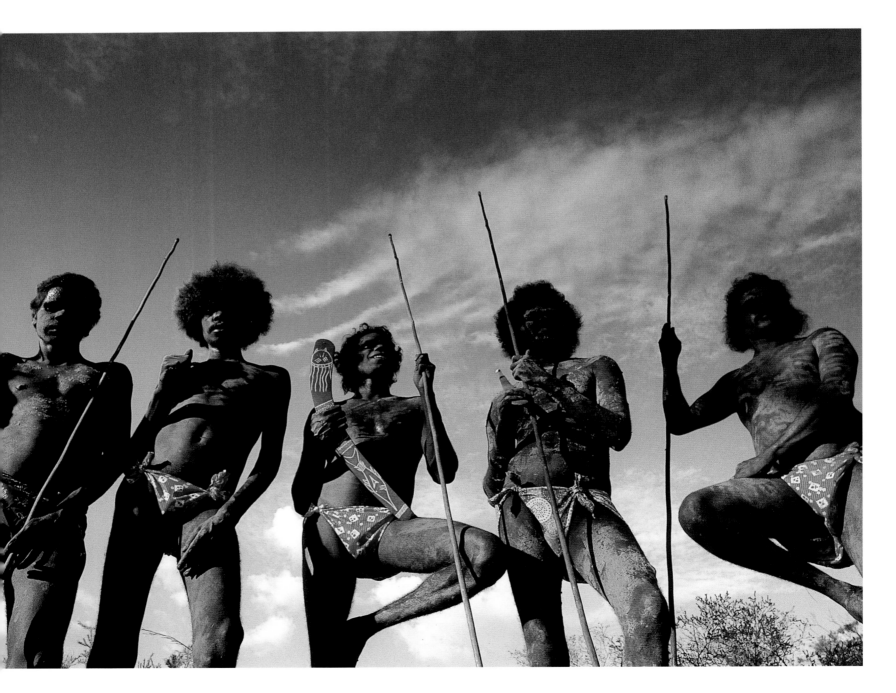

Desert resources

Water is perhaps the most precious natural resource in the desert and is exploited wherever it can be found. Increasing scarcity is a major issue in areas of rapid population growth such as the Middle East and southwest states of USA, and can even be a source of conflict where international boundaries are involved. Water scarcity has recently been described as the single biggest threat to global food security. Modern technology has made possible the exploitation of ancient underground water supplies, the desalination of sea water and the long-distance transport of water from sources outside the desert region. Rapid changes in water supply can, however, create problems such as salinization of soils in dryland areas.

Cultivation of naturally adapted desert plants can help to conserve precious water supplies, and some of the plants naturally associated with desert areas have become major commercial resources in dryland agriculture. The date palm (*Phoenix dactylifera*) has been in cultivation since 4000BC and is now widely grown commercially in Iraq, North Africa and California. *Aloe vera*, another desert species, again no longer known in the wild, has been cultivated for several millennia and is now a major crop in countries such as the USA, Mexico, South Africa and China. The cultivation of cacti as houseplants is a major industry – although unfortunately one from which Mexico, the country with the highest natural diversity of cacti, has scarcely benefited.

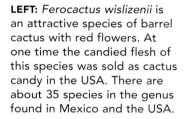

LEFT: *Ferocactus wislizenii* is an attractive species of barrel cactus with red flowers. At one time the candied flesh of this species was sold as cactus candy in the USA. There are about 35 species in the genus found in Mexico and the USA.

BELOW: In total there are about 2500 species of cacti, many of which are cultivated as pot plants. Interest by collectors has resulted in the virtual extinction in the wild of many of the rarer species.

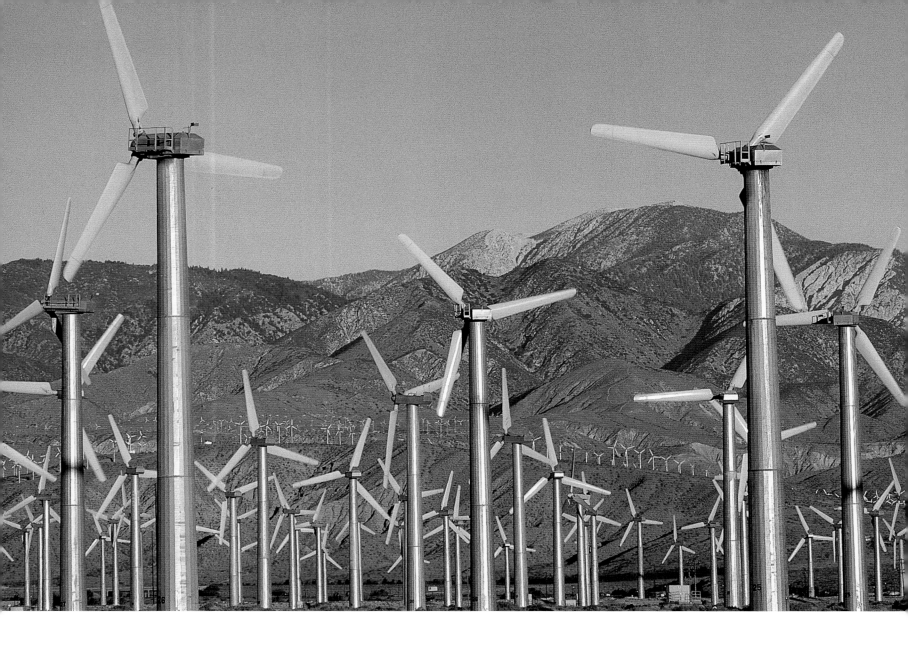

Desert crops

Some of the major plant crops of the world have originated in the semi-arid areas. Wheat, barley, sorghum, millet, various pulses and cotton all originally grew wild in dryland ecosystems, and the earliest recorded agriculture is associated with arid regions. The selective breeding of crop plants began between 5,000 and 10,000 years ago, and it is generally accepted that agriculture originated more or less simultaneously in various parts of the world. The Fertile Crescent, which lies between the Rivers Tigris and Euphrates in what is now Iraq, is the source of domestication of wheat and barley, together with certain pulses such as the lentil. Early agricultural development also took place in the fertile loess deposits (light, wind-blown dust) north of the 'Yellow River' in China, based on the cereal millet, and in Mexico where squashes, beans, peppers and maize were domesticated. Agriculture is also thought to have developed independently at the same time in the South American Andes.

More localized food crops of the drylands include teff (*Eragrostis tef*), which was first domesticated in Ethiopia and remains the most widely grown crop in the country. Teff is used to make a pancake-like bread called *injera*, and also porridge and alcoholic drinks. The straw is used as cattle feed and in house construction. Elsewhere teff is cultivated only in North and South Yemen.

Hidden riches

Over the past 150 years or so oil has become the most economically valuable natural resource associated with dryland regions. In the late 19th century major oil discoveries were made in the arid regions of Texas and California, and during the last century oil has transformed the fate of the countries of North Africa and the Middle East. Oil brings wealth which has enabled technological solutions to water shortage in various parts of the world.

Other minerals found in desert regions include diamonds along the Diamond Coast of Namibia and in the Kalahari Desert, iron ore in the Saharan country of Mauritania, copper which is mined in the Atacama Desert region in Chile, and gold, silver and opals in Australia. The deserts of Central Asia also have considerable mineral wealth with deposits of coal,

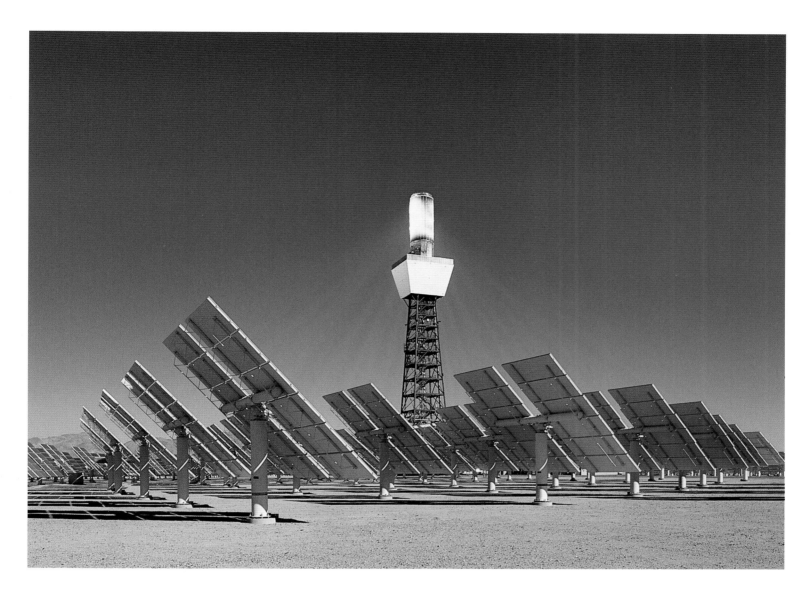

lead, zinc, iron and copper. Great ingenuity has been needed to exploit mineral resources in the harsh arid conditions, and sadly considerable despoliation of the environment has taken place in the process. As in other ecosystems the importance of exploiting desert resources in a sustainable way is now generally recognized, but not yet fully practised.

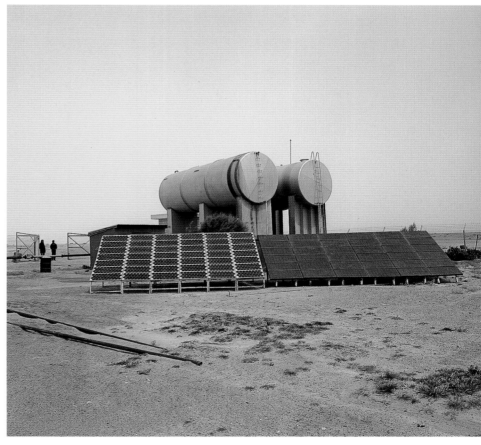

OPPOSITE: Wind turbines produce energy for the city of Palm Springs in California.

ABOVE: Heliostats or sun-tracking mirrors form part of a solar power plant in California. Commercial solar power plants are starting to supply the state's energy needs.

RIGHT: Jordan is one of the countries that has developed new renewable energy technologies, making use of solar power. This solar power water pump is near the city of Badia.

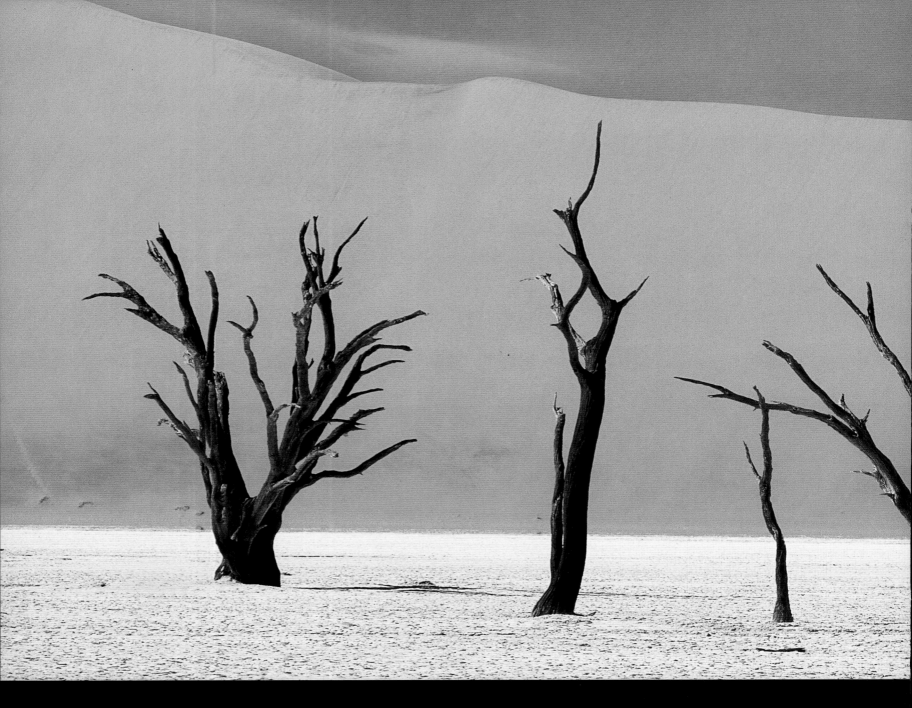

CHAPTER TWO
Africa
The Sahara, Kalahari and Madagascar

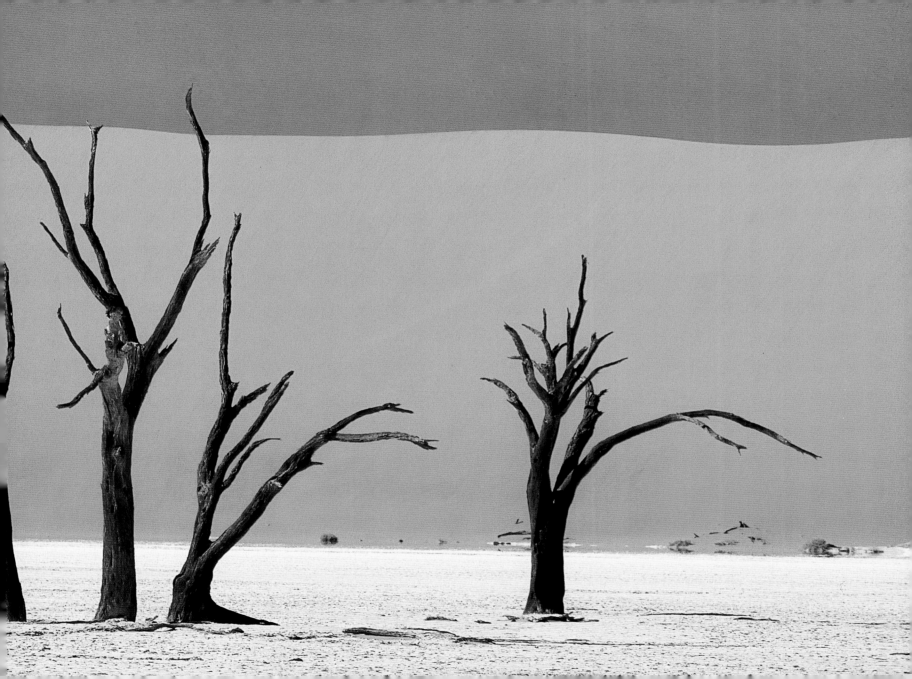

The Sahara

Stretching from the Red Sea coast of Egypt and Sudan in the east to the Atlantic Ocean in the west, this is the largest desert in the world. This vast expanse, covering around 9 million square kilometres (3½ million square miles) – one-third of the African continent – is relatively young in geological terms, forming a westerly extension of the ancient sweep of drylands of Central Asia and the Middle East.

During the Miocene period (6–25 million years ago) lush tropical forests covered much of Northern Africa – the area now occupied by the Sahara Desert. Only small areas of desert occurred in the east of the region. The climate gradually changed towards the end of this geological time period and the eastern regions

became drier. The expansion of the desert, and drifting apart of the African and Eurasian continents, took place about 15 million years ago.

Much later (some 10,000 years ago) when the first pastoralists migrated across Northern Africa, the central part of what is now the Sahara was still covered in rich vegetation. Increasing human populations and grazing by animals, together with climate change, led to the formation of the vast Sahara Desert between 4,000 and 10,000 years ago.

Prehistoric rock paintings

The prehistoric changes in the Sahara are recorded in ancient rock paintings found at Tassili n'Ajjer in southeast Algeria. Herds of elephants, ostriches and gazelle are portrayed roaming open plains. Later paintings at this same site show herds of cattle, brought into the area by migrant pastoralists. Fish hooks, used by early migrants, have also been found in

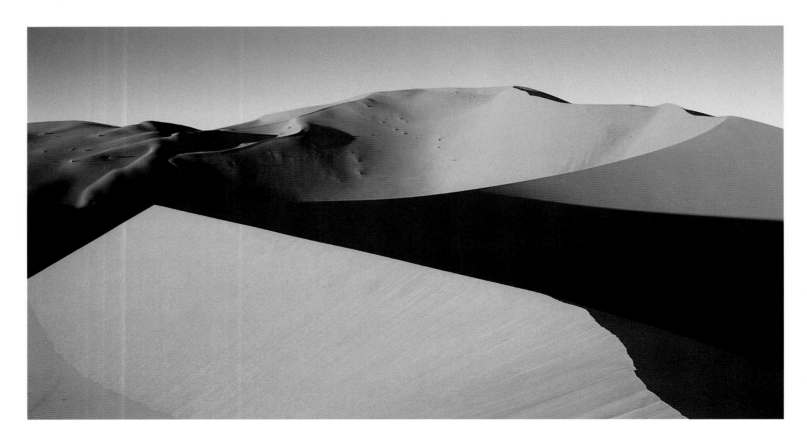

areas where rain now rarely occurs. High in the Tassili and Ahaggar Mountains, sheltering in deep gulleys, are ancient cypress, oleander and olive trees – leftovers from a time of Mediterranean climate. In remote mountain pools crocodiles survived until early in the 20th century.

Landscapes of the Sahara

The Sahara today is a region of varied landscapes. Seas of sand, the popular image of the Sahara, cover about one-third of the desert. The most extensive sand seas are in the northern Sahara – the Great Western Erg and Great Eastern Erg of Algeria, the Idehan Mourzouk of Libya, and the Western Desert of Egypt. There are also wind-scoured stony plains known as regs, and the hammada, rocky plateaux with deep gorges. In the centre of the Sahara are mountain ranges, including the eroded volcanic massifs of Aïr and Tibesti.

People of the Sahara

Much of the hostile Saharan region is uninhabited. In total about 12 million people are scattered across the major dry expanses, an area roughly the size of the USA. Four times this number live in the part of the desert that is served by the two major rivers, the Nile and the Niger. The Sahara crosses the borders of 11 different countries, the boundaries of which were largely drawn in the era of European colonial settlement. These boundaries cut across the homelands and old caravan routes of the traditional Saharan inhabitants.

The most famous of the Saharan tribes are the Tuareg, sometimes known as the 'blue men of the desert' because of their famous indigo-coloured robes. The Tuareg people actually comprise various different groups who share a common language, known as Tamahaq, a common history and a common religion, Islam.

The Greek explorer and historian Herodotus first recorded the presence of the Tuareg in Northern Africa. Over the past two millennia many Tuareg groups have migrated southwards in response to pressures from Arab settlers in the north and the promise of more prosperous land in the south. The Tuareg homeland includes parts of Mali, Burkina Faso, Mauritania, Niger, Algeria and Libya. There are around 1 million Tuareg people today, most of whom live in the cities bordering the Sahara that once were the great centres of trade for Western Africa. It has become increasingly difficult for the Tuareg to maintain their traditional independence.

PAGES 32–33: Dead Vlei is an old pan in the Namib-Naukluft National Park, Namibia. It has not had regular water since the local river changed its course. Skeletons of old Acacia trees haunt the landscape.

OPPOSITE TOP: Ancient rock paintings are found in various desert regions and help to record the history of desert formation. These are in the Namib Desert.

OPPOSITE BOTTOM: Saharan dunes at sunset in southern Algeria.

BELOW: The Tuaregs of the Saharan Desert are Muslims but the women do not generally wear the veil. Women have a strong position in Tuareg society and social status of the Tuareg people depends on matrilineal descent.

PAGES 36–37: The waters of the Nile are of immense importance for transport, irrigation, trade and settlement along the banks of this mighty river. In Egypt around 60 million people live along the banks of the Nile.

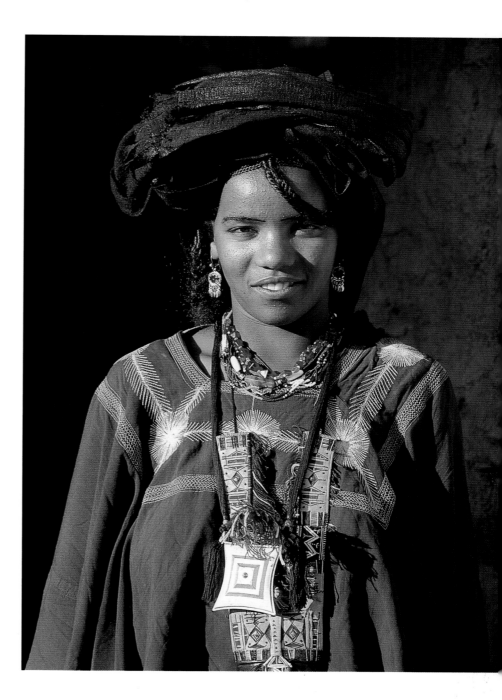

Tuareg camel caravans played the primary role in trans-Saharan trade until the middle of the 20th century, when trucks took over. Salt was one of the important items of trade during the early 20th century. Historically the Tuareg traded mainly in luxury items, and were also responsible for transporting slaves from West Africa for sale in Europe and the Middle East. Tuareg society was a hierarchy of nobles, vassals and slaves. Cultivating the land and looking after the animal herds was considered the work of the lower classes, while the nobles were traders who controlled the caravan routes. Usually groups of settled Tuareg paid allegience to a locally appointed headman, who in turn would report to the ruling tribal leader. Over time, however, the settled groups of Tuareg have grown relatively prosperous, whereas the traders have suffered as their control of trans-Saharan trade routes declined.

Rivers through the Sahara

Two major river systems cross the Sahara: the Nile and the Niger. Both are of immense importance for human livelihoods and have supported civilizations since ancient times. The Nile, the world's longest river, flows for over 6,600 kilometres (4,100 miles) from its two sources north to the Mediterranean, draining a huge area of Northeast Africa – approximately 10 per cent of the entire continent – and providing the only reliable source of water for millions of people. The Blue Nile originates in Lake Tana in the Ethiopian Highlands, and the White Nile begins at Lake Victoria in Uganda. Over 80 per cent of the water of the Nile originates in the mountains of Ethiopia, particularly during the monsoon season from June to September. Around 60 million people live along the banks of the Nile in Egypt, and securing the long-term flow of the river through the country is a major political issue. Construction of dams upstream in Sudan and Ethiopia could significantly reduce water availability in the desert country of Egypt.

The Niger flows through a variety of West African climatic and vegetation zones on its 4,200-kilometre (2,608-mile) journey from its source in the highlands of Guinea to Nigeria. The inland delta of the Niger River in Mali is an extremely important water resource in the dryland region. Every year seasonal flood waters from the Niger and Bani Rivers spill onto a vast flood plain to create a mosaic of wetland habitats surrounding dry areas on higher ground. In the centre of the delta area lies Lake Debo. Over 500,000 people are dependent on the inland delta, relying on rice cultivation on the periodically flooded ground, millet cultivation in the drier areas, pastoralism with sheep, goats and cattle, and fishing.

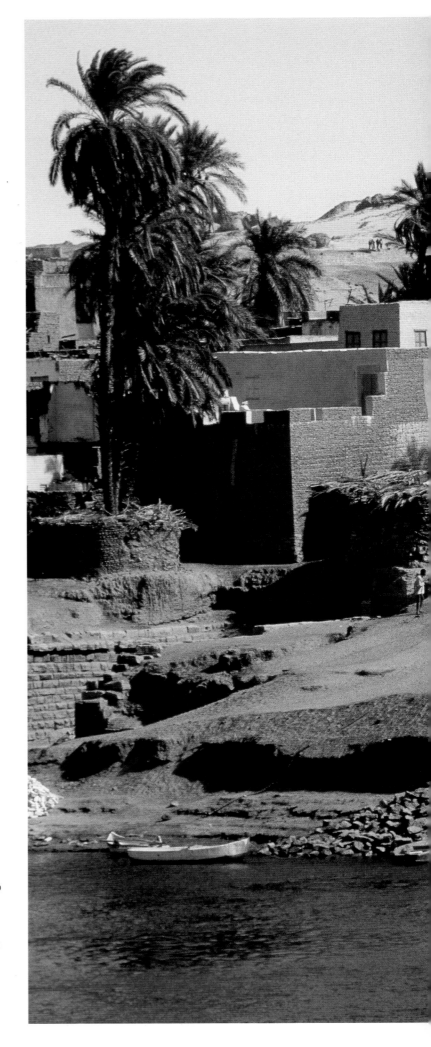

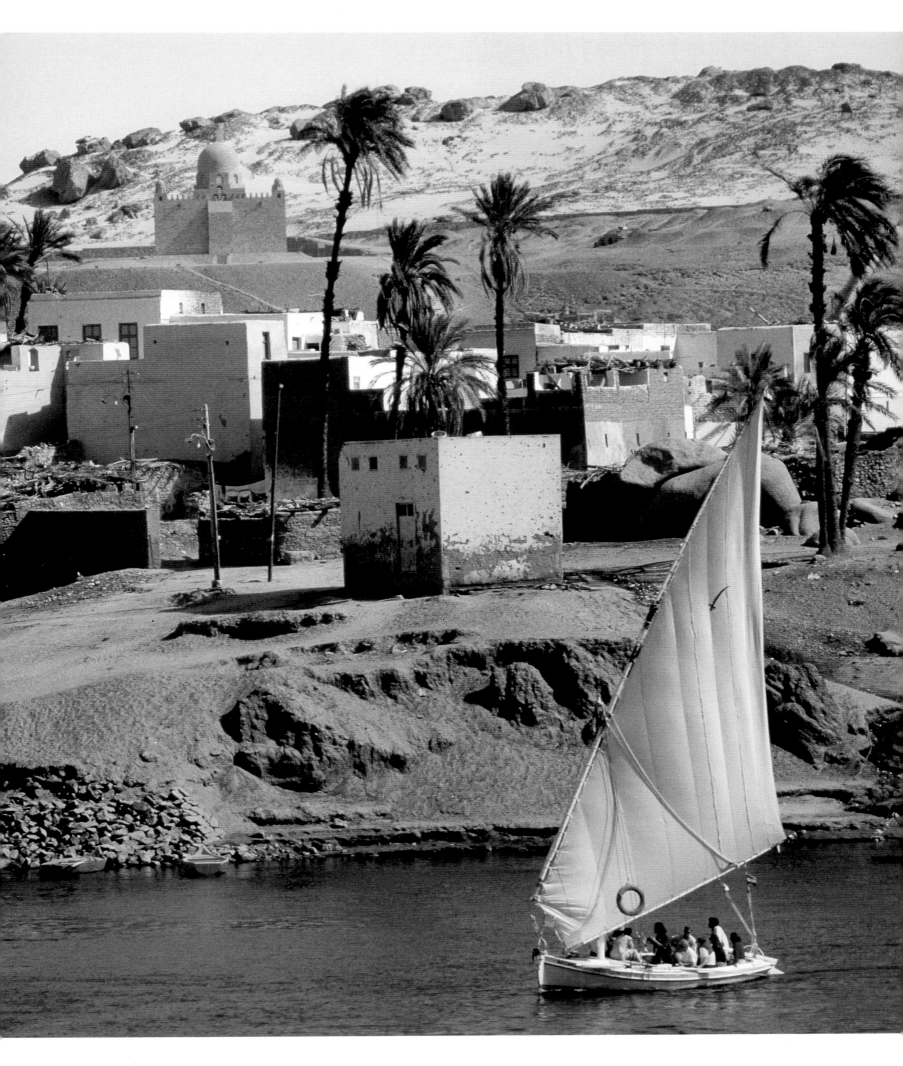

Desert margins

The dryland areas adjacent to the Sahara form the region known as the Sahel. The word *sahel* means 'shore' in Arabic; the Sahel region provides the 'shoreline' of the Saharan sea of sand. Extending in a broad band across Africa, south of the Sahara, the Sahel is a zone of transitional vegetation between the true desert to the north and the lusher savannahs and forests to the south.

Trees of the Sahel

Vegetation in the Sahel is typically composed of thinly scattered trees with grasses and annual plants which are lost in times of drought. The trees, better adapted to survive prolonged dry spells, are vitally important in this harsh environment. Tree species help to retain and nourish the soil and provide food and shelter for dryland animals and birds. Trees are also essential to the rural livelihoods of local people. Wood forms over 95 per cent of the total energy supply in Mali and only slightly less in the neighbouring country of Burkina

Faso. With increasing population pressure and climate change, trees around major urban areas have all but disappeared. With decreasing availability of wood, villagers have turned to burning more cattle dung and agricultural residues which otherwise would be used to fertilize the soils.

The trees of the Sahel region tend to be widespread species that have an extensive distribution in Africa, often extending into the Middle East. *Acacia senegal* is one such characteristic example, and is found from the Red Sea to Senegal. Like many of the Sahel species this is a truly multi-purpose tree. When the gnarled and spiny branches of *Acacia senegal* are wounded, a viscous gum is produced that dries in globules on the bark. Known internationally as gum arabic, this product is the main source of income in parts of the Sahel. The Egyptians used gum arabic in medicines and pottery production over 4,000 years ago, and it has been imported into Europe for several millennia. The wood from this tree is used for fuel, charcoal and local building construction.

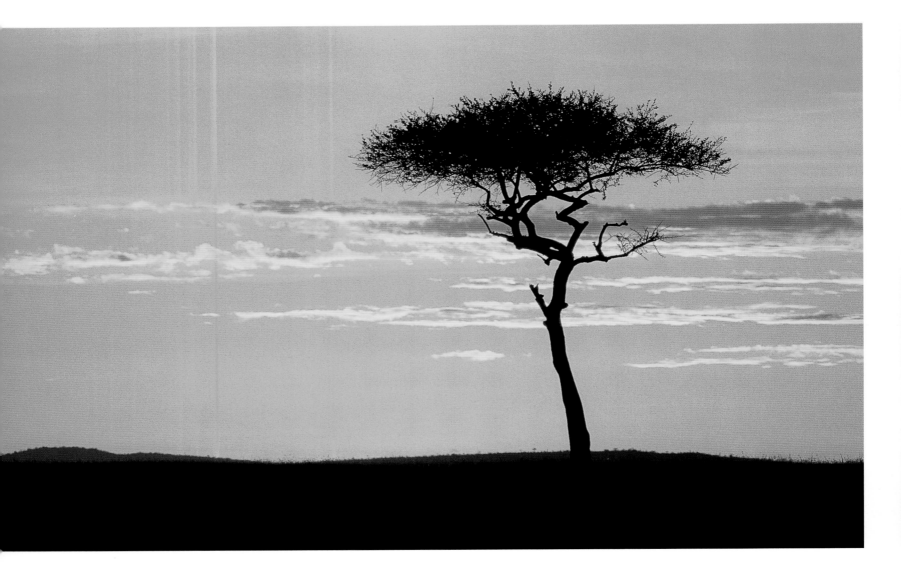

The tree is also used to stabilize the dry soils and for hedging, and ropes are made from the bark and roots. Seeds are dried and eaten, and various parts of the tree are used medicinally.

Another characteristic species is African blackwood (*Dalbergia melanoxylon*). This tree has a widespread distribution throughout sub-Saharan Africa and produces a particularly valuable heavy, dark timber. The wood used to make musical instruments, such as clarinets and oboes, is sourced further south in the savannah woodlands of Mozambique and Tanzania, whereas the Sahel wood is highly prized for carving. It is the most valuable timber by weight of all the trees of the Sahel.

People of the desert margins

The population of the Sahel is around 60 million, and includes many of the world's poorest people. Their traditional ways of life, involving complex patterns of interaction between farmers and pastoralists, developed over centuries, but have been made harder by colonial policies which denied local people control over their woodland grazing resources. After independence, in 1960, centralized state control generally continued similar policies. Climate change has also made life more difficult. SOS Sahel is one organization which has been cooperating with local communities to improve the management of natural resources. In a typical project in Niger, SOS Sahel has been working with the agricultural Houssa people in the Takieta woodland. This woodland area is severely degraded, and replanting of trees has been carried out for over 20 years. In 1995 a forest management project was set up with support from SOS Sahel to transfer responsibility for resource management to the local communities. As the area is utilized by Peuhl and Tuareg pastoralists it was important that they were brought into the discussions and negotiations. A general assembly and management committees have been established so that all the people who have an interest in maintaining the trees in this dryland region can now influence its management.

OPPOSITE: An acacia tree at sunrise. There are over 1,000 *Acacia* species found mainly in arid regions, many of which are of great value to local people.

LEFT: This Bedouin camel rider is in front of the pyramid of Djosser at Sakkara – the oldest of Egypt's 97 pyramids.

BELOW: Tree planting is an important activity at the desert margins. The young trees, if carefully tended, can help to stabilize the fragile soils and prevent the spread of deserts into cultivated land. Many trees have been lost through overgrazing and collection for fuel.

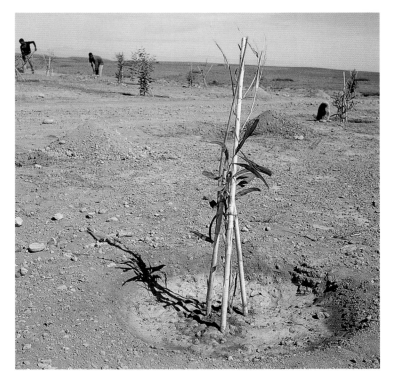

East Africa and the Horn of Africa

The Horn of Africa was arid when forests still flourished in what is now the Sahara. This ancient corner of Africa is remarkably rich in arid plant and animal species which are not found elsewhere. It has three distinct ecological zones: the northern uplands of Somalia (which run parallel to the Gulf of Aden); the Haud, or Ogaden (an inland plateau); and a low-lying coastal area with infertile sandy soils.

Afar, Beja and Somali people

Around 60 million people live in the Horn of Africa, divided into two broad ethnic groups – Semitic and Hamitic – primarily on the basis of language. Amharic forms of language (as, for example, spoken in the highlands of Ethiopia) are related to both Arabic and Hebrew – the Semitic languages. The Somalis speak a very different Hamitic language, which is related to the languages spoken by the Oromo, Beja and Afar people who live in lowland parts of Ethiopia and Eritrea.

The Afar people of Eritrea and Djibouti are also known as the Danakil. These nomadic people live in some of the hottest and most inhospitable conditions on the globe. The Afar are pastoralists who herd sheep, goats, cattle and, most important of all, camels. Typical Afar camps are called *burra*, and are made up of simple shelters constructed from animal skins stretched over a framework of curved wooden supports. Camels are used primarily for transport, to move the shelters to new areas in search of pasture. Staple foods are meat and milk, and livestock products are also bartered for grain and vegetables; some Afar tribes also trade salt which they mine in places such as the Dobi Desert.

The closely related Beja people live along the Red Sea coast to the north of Afar territory, extending from Eritrea into coastal Sudan. The Beja are renowned camel breeders. Apparently, however, they have little interest in the commercial value of their beasts and allow the Rashaida tribe, relatively recent immigrants from Saudi Arabia, to control the trade in camels with Egypt.

The people of Somalia share a common language – Somali – which, at the time of independence in 1960, did not exist in written form. They also share a common religion – Islam. Somalis also have a nomadic heritage, with almost half the population continuing to live as pastoralists and owning nearly half the world's camel population. Women and children are responsible for herding goats, and boys from the age of seven upwards are entrusted with the care of the precious camels. Most of the country has under 500 millimetres (20 inches) rainfall per year; only about 13 per cent of the land is suitable for cultivation, mainly in the area between the Juba and Shebele rivers. In the Ogaden Desert many well sites have been used for up to 2,000 years.

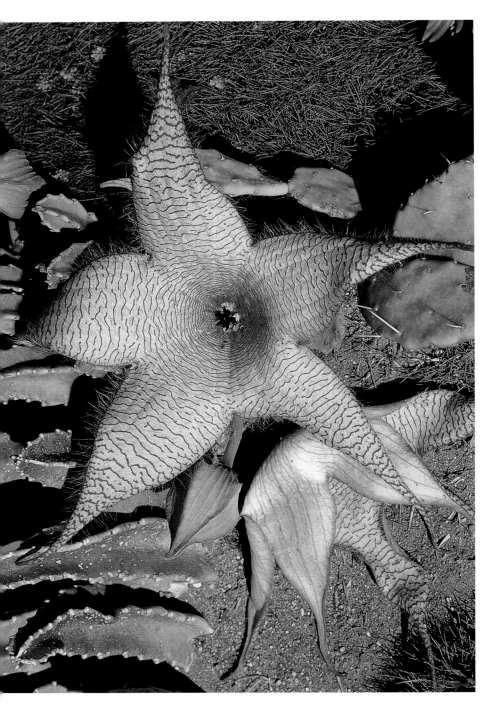

LEFT: There are around 50 species of *Stapelia*, commonly known as carrion flowers because of their smell which is attractive to flies. *Stapelia* species and other succulents in the family *Asclepiadaceae* are popular with succulent plant collectors.

OPPOSITE: The Orange River Aloe (*Aloe gariepensis*) is one of the many succulents found in the Richtersveld National Park. This species, which is native to both Namibia and South Africa, has flower spikes over 1 metre (3¼ feet) tall bearing yellow flowers.

Plants and animals of African deserts

In Africa semi-desert vegetation occurs in areas with less than about 250 millimetres (10 inches) rainfall each year. True deserts in the most arid areas include the magnificent Sahara, the floristically richer Namib Desert, and parts of northern Kenya. The desert plants of Africa show a remarkable variety of adaptations to the arid climate.

Palms

Palms are able to survive harsh desert conditions via various mechanisms to reduce water loss through the stems and leaves, and include species of *Borassus*, *Hyphaene* and *Phoenix*. The date palm (*Phoenix dactylifera*) is a classic symbol of desert regions. The exact origin of this widely cultivated plant is uncertain, but its original distribution is thought to be in the desert oases of North Africa, Arabia, Persia and West Asia.

The African fan or ron palm (*Borassus aethiopum*) is important in local economies throughout semi-arid and sub-humid areas. As with the date palm, nearly all parts of the plant can be used locally and as a source of income in rural communities. The timber is used for construction, the leaves for basketwork and thatching, the fruit pulp and seeds are edible, the sap makes a good palm wine, and the roots are used to produce a mouthwash and cure for asthma.

Other species of palm are very scarce in the wild. The argun palm (*Medemia argun*) is now on the 'Critically Endangered' list and known only from a few oases in Egypt and Sudan. It is thought that this palm was widespread in ancient Egypt, at which time it was called *Mama enxanine* and was placed in tombs as an offering to the gods. Over the years, exploitation of the fruit and fronds of the argun palm and destruction of its habitat along the banks of the Nile have led to its near extinction.

Succulents

A wide variety of succulent plants have adapted to survive the arid conditions of Africa's drylands. These plants have the ability to store water in their stem, leaves or roots.

The largest family of African succulents is the *Aizoaceae*, which includes the mesems (*Mesembryanthemum*), with their wonderful diversity of growth forms and attractive brightly coloured flowers. Nearly all the plants of this group are native to South Africa and Namibia.

More widespread are the aloes and succulent *Euphorbias*; the genus *Aloe* consists of around 360 taxa of succulent plants. The distribution range of the genus extends throughout Africa, with species mainly in the drier areas, and into the Arabian Peninsula and islands off the east coast from Socotra to Madagascar. A number of *Aloe* species are very important to local communities as extracts from the succulent leaves provide a cure for a range of ailments.

One of the most extraordinary African desert plants is *Harpagophytum* or devil's claw. Two species of *Harpagophytum* are found only in the Kalahari sands and surrounding areas of Southern Africa. Both are prostrate perennial scrambling vines with central tap

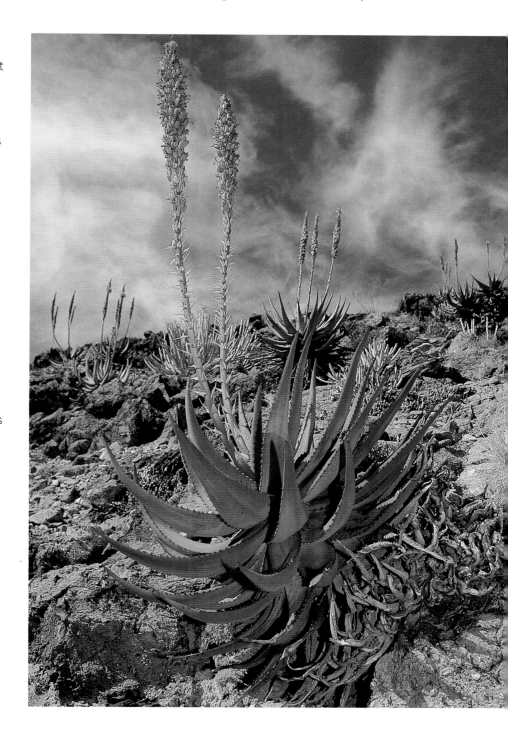

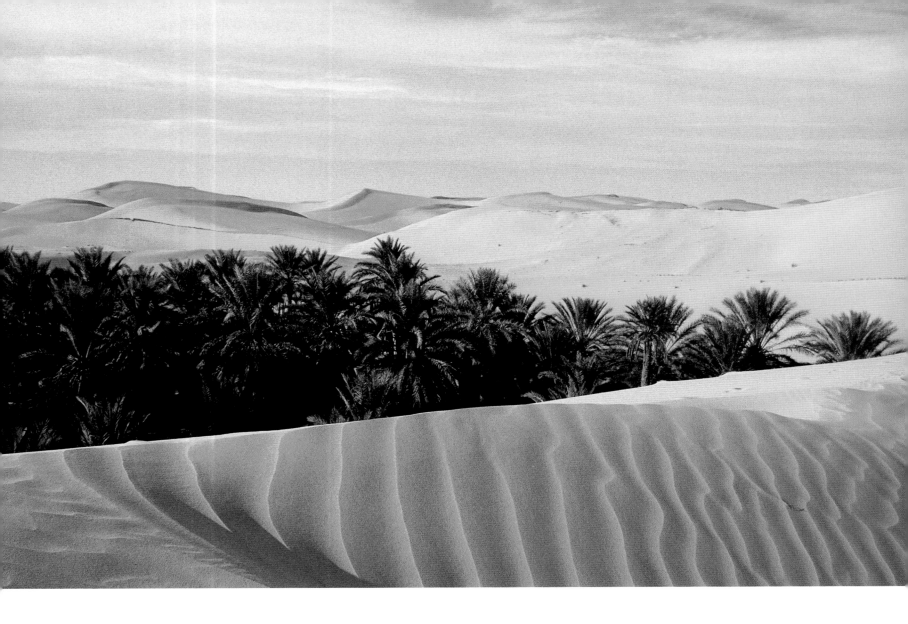

roots and secondary radial tubers. The secondary tubers are dug up by peoples such as the San Bushmen of Namibia, then sliced, dried and exported for use as a cure for arthritis and related ailments. There has been concern about the impact of trade on the survival of these two plant species. Various conservation groups, including Fauna & Flora International (FFI), have been working to provide solutions that accommodate both biological sustainability of the plants and the needs of the local people.

African desert animals

The animals which survive in the deserts of Africa are ultimately all dependent on the sparse vegetation. Characteristic animals of the Sahara include the pale-coloured fennec fox (*Fennecus zerda*) with its extraordinarily large ears (up to 15 centimetres/6 inches long) and feet with hairy soles adapted for travel over soft sand. The fennec fox feeds on small animals such as lizards and locusts, and can probably survive without water. The sand cat (*Felis margarita*), which can also survive without drinking water, is another typical species, as is the now uncommon dorca gazelle (*Gazella dorcas*).

The desert mountains provide refuges for species such as the leopard, the addax (*Addax nasomaculatus*) and the slender-horned or sand gazelle (*Gazella leptocerus*), which is able to survive on dew and moisture from plants. This graceful nomadic species – one of the least known of the antelopes – has specially adapted splayed hooves to make it easier to travel across the desert sands. Hunting has been the main cause of population decline. The Saharan mountains are also home to the barbary sheep (*Ammotragus lervia*).

Protected habitats

One of the most important protected areas of the Sahara is the National Nature Reserve of Air and Ténéré in Niger. This large reserve, which covers about 6 per cent of the entire land area of Niger, gives protection to addax, scimitar-horned oryx (*Oryx dammah*), barbary sheep, cheetah and various species of gazelle. Around 140 species of birds have been recorded from the area. The reserve has been planned to provide a model of integrated conservation which takes into account the needs of local people – in this case mainly the Tuareg, who live within the boundaries of the protected area.

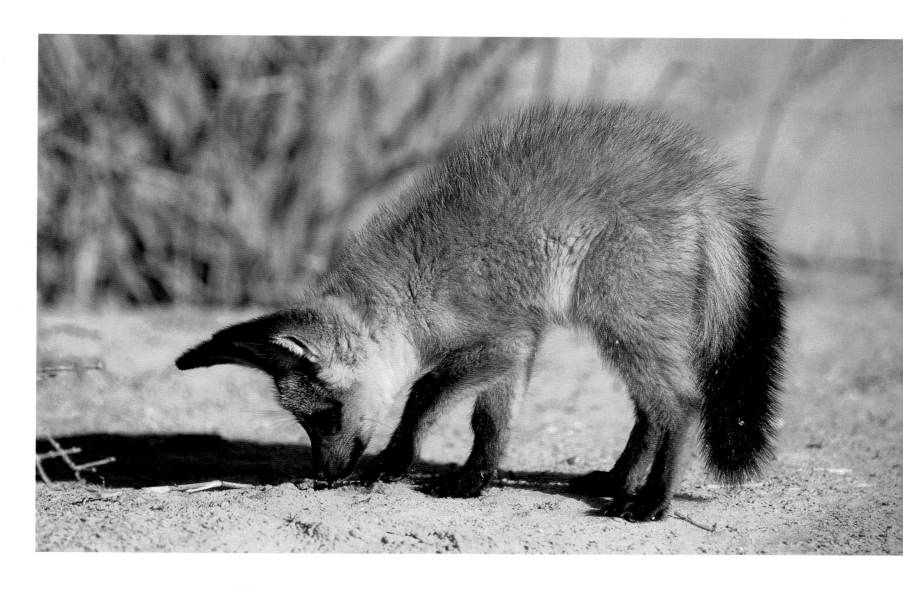

OPPOSITE: A typical palm grove in the Sahara Desert.

ABOVE: The bat-eared fox (*Otocyon megalotis*) has long legs and large ears. It has a disjunctive distribution occurring in East Africa and Southern Africa, in sandy steppe and savannah habitats. The bat-eared fox is active mainly at dusk, resting in its burrow or sunbathing by day.

RIGHT: The large long-legged secretary bird (*Sagittarius serpentarius*) is a common bird of southern Africa found in various different habitats. It roosts in the tops of thorn trees.

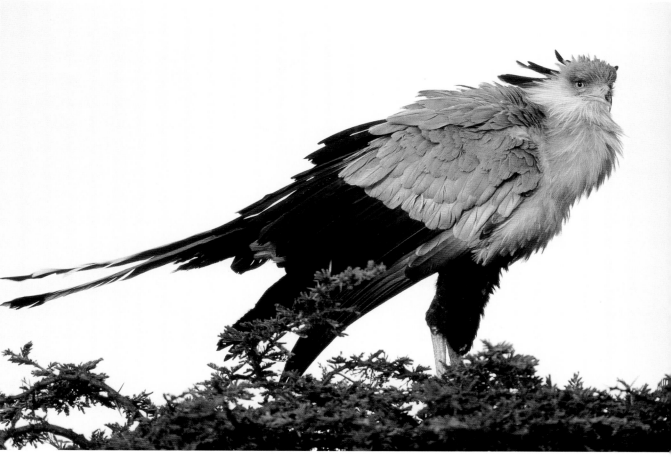

Fauna of the Horn of Africa

The Horn of Africa has a special fauna with a range of endemic animals. It is considered to be a centre of evolution for desert animals, particularly antelopes. Endemic animals include the dibatag or Clarke's gazelle (*Ammodorcas clarkei*) and the Beira antelope (*Dorcatragus megalotis*).

The dibitag is a graceful, long-legged gazelle, the only species in its genus. It has a slender body with reddish coat, white underparts and rump and a black tail, and a very long neck, which enables it to browse acacia trees and shrubs. The dibitag is found only in semi-arid areas of Ethiopia and Somalia. The main threats to this lovely species – particularly in Somalia – are hunting, degradation of habitat caused by drought, and competition with domestic animals for grazing land.

The handsome, large-eared Beira antelope lives in the mountainous areas of Djibouti, Ethiopia and Somalia. Like the dibitag, the Beira antelope is under threat in the wild and is now classified as 'Vulnerable' by IUCN.

LEFT: A juvenile addax (*Addax nasomaculatus*). In the 18th century this species was found throughout the Sahara but there has been a dramatic decline largely as a result of hunting. Now the species is considered to be 'Critically Endangered'.

BELOW: The barbary sheep (*Ammotragus lervia*) is another species on the IUCN Red List. It is considered to be 'Vulnerable' in the wild and is in need of conservation attention within its North African and Middle Eastern habitats.

OPPOSITE: Madagascar has six species of baobab tree compared to one species on mainland Africa and one in Australia. This species is *Adansonia grandidieri* and is found in the Morondava region in the west of the island.

The spiny forests of Madagascar

Madagascar has an extraordinary variety of plants and animals and is considered to be one of the top global priorities for biodiversity conservation. The world's fourth largest island, lying in the Indian Ocean 400 kilometres (248 miles) from southern Africa, it has a unique natural and cultural heritage. Species have evolved in relative isolation since the separation approximately 65 million years ago of Madagascar from the ancient land mass of Gondwanaland. Biologically Madagascar shows few affinities with either Africa or Asia. The tropical island has dramatic escarpments, mountain ranges and a central plateau, together with gentle foothills and coastal plains. There are no true deserts on Madagascar, but the driest parts of the island in the south receive low, sporadic rain and some years have no measurable rainfall. In these drought years early morning dew is the only humidity.

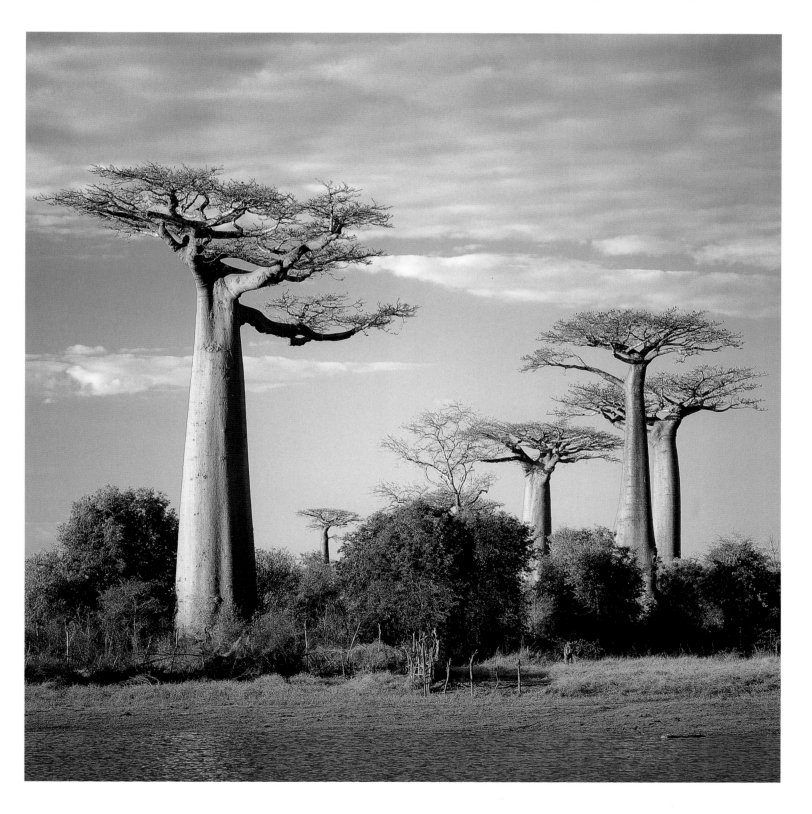

Endemic succulents under threat

Madagascar has a remarkable succulent plant flora, the spiny desert of the south being the most amazing succulent vegetation type. Made up of succulent *Euphorbia* species and plants of the endemic *Didiereaceae* family, this is found on poor skeletal soils in a small coastal region about 50 kilometres (31 miles) wide. The four genera of this family are all confined to the south and southwest of the island. The closest relative to the *Didiereaceae* family is the *Cactaceae*, and plants of the *Didiereaceae* are sometimes known as 'the cacti of the old world'.

Growing in this 'spiny desert', *Alluaudia procera* – sometimes known as the Madagascan ocotillo – is often felt for housebuilding and charcoal production, both locally and for sale in the cities. Prolific tiny round leaves appear along the spiny stems of *Alluaudia procera* after rain; they fall at the onset of the winter drought. The stems of this succulent tree bear heavy spines, but these do not deter the lemurs, which survive here, and leap from tree to tree. *Alluaudia procera* is more common than other species of the *Didiereaceae*, but all species are threatened because the spiny forest habitat is being cleared for dryland agriculture. Fortunately the Strict Nature Reserve of Tsimanampetsota protects *Alluaudia procera* and other succulent species.

Another threat to the *Didiereaceae* has been the commercial collection of wild plants for sale to

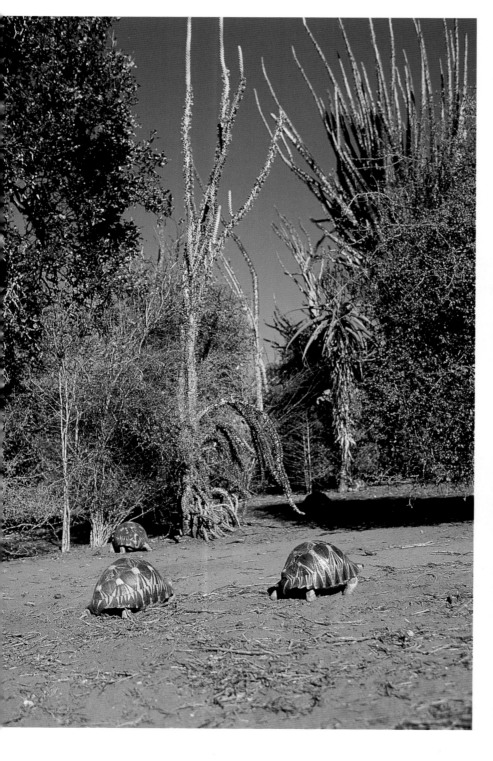

succulent plant enthusiasts in Europe, Japan and the USA. In an effort to control this trade, the entire family of *Didiereaceae* is listed on Appendix II of CITES. Monitoring of trade under the terms of CITES helped to stop the import of thousands of wild collected specimens of the *Didiereaceae* into Europe during the 1980s. It was claimed that the plants had been propagated in nurseries, but this was revealed to be untrue, and increased efforts were taken to stop the illegal trade.

In total Madagascar has over 600 species of succulent plants, most of which are endemic to the island. Sadly many species are threatened as around 80 per cent of the original vegetation has been destroyed. Much of the 'great red island' is covered with degraded grassland, and the fragile soils are washed into the sea during the rainy season. The loss of red soil is so extensive during the summer rains that the red ring in the sea around Madagascar can be seen from outer space.

OPPOSITE: The remarkable spiny desert of Madagascar is home to succulent tree species of the endemic family *Didiereaceae* as well as endemic tortoise species.

BELOW: The production of charcoal is one of the main threats to the *Didiereaceae*. Conservation solutions need to be found for these extraordinary trees which take into account the needs of local people.

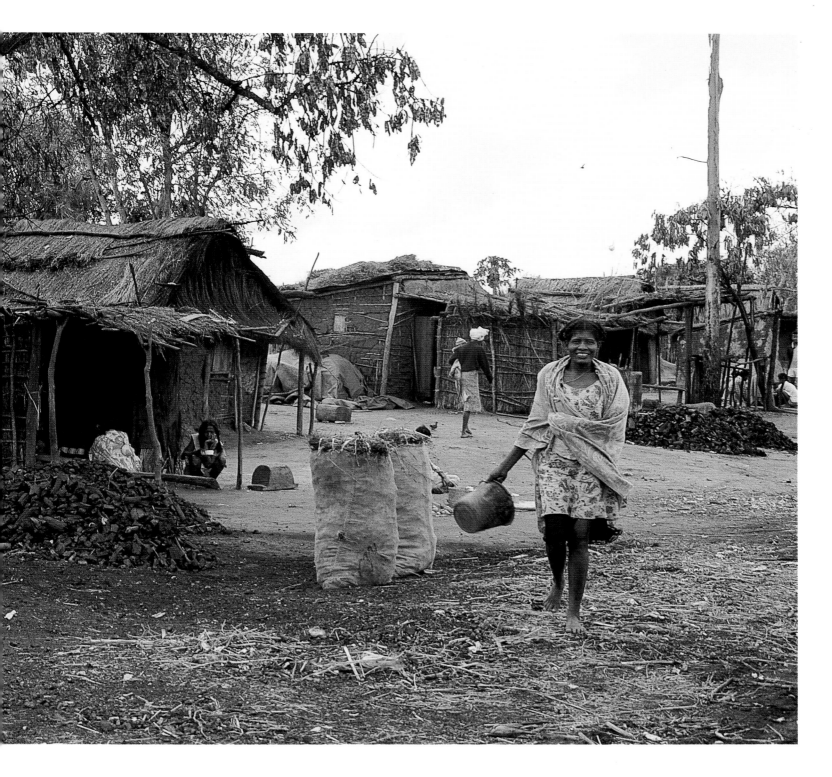

The drylands of southern Africa

Much of the western half of southern Africa – spanning Botswana, Namibia and a large portion of South Africa – consists of desert or semi-arid lands. The Kalahari Desert, in the centre of this broad region, covers a large part of Botswana and extends into the neighbouring countries of Namibia and South Africa. Expansive areas of sand dunes are found within the Kalahari, but there are also extensive areas of sparse savannah vegetation. There is an almost complete lack of surface water in the Kalahari, except where seasonal rainfall collects in natural depressions known as pans. The largest of these are the Makgadikgadi Pans in Botswana, site of an ancient dried lake, which resembles an extraordinary moonscape in the dry season, and the Etosha Pan in northern Namibia.

Kalahari reserve

The Central Kalahari Game Reserve is the largest game reserve in the world, covering an area of 52,800 square kilometres (20,380 square miles). It was originally created as a refuge for the San Bushmen, who have inhabited the Kalahari for the past 30,000 years.

The San traditionally lived in nomadic hunter-gatherer family groups and were remarkably skilled in meeting all their basic needs from the desert. The Europeans who colonized Southern Africa persecuted the Bushmen relentlessly and, in 1961, when Botswana was still a British Protectorate, the Central Kalahari Game Reserve was formed as their homeland. In 1986 the government of Botswana decided to move the inhabitants of the reserve to other areas, and the highly controversial resettlement took place in May and June 1997. Most of the San of the area have now intermixed with other tribes and live in villages at the southern end of the game reserve. Their traditional lifestyle has been transformed, but some bush survival knowledge is still passed down from generation to generation.

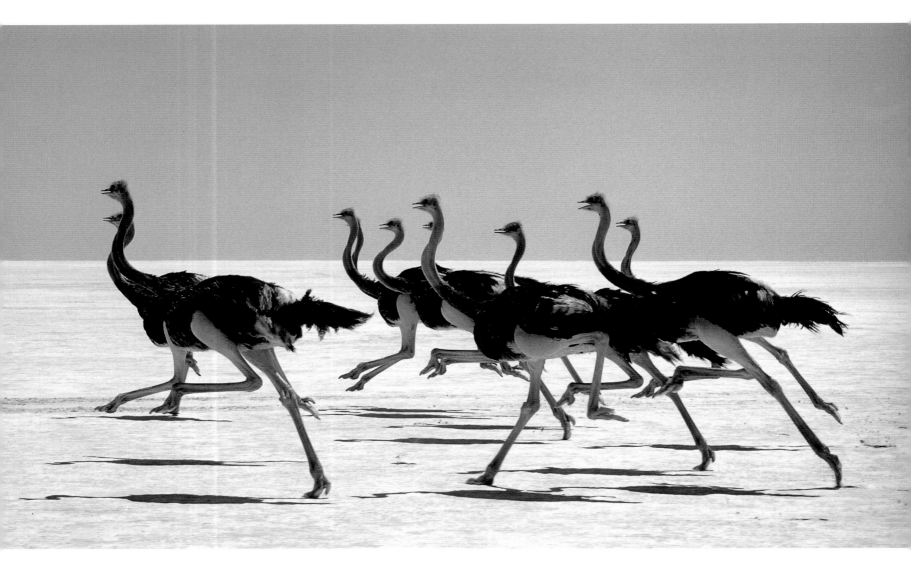

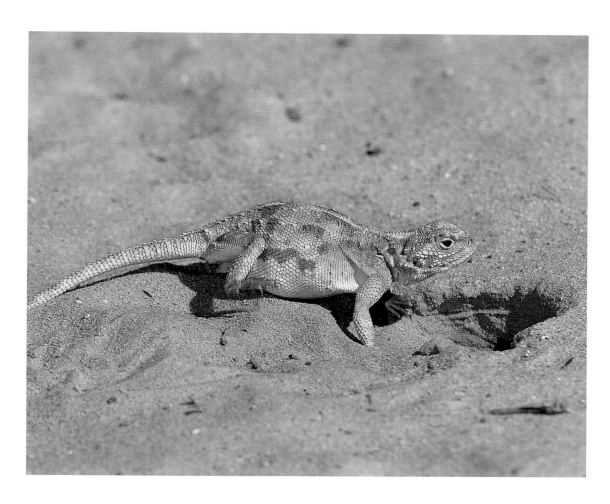

OPPOSITE: Ostriches running on Etosha Pan, Etosha National Park, Namibia.

LEFT: This species of ground agama (*Agama aculeate*) is digging a burrow to shelter from the sun in Kalahari Gemsbok Park in South Africa. This protected area is renowned for its herds of antelope species and has over 200 species of birds.

BELOW: The San Bushmen have traditionally passed on remarkable skills in desert survival from generation to generation. Tracking wild animals and gathering wild plants were essential for their survival.

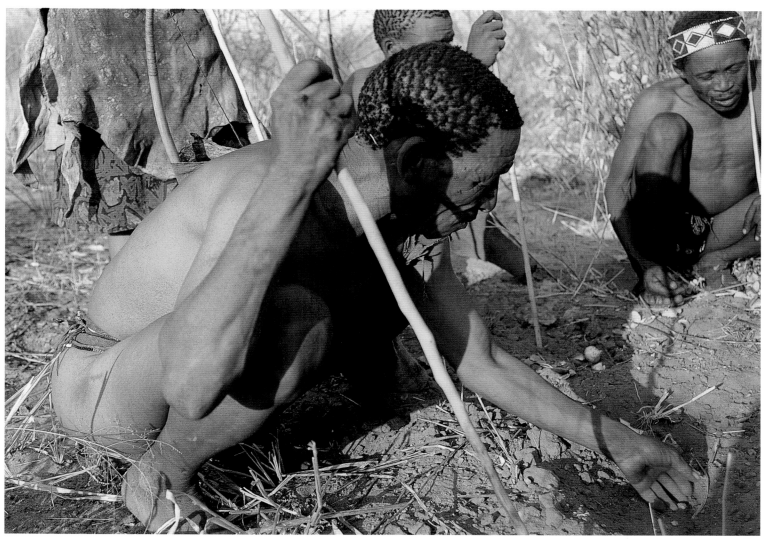

The Okavango Delta – a precious wetland resource

The Okavango Delta is a jewel in the crown of Africa's natural wonders. Situated at the northern limit of the Kalahari Desert, the Okavango is one of the largest inland deltas in the world. It is an area of stunning natural beauty and great wildlife wealth. It is actually an alluvial fan of sediment and debris, which filled a trough formed by the sinking of the earth's crust between a series of parallel faults across the Okavango river.

The delta is fed by this river, which originates 1,280 kilometres (almost 800 miles) away in the highlands of Angola. Here there is an average rainfall of 1,200–2,000

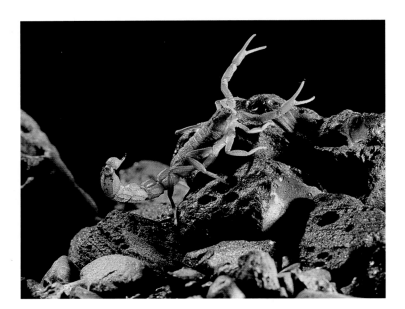

millimetres (47–78 inches) per year, compared to around 400–600 millimetres (16–23 inches) in the Okavango. The delta therefore fluctuates in size depending on local rains and the Angolan flood waters. The spillover from the rising river starts pushing gently into the Okavango in January and reaches a peak in about May. By June or July each year the water levels are at their maximum.

The delta consists of permanent swamp, characterized by channels and lagoons with extensive beds of papyrus (*Cyperus papyrus*) and *Phragmites* reeds. The extent of the seasonal inundation depends largely on the amount of rainfall and the size of the annual flood from Angola and the higher dry land masses. The three main dry areas in the delta are Moremi Wildlife Reserve, Chief's Island and a large area of sand-veld vegetation in the West.

Animals and people of the Okavango

The Okavango supports a remarkable diversity of wildlife. Some species are almost totally aquatic – such as the crocodile and hippopotamus – while others are semi-aquatic – for example the sitatunga (*Tragelaphus spekeii*) and lechwe (*Kobus leche*). The sitatunga is a spiral-horned antelope that lives in African swamps, reed-beds and marshes. It has specially adapted long, splayed hooves, which enable the animal to walk through mud without sinking. Other species, such as

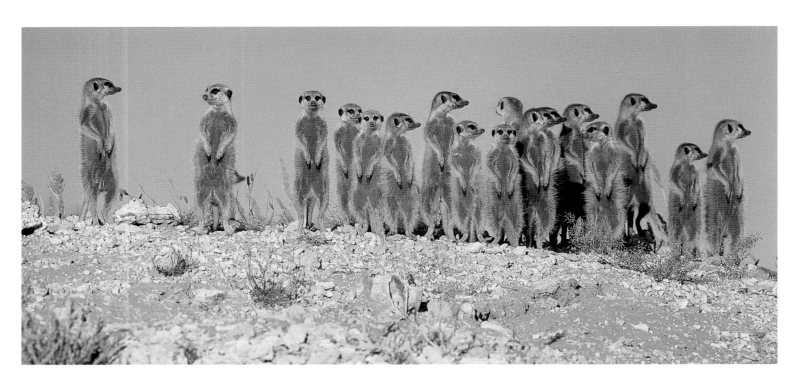

the gemsbok and ostrich, are more typical of the arid lands to the south. More than 400 bird species have been recorded in the Okavango. The fish eagle (*Haliaetus vocifer*) is common throughout the area; the marabou stork (*Leptoptilus crumeniferus*), wood ibis (*Ibis ibis*) and fishing owl (*Scotopelia peli*) are also resident.

Various local groups of people continue to live in the Okavango, generally pursuing a common mixed subsistence strategy of fishing, farming, collecting wild foods, herding and hunting, although government regulation of hunting has greatly reduced this component. The Bugakwe and Xanekwe peoples are substantially more oriented towards foraging, and have far fewer cattle and smaller fields than members of the other ethnic groups.

The future for the Okavango Delta

The long-term fate of the Okavango Delta, its wildlife and people, remains somewhat vulnerable in a region of extreme aridity. Various schemes have been proposed to utilize the much-needed waters of the Okavango river and delta, 98 per cent of which evaporates each year.

In the 1980s, when there were water shortages in the town of Maun and further south at the Orapa diamond mine, the government of Botswana planned to dredge the Boro river in the southern Okavango Delta. This plan was withdrawn as a result of social impact assessment (which focused attention on the negative impact of dredging on traditional livelihoods) and lobbying by the IUCN.

In 1996 the Namibian government announced plans to build a pipeline from where the Okavango flows through the Caprivi Strip to Namibia's capital, Windhoek, to relieve a prolonged period of drought. This plan was also shelved – this time with the arrival

of rains that helped counteract the problems of water shortage, and after objections by NGOs and the government of Botswana.

Since 1994 Angola, Botswana and Namibia, the three countries that use the waters of the Okavango river, have had a regional agreement to control usage that is overseen by a Permanent Okavango River Basin Water Commission (OKACOM).

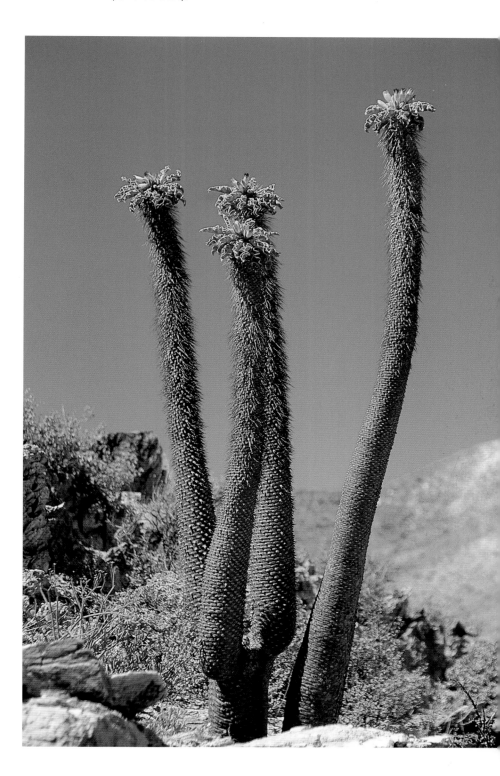

OPPOSITE TOP: A small desert scorpion.

OPPOSITE BOTTOM: Meerkats form colonies of 50 or more individuals. They live in dry open plains and rocky areas of hills generally with sparse vegetation, in southern Africa. Their diet consists of small mammals, reptiles and birds.

RIGHT: *Pachypodium namaquanum* is commonly known as halfmens or elephant's foot. It occurs in Namibia and South Africa. In the past, collecting for the horticultural trade has been a threat to this species but now succulent plant enthusiasts generally buy nursery-grown plants.

The Namib Desert and its unique plants

The Namib – a strip of desert 30–140 kilometres (19–87 miles) wide – stretches along the southwest coast of southern Africa from the Cunene River (which forms the border between Namibia and Angola in the north) to the Orange river (the border between Namibia and South Africa in the south). Rainfall is very low, but the Namib receives additional precipitation from coastal fog. The northern section forms the Skeleton Coast.

Extending south from the Namib Desert is the Karroo region of South Africa with desert and semi-arid lands.

The Namib Desert and Karroo region is truly remarkable for its wealth of biodiversity, with a high proportion of species found nowhere else on earth. Biologists describe the region as the Karroo–Namib centre of endemism, and it is also known as the Succulent Karroo. This whole arid region is one of the

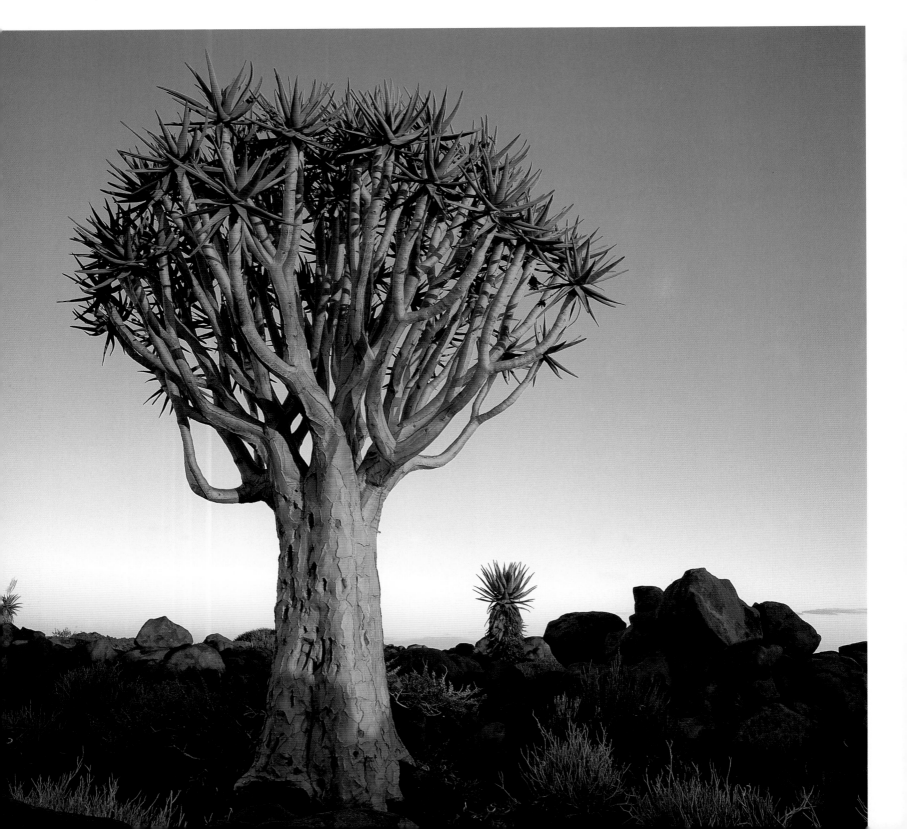

25 global biodiversity hotspots identified by Conservation International, and the only one that is entirely arid.

Vegetation includes very sparse plant cover on the desert dunes and open succulent shrubland. Distinctive plants include *Pachypodium namaquanum*, *Aloe dichotoma* and *Aloe pillansii*. These tree-like succulents are among the few perennial plants able to tolerate the intensely hot and arid conditions of the Namib.

Extraordinary succulents and conifers

Pachypodium namaquanum is a spiny, thick-trunked succulent tree, sometimes known as elephant's foot or halfmens. The stems of this unusual plant grow to face north, to ensure that the leaves and flowerheads produced in the foggy winter months receive the maximum sun. The local Khoisian Nama people call the plant 'half men'; according to traditional mythology

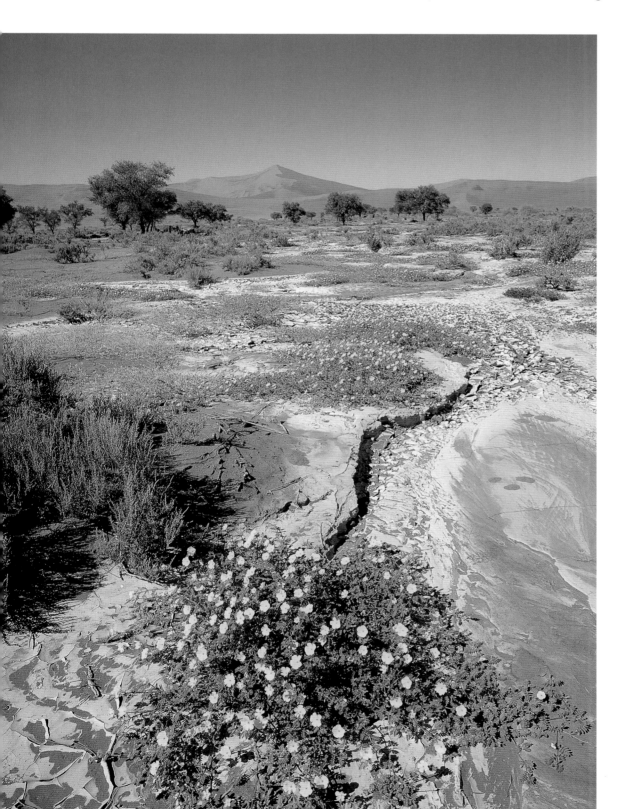

OPPOSITE: The Quiver tree (*Aloe dichotoma*) grows on rocky ground in the deserts and semi-deserts of Namibia and South Africa. It has bright yellow flowers which rise above the succulent leaf rosettes. Social weaver birds favour this tree for their nest sites.

LEFT: After sporadic periods of heavy rain, carpets of ephemeral flowers bloom in the Namib Desert.

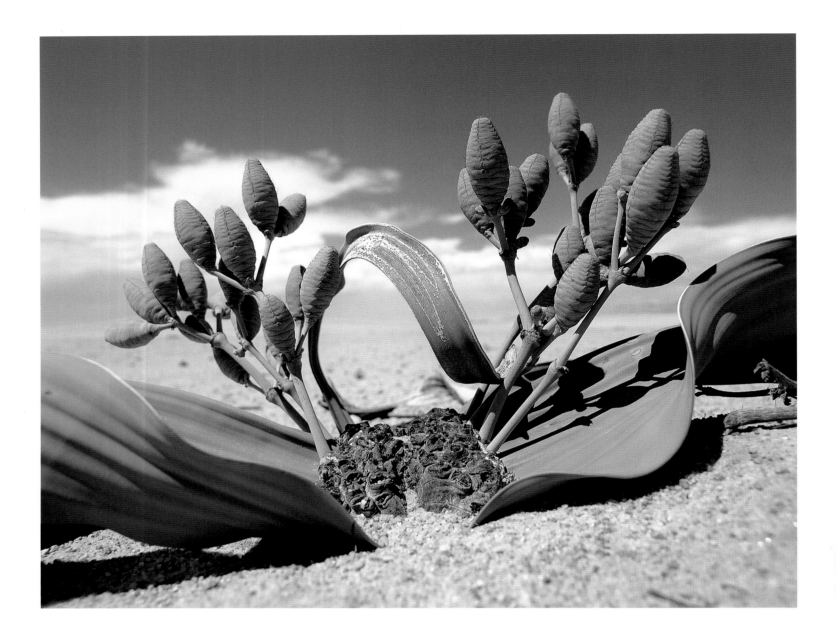

these plants were once people, punished by the gods for turning back to look at their northern homelands which they were forced to leave. The weird halfmens plant grows in shrubland along the lower Orange River Valley from the Tantalite Valley and Pella Mountain range in the east to the Richtersveld, Huib-Hoch and Huns Mountains in the west. Although reasonably abundant, the species has suffered from much illegal collecting, especially in the Richtersveld; plants are highly sought-after by succulent plant growers around the world. Fortunately nursery-grown plants are now widely available and the demand for wild plants has been reduced. The plants growing on the Namibian side of the Orange river are inaccessible and therefore generally secure. There are, however, further threats from mining activities in Namibia, and intense grazing and trampling of the surrounding vegetation by domestic livestock in the Richtersveld. The Richtersveld plants are contained within a national park and provincial nature reserve which should help with conservation in the long term.

The kokerboom or quiver tree (*Aloe dichotoma*) grows in the Namib, usually on rocky ridges. The soft branches of this small, succulent tree were used by the San people as quivers for their hunting arrows.

Aloe pillansii has a taller trunk with fewer branches and a sparse crown. It is much more restricted in range than the quiver tree, and considered 'Critically Endangered'. A tree aloe which grows up to 10 metres (33 feet) tall, *Aloe pillansii* is confined to Namibia and the Northern Cape of South Africa, and is known largely from an area in the Richtersveld. A serious decline in the wild population has reduced the numbers to less than 200 individuals. There appears to be no regeneration and the older plants are dying. Baboons and porcupines damage the plants by gnawing the stems, and grazing by goats and donkeys may also be detrimental. Rare plant collectors have also taken their toll. The few remaining wild plants provide an ecologically important source of shelter, nectar, food and moisture, particularly for birds.

Another extraordinary plant is *Welwitschia mirabilis*. This primitive species (in its own plant family related to

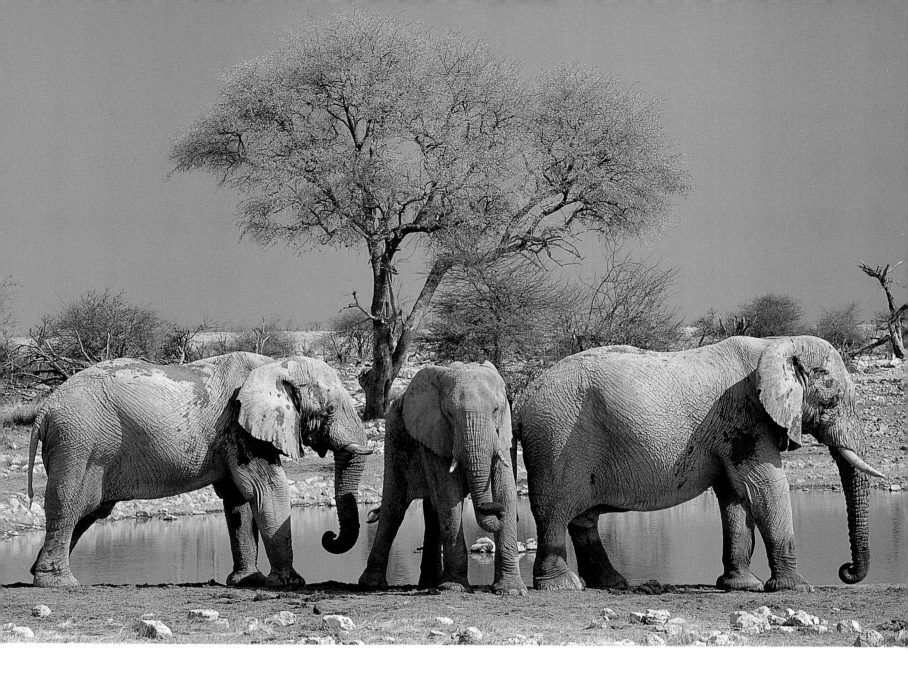

the conifers) is found only in Namibia and Angola. Each plant has a deep tap root, a short stem and a pair of long strip-like leaves which can continue to grow for over 2,000 years, slowly wearing away at the leaf tips. Male and female plants both produce red cones that emerge from between the leaf bases. Following pollination by desert insects, winged seeds are produced that germinate in rare wet years.

Elephants in the desert

The presence of elephants in the northern Namib Desert is extraordinary. The watercourses on the eastern desert margins provide a habitat for a small number of elephants. They help maintain waterholes by excavating the sand in the dry river beds. These elephants are one group of only two known populations of desert-dwelling elephants in the world, the other being in Mali. They are specially adapted to extremely dry and sandy conditions, with smaller bodies and larger feet than other elephants. By the 1980s most of the 3,000 elephants living in Namibia's

OPPOSITE: *Welwitschia mirabalis* is one of the world's most bizarre plants. It grows in the deserts of Namibia and Angola, where it is dependent on moisture from sea-fog dew. Each plant has two leaves which can grow to 9 metres (29½ feet) long. This is a female specimen bearing the red cones which are pollinated by insects.

ABOVE: The African elephant lives in habitats varying from the rainforest to the desert margins. Persecuted widely throughout the continent, Southern Africa has relatively large and well-managed populations. National parks and other protected areas are important for the conservation of this magnificent and much-loved species.

Kunene region were killed by hunters and poachers, but as a result of measures taken to protect desert elephants their population is approximately 600 at the moment.

Further to the east, the Etosha National Park has around 2,000 elephants, about 20 per cent of Namibia's total population. They nearly became extinct in the country at the end of the 19th century because of hunting and poaching. Today most of Namibia's elephants occur in the northeastern parts of the

country, and the Etosha population has the distinction of being considered the tallest in Africa.

The Etosha National Park is one of Southern Africa's most important protected areas. Declared a National Park in 1907 and covering an area of 22,270 square kilometres (8,596 square miles), it has in total 114 mammal species, 340 bird species, 110 reptile species and 16 amphibian species. Etosha, meaning 'great white place', is dominated by a massive mineral pan which forms part of the Kalahari Basin. The Etosha Pan rarely holds water as any rainfall rapidly evaporates.

The best time to see game in Etosha is from May to September. As well as elephant, visitors can expect to see many buck species, giraffe, rhino and lions. More fortunate visitors will see leopard and cheetah. The waterhole at Okaukuejo is famous for rhino and elephant.

BELOW: The Etosha National Park is an excellent place to see the variety of African wildlife.

RIGHT: Water in arid areas acts as a magnet for wildlife, as at this waterhole at the Etosha National Park.

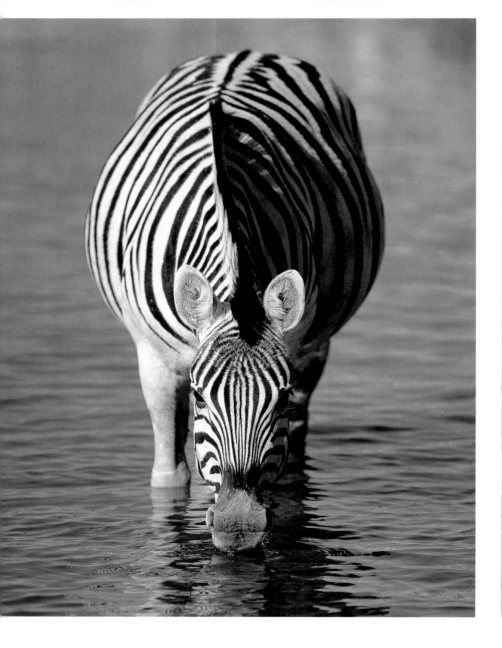

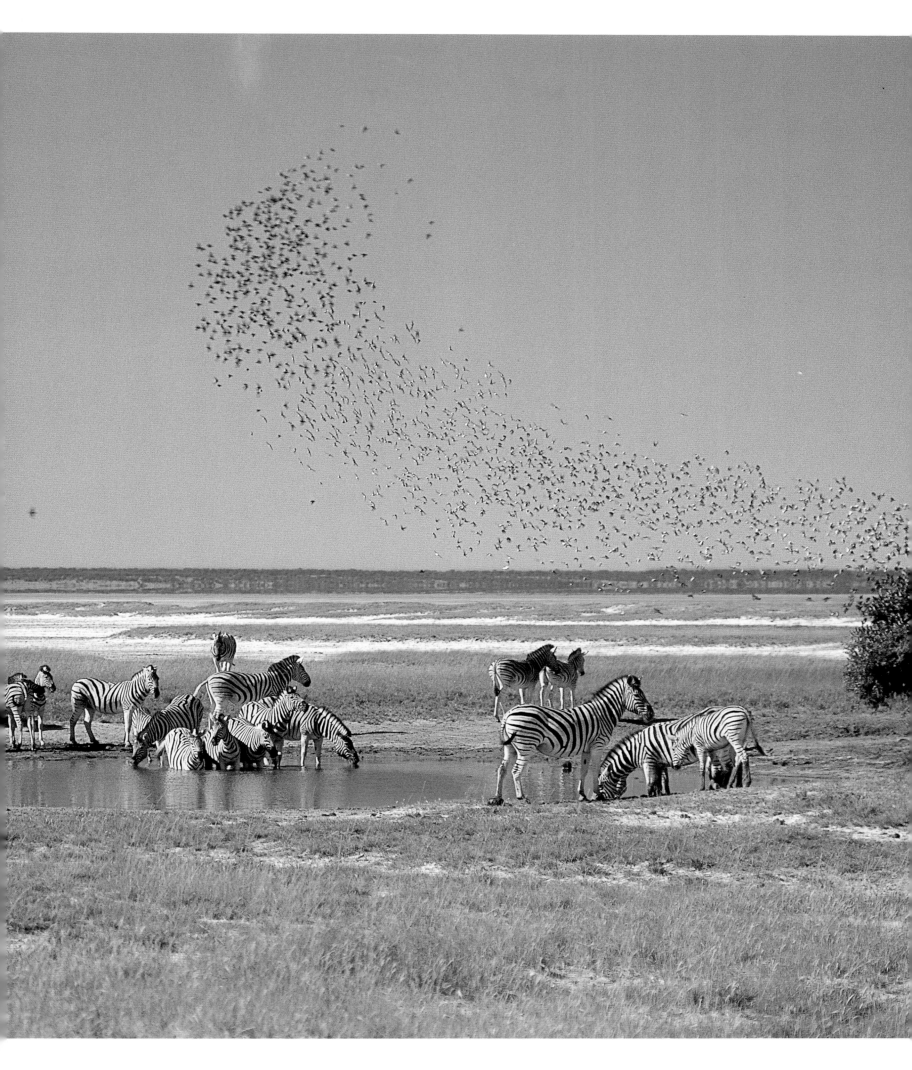

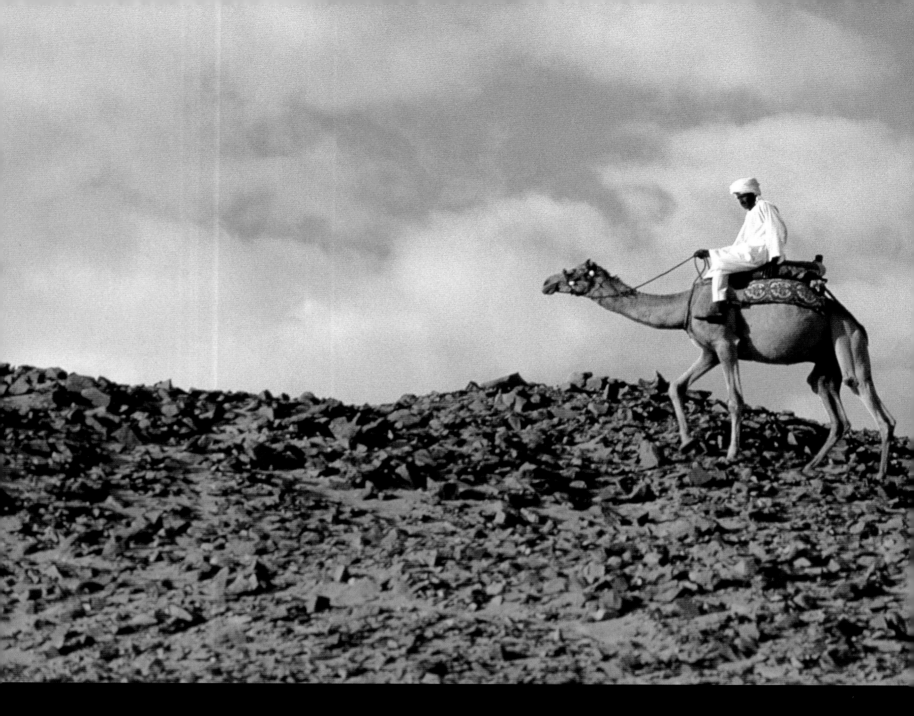

The Middle East
Saudi Arabia, Yemen and Jordan

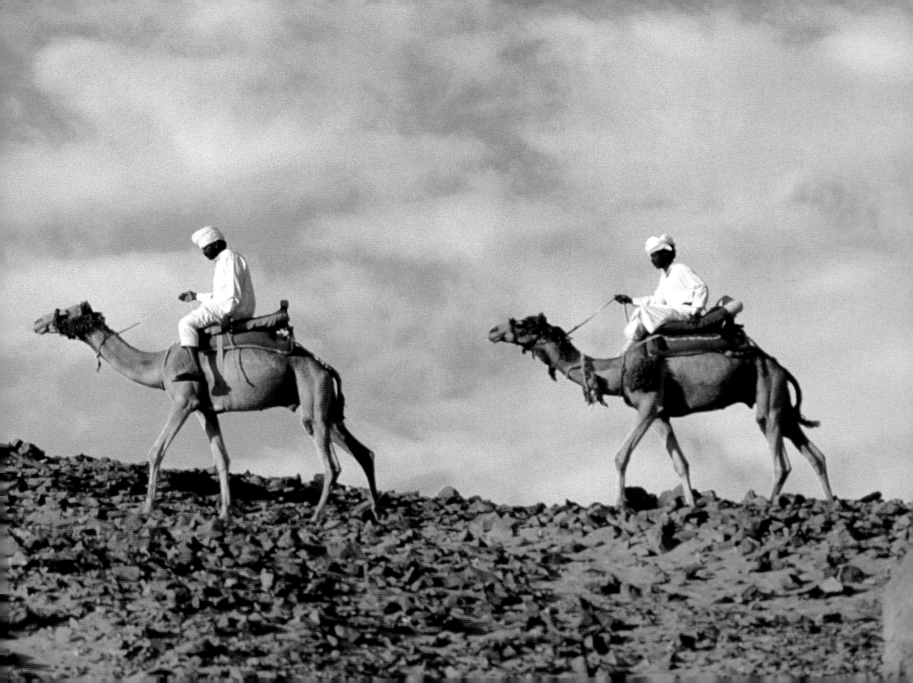

The Arabian Desert, Empty Quarter and Yemen Highlands

The Arabian Desert extends south from the Euphrates River, which flows through Iraq, to the coastline of Yemen and Oman on the Arabian Sea. Bounded to the east by the Red Sea and to the west by the Persian Gulf, 90 per cent of the Arabian Peninsula is desert. In the north, desert and semi-arid lands extend through Syria into Turkey, and to the east the drylands continue through Iran to Pakistan and India.

Within the Arabian Peninsula only parts of Yemen and Oman, together with scattered areas elsewhere, can be cultivated. The most arid and inhospitable part is Rub Al Khali or the Empty Quarter, stretching from west to east across southern Saudi Arabia, and long considered the ultimate challenge to intrepid European explorers.

To the southwest of the Empty Quarter lie the Asir Mountains of Saudi Arabia and the Yemen Highlands. These upland areas capture rain carried by winds bringing moisture off the Red Sea and in places support ancient juniper woodlands and a greater diversity of wildlife than elsewhere in the Arabian Peninsula. The Dhofar fog oasis of Oman and Yemen, where the Jebel Qamar and Jebel Qara coastal mountain ranges are cloaked in thick fog during the summer months, is a remarkable area. Annual rainfall on the narrow coastal plain is around 100 millimetres (4 inches), rising to 200–400 millimetres (8–16 inches) on the mountains. Fog moisture doubles the level of precipitation, and fog density is as high as anywhere recorded in the world.

The Dhofar fog oasis has unique species of trees and useful plants such as the endemic *Aloe dhufarensis*, which is used medicinally. The frankincense tree (*Boswellia sacra*) occurs here and was a source of great wealth in centuries past. Nowadays the Jabali tribal people who live here are mainly camel and cattle herders. The Qarra people, of ancient pre-Arab origin and who retain their own language, also inhabit this region. The drier coastal plain and desert foothills are used for goat, sheep and cattle grazing.

The Arabian Desert extends into Iraq, and about 80 per cent of the land surface of this country is desert. The area between Iraq's two great rivers, the Tigris and Euphrates (the Fertile Crescent of biblical times), has large areas of shallow lakes or *haurs*. Iraq's other main area of arid land is the semi-desert plain known as the Jazirah. This plain is northwest of the capital, Baghdad.

PAGES 58–59: An Egyptian camel train.

LEFT: The fragrant resin from frankincense trees has been a source of immense wealth to traders in the Middle East. One of the oldest records of plant collecting is of frankincense trees being taken to Egypt from the land of Punt (Somalia) in 1495 BC.

Islam – religion and way of life

Islam is the dominant religion throughout the Middle East. The prophet Muhammad, founder of Islam, was born in Mecca, western Arabia, in AD570. He received the first in a series of divine revelations when he was about 40 years old and began to preach against the local religious traditions. With his followers he fled to Medina in AD622, the event which marks the beginning of the Muslim calendar. Muhammad returned in triumph to Mecca in AD630, 60 years after his birth, and by the time of his death in 632 the Islamic faith was known throughout Arabia. Muhammad's successors, Abu Bakr and Omar, were responsible for the spread of the Muslim faith from Spain in the west to the Sassanian Empire of Persia in the east.

The followers of Islam are divided into two broad groups: the Sunni and Shia. Sunni Muslims represent about 80 per cent of the religion worldwide, whereas Shia Muslims are mainly found in Iran.

In the 18th century the puritanical Wahhabi sect developed among the Bedouins of the Najd region in the centre of the Arabian Peninsula. The present Saudi royal family is descended from this group.

BELOW: A rocky desert landscape at dawn in central Saudi Arabia. Rocky plateaux or 'hammadas' cover large areas of the kingdom.

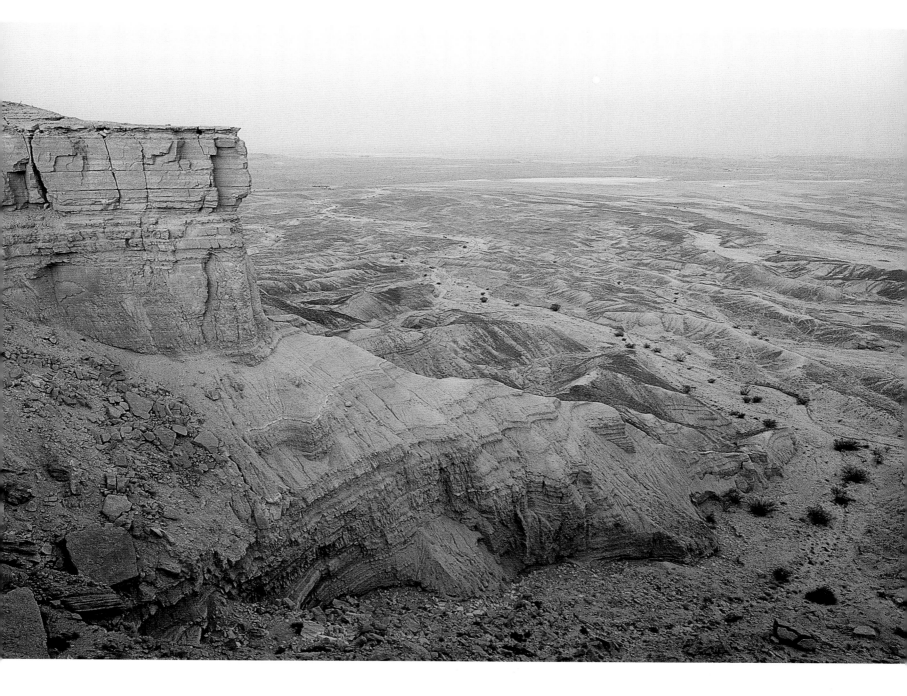

The Bedouin

The traditional people of the Arabian Desert are the Bedouin. This ancient tribal society is based on camel, goat and sheep pastoralism, and Bedouin tents are made from the hair of goats and camels. Dates and camel milk provide the staple foods for this tight-knit society. Camel domestication in this part of the world dates back to at least 2000BC, and Arabia remains the world's chief camel breeding centre. The language of the Bedouin is loosely related to classical Arabic and the traditional way of life has changed little in thousands of years, making the Bedouin culture one of the most perfectly preserved of all peoples.

The legendary Lawrence of Arabia wrote, 'Bedouin ways were hard, even for those brought up in them, and for strangers terrible: a death in life.'

Today Bedouin society extends from the Sinai Desert of Egypt through to Iraq, with around 70,000 Bedouin in the Negev Desert of Israel. Total numbers of Bedouin are unknown.

The Bedouin people retain much of their intricate social clan structure. The clan consists of a number of families, bound by blood ties, travelling and forming encampments together. The leader of an individual clan is the sheikh who governs by consensus in the democratic Bedouin society. The clans group together to form tribes, sharing water, food and grazing land.

BELOW: Nomadic Bedouin tribesmen in the Arabian Desert gather to smoke water pipes as the sun goes down.

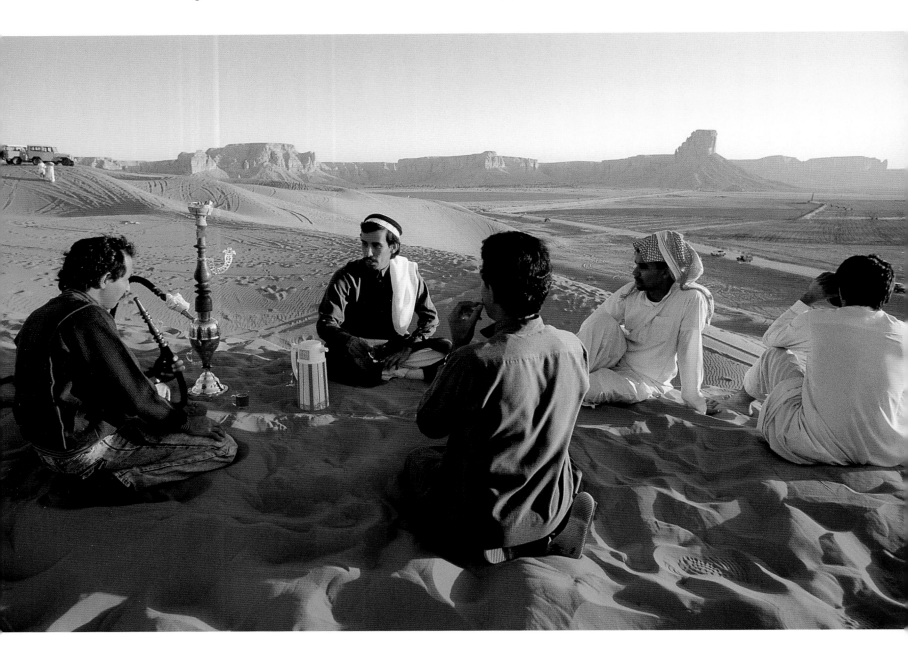

Marsh Arabs

The Ma'dan, or Marsh Arabs, followed a unique way of life in the Amara or Central Marshes of Iraq for over 5,000 years until the end of the 20th century. The Amara marshes lie to the west of the Tigris and north of the Euphrates, and are fed by both rivers. Tall reed-beds of *Phragmites* and *Typha* dominated the area, together with extensive lakes such as Haur Hamar and Zikri. Since 1991 major drainage works have been undertaken which have lead to massive destruction of the wetland habitats and deliberate displacement of the Marsh Arabs.

The Ma'dan are Shia Muslims with their own dialect of Arabic. Early inhabitants of the marshes can be traced back to settlers from Iran who built reed houses, made boats and caught fish, traditions that continued into modern times. Later, around 3000BC, settlers from Anatolia introduced the domestic water buffalo. At the beginning of the 7th century the Arabs invaded Iraq and founded the Abbasid Caliphate, which lasted for 500 years until invasion by Mongol conquerors. Subsequently Iraq was ruled by Turkomans, then Persians, and from 1534 until World War I by Turks. During all this time the Amara Marshes provided a sanctuary for defeated people, and the area has a history of lawlessness and rebellion.

BELOW: The harsh desert landscape of Saudi Arabia. Until the middle of the 20th century this region was largely unknown to the western world, but a source of myths and legends for centuries.

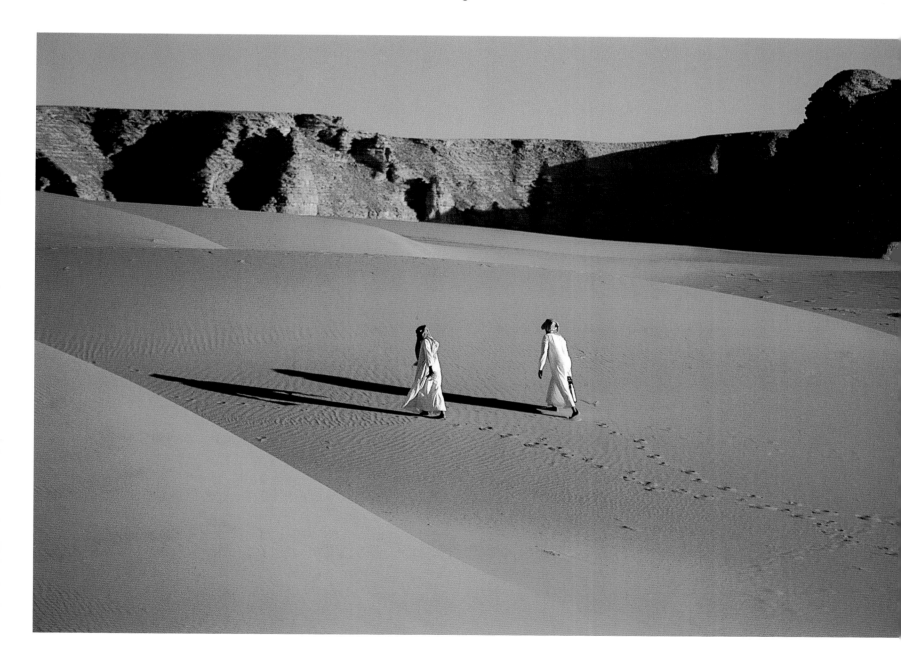

The Marsh Arabs lived on islands and in homes constructed entirely of reeds. Some of the buildings were beautiful, cathedral-like guesthouses known as *mudhif*. The marshes provided all the raw materials needed for the sustainable livelihoods of the Mad'an: for mat weaving (as a basis for construction), fishing, hunting and the grazing of water buffalo. Over the past 10 years or so all this has changed. The destruction of the Amara Marshes have been described as an act of vengeance undertaken by Saddam Hussein, a Sunni Muslim, for the Shia uprising against him after the 1991 Gulf War. The population of Marsh Arabs was reduced from 250,000 to 40,000. Thousands were killed, an estimated 40,000 fled as refugees to Iran, and 100,000 were displaced to elsewhere in Iraq.

It may be possible to restore the Amara marshes, but this will represent an immense environmental challenge. Since the drainage of the marshes, Turkey has dammed the Tigris, reducing the flow of water into Iraq. Even if the marshland drainage system was reversed, there may not be enough water in the Tigris to reflood the marshes. It is uncertain whether the Marsh Arabs would wish – or be able – to return to their former lifestyle.

ABOVE: Wetlands in the desert provide a source of reeds which are used to build shelters – The Marsh Arabs of Iraq perfected the skills of construction using reeds, producing remarkable villages made from this material.

RIGHT: Camels are very important in traditional Berber society and have provided the main form of desert transport for centuries. Here, a proud Berber poses with his beasts.

As well as the unique ecosystem of the area and traditional way of life of the Marsh Arabs, various species of birds and mammals have been lost from the Amara marshes. The smooth-coated otter (*Lutra perspicillata*), Indian crested porcupine (*Hystrix indica*) and grey wolf (*Canis lupus*) are thought to have become extinct in the area. The remaining wetlands support almost the entire world population of two species: the Basrah reed warbler (*Acrocephalis griseldis*) and the Iraq babbler (*Turdoides altirostris*). The marshes have also provided a habitat for two-thirds of the wintering wildfowl of the Middle East, acting as a vital staging area for birds migrating between breeding grounds in western Siberia and Central Asia and winter quarters in Africa. The fate of the rich birdlife of the Amara marshes remains uncertain.

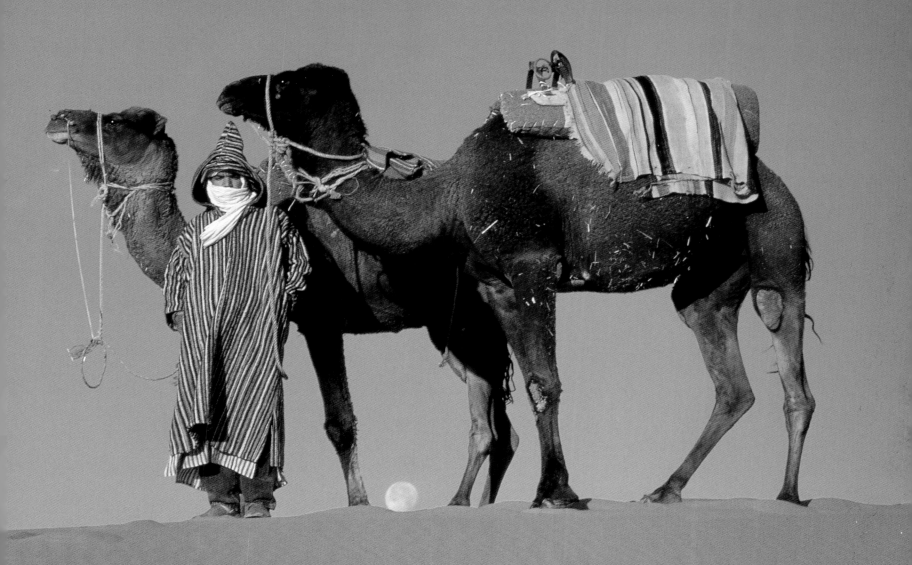

A network of trade routes

Today, 60 per cent of the population of Saudi Arabia lives along the shores of the Red Sea and the coastal region, and for thousands of years the ports of the Arabian Peninsula have acted as hubs in trading routes by sea and land. Since prehistoric times the Red Sea, linking the Mediterranean Sea and the Indian Ocean, has been one of the world's most important shipping routes. Overland routes also run from east to west connecting the Silk Route, via the Persian Gulf, to the Mediterranean, and from south to north through the Arabian Peninsula.

Frankincense from the Dhofar region of what is now Oman provided much wealth through centuries of trade with Egypt, Jordan and Syria. Caravan routes carried the precious resource across the Arabian Peninsula. In 24BC the Roman Emperor Augustus sent in an army to capture the land where frankincense originated, but lack of water defeated the army. Much later the Yemen coast of the Red Sea became famous for importing coffee, which brought wealth to the port of Mocha in the 17th century.

The discovery and exploitation of the Middle East's huge oil reserves have transformed the economy of the the region over the past 70 years or so. Traditional ways of life, virtually unchanged for centuries, have altered dramatically with increased wealth and the rapid spread of modern transport. This was particularly marked in the 1970s when huge increases in the price of oil brought untold riches to the region.

Oil was discovered in northern Iraq in 1927, following commercial discoveries in Iran in 1908. Oil reserves were found in Saudi Arabia in 1938 and production began after World War II. Oil was first found in Kuwait in the same year. Most of the oilfields of the Arabian Peninsula lie along the east coast and in the Persian Gulf.

BELOW: Drilling rigs in Saudi Arabia are now part of the desert landscape, providing great wealth for the country.

OPPOSITE: The umbrella tree (*Acacia tortilis*) is a widespread tree species of seasonally dry areas of the Middle East and Africa. It is a very important source of food for wild and domesticated browsing animals.

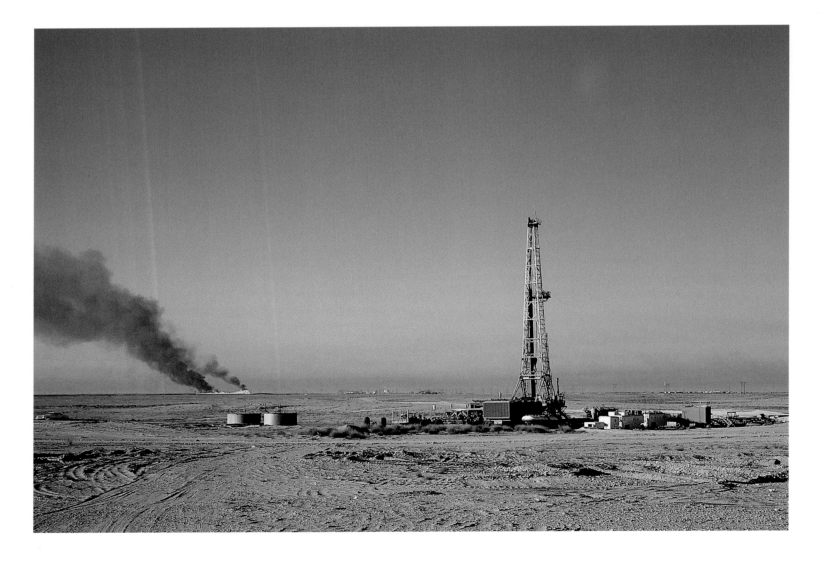

Dryland plants and animals

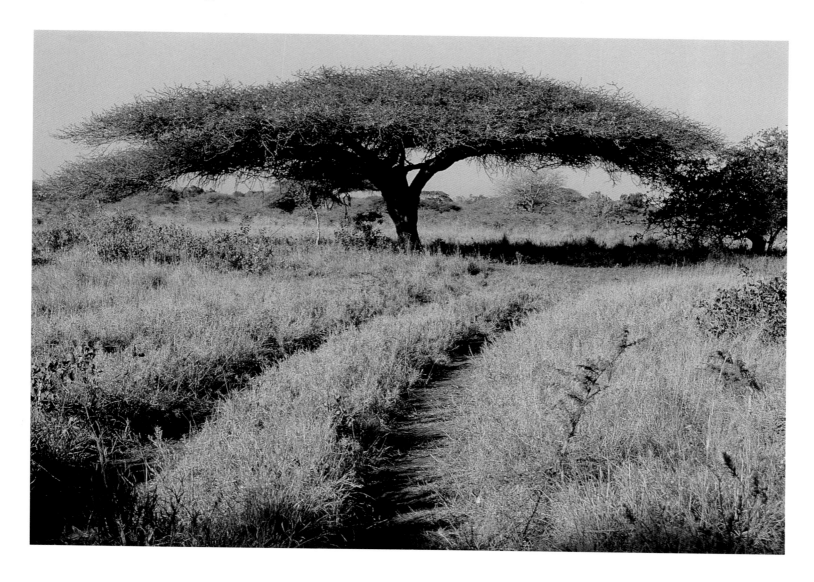

The drylands of the Middle East include rolling deserts and rugged mountains. Vegetation types range from the forests of the Asir Mountains of Saudi Arabia and Jebel Akhdar in Oman to the sparsely vegetated gravel plains barren sand dunes. Succulents found in the drylands include endemic species of *Aloe* and asclepiads. Native trees of the Arabian Desert include the ghaf tree (*Prosopis cineraria*) which has a distribution extending through the drylands of Iran, Pakistan, Afghanistan and India (where it is known as *khejri*), various species of *Acacia*, and the sidr or jujube tree (*Ziziphus spina-christi*).

Ghaf and sidr trees

The evergreen ghaf tree, which grows to a height of around 12 metres (40 feet), is of great importance in the desert environment. Usually indicating the presence of underground water, this tree can withstand prolonged drought and heavy levels of salinity. It is a very important source of fodder for livestock, and in particular camels, which relish the drooping branches and leaves. The pods, leaves – and, in times of famine, bark – have also provided food for local people. The wood is used for construction, and dead trees and stumps are used for fuel.

The sidr tree, also sometimes known as Christ's thorn or thorn of crowns, produces a valuable fruit, enjoyed by many species of birds and harvested by people. The leaves provide fodder for camels and goats, the leaves and fruit are used as a source of traditional medicines, the thorny branches are used to make livestock barriers, and wood is utilized for construction and fuel.

Indigenous animals of the Middle East

Animals of the region include species shared with Africa and those with ranges extending to the east. The fennec fox (*Fennecus zerda*), typical of the Sahara Desert, is also found in the Arabian Peninsula but as a result of hunting is now very rare in this region. The

lion (*Panthera leo*) became extinct in the Middle East during the last century, and the cheetah (*Acinonyx jubatus*) disappeared for good in Arabia in 1977. A subspecies of leopard, *Panthera pardus nimr*, survives in Arabia, north to Jordan and Israel, and another rare subspecies *Panthera pardus jarvisi* is recorded from the Sinai Peninsula.

Larks are characteristic birds of the Middle East region. All larks are ground-feeding and ground-nesting, so they are not reliant on the presence of trees. The Harrat al-Harrah Special Nature Reserve in northern Saudi Arabia has the most diverse breeding assemblage of larks in the Middle East. This area of black basalt boulder fields and shallow wadis supports sparse vegetation with a few stunted palms and small shrubs of *Artemisia* and *Haloxylon*. Ten species of lark breed in the protected area including the desert lark (*Ammomanes deserti*), the bar-tailed desert lark

(*A. cincturus*), and the more restricted Dunn's lark (*Eremalauda dunni*), which is confined to the Arabian Peninsula. The nature reserve is also important in the winter for sandgrouse, particularly *Pterocles orientalis*, and was one of the last sites in the country for the ostrich (*Struthio camelus*) before it was hunted to extinction in the 20th century.

Endangered birds

Bustards, large ground-living birds typically found in warm, dry open landscapes, remain within the desert habitats of the Middle East. They feed opportunistically on a range of plants and small animals and do not generally need to drink.

Several species of bustard are closely associated with desert and semi-desert ecosystems. The Arabian bustard (*Ardeotis arabs*) survives on the fringes of the Sahara in the Sahel region. Small populations

persisted in the south of the Arabian Peninsula but sadly these are most likely now extinct.

Of all the bustards, the houbara bustard (*Chamydotis undulata*) is the species best adapted to desert conditions. The houbara occurs sparingly throughout the arid band from Fuerteventura in the Canary Islands to the Gobi Desert of Mongolia and China. There are various different subspecies including the Asian race, *C. undulata macqueenii*, which extends from the Middle East to China, breeding mainly in Kazakhstan. For centuries the houbara bustard has been the popular prey of sporting hunters and falconers from Arabia and the Far East.

Traditionally Arabian dignitaries would ride into the desert on camel or horseback with their hunting parties. Falconers, at the behest of the Arabian princes, used highly trained falcons to hunt for hares, stone curlew and the prized houbara bustard. Modern

hunting parties travel by cross-country motor vehicles and can stay in the desert for longer periods. Hunting is much more intensive and has devastated various forms of wildlife.

Today very few houbaras breed in Arabia, and the birds that are hunted in this region are winter migrants from breeding sites in Kazakhstan. Because these bustards are so scarce, falconers travel to North Africa and Pakistan to pursue their prey.

OPPOSITE: The Arabian gum tree (*Acacia arabica*) has yellow flowers followed by greyish fruit pods. This tree, which has a wide variety of uses, can withstand long periods of drought. It is commonly cultivated in desert countries.

BELOW: A sand skink in the desert of Saudi Arabia. Commonly known as sand swimmers or sandfish, these animals have been used as a source of food by Bedouins for many centuries.

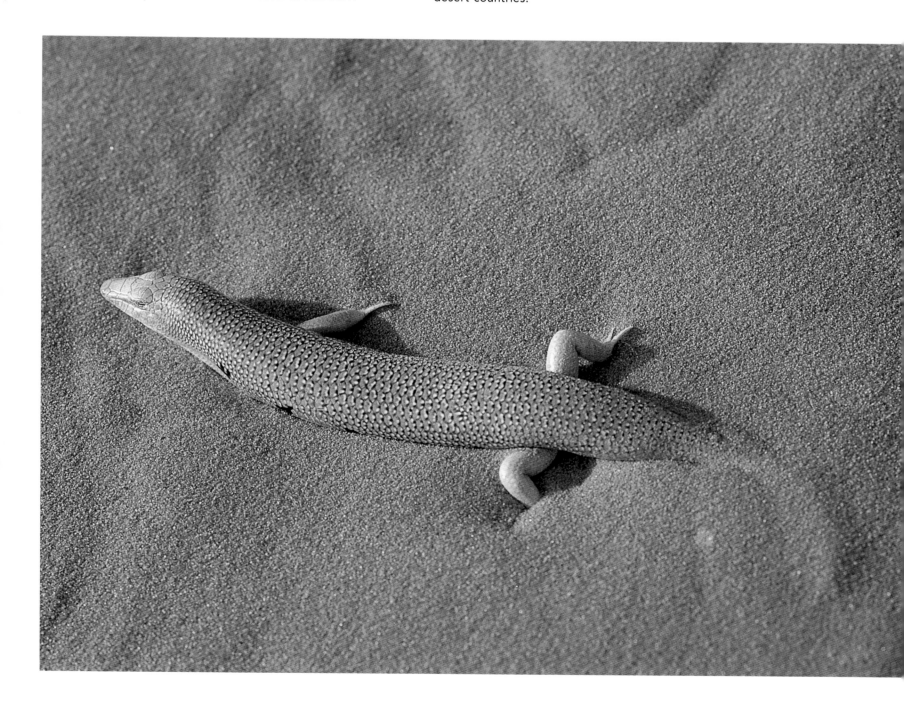

Wildlife protection and Islam

Within the Middle East generally there are relatively few national parks and protected areas of similar status. There is, however, an Islamic tradition for protecting wildlife and wild habitats derived from the Koran and sharia – Islamic law. Under such law, local communities establish reserves known as *hima* for the common good.

Various forms of land use have been permitted within the *hima* reserves, typically consisting of a wadi system or hillside with defined boundaries. In some, grazing is forbidden but fodder can be cut during drought years. In others the land is reserved for beekeeping or for the protection of trees.

Around the holy cities of Mecca and Medina there are large sanctuaries called 'holy harams', where wildlife and natural vegetation are strictly protected. The Arabian Oryx Sanctuary, one such site, which is the largest protected area on the Arabian Peninsula and a World Heritage site, is an extremely important refuge for mammal diversity. Its rare fauna includes, of course, the Arabian oryx, which was reintroduced here in 1982.

BELOW: Addax (*Addax nasomaculatus*) in the Hai-Bar Yotvata Reserve, near Eilat in Israel. The onager, Arabian oryx, and scimitar-horned oryx are also protected in this reserve. Acacia trees provide an essential source of food for the animals.

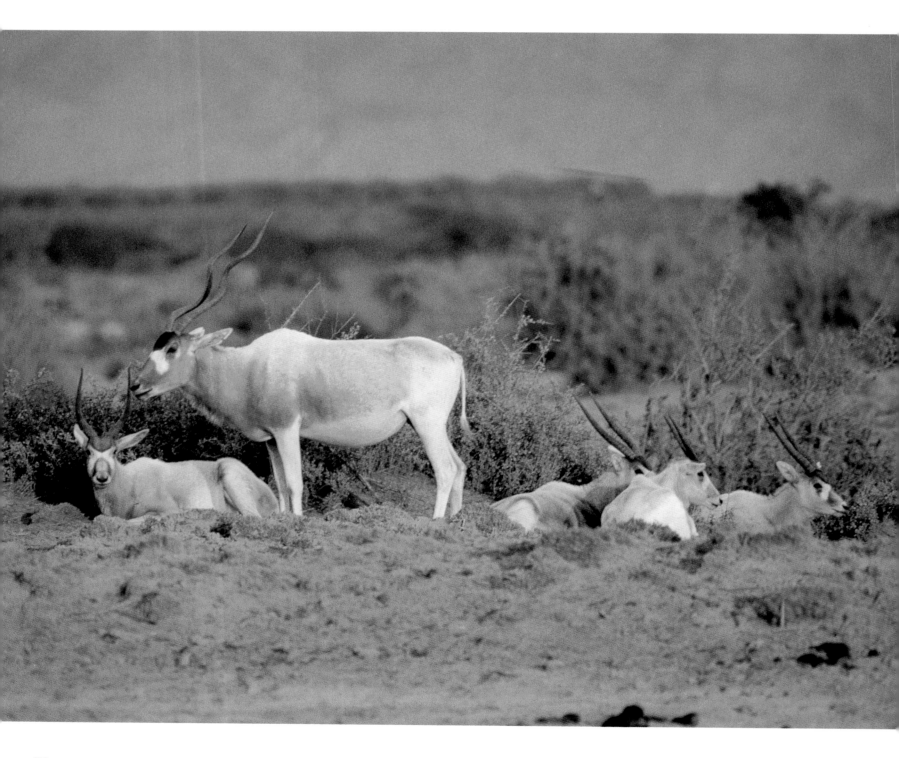

Nature conservation in Jordan

The small, virtually land-locked Kingdom of Jordan covers around 90,000 square kilometres (34,740 square miles), situated in the heart of the Middle East between Israel, Syria, Iraq and Saudi Arabia. A short stretch of coastline borders the Gulf of Aqaba of the Red Sea in the southwest. In the west of the country are high mountains and away from these much of the country is desert. Black basalt desert covers a large part of Jordan and neighbouring Syria and forms a unique ecosystem. Extensive sand dune desert is found in the south of the country.

Jordan is unusual in the Middle East in having an independent voluntary conservation organization that has been given responsibility for the country's wildlife and protected areas. The Royal Society for the Conservation of Nature (RSCN) was established in 1966 and since that time has achieved many conservation successes. Jordan now has six wildlife reserves covering over 1,200 square kilometres (463 square miles), and a further five are planned. In addition there are several national parks which are created primarily for recreation and tourism.

LEFT: Desert landscape near the Dead Sea.

PAGE 72: Erosional hills in the Dead Sea region.

PAGE 73: The caracal (*Felis caracal*) a nocturnal species that feeds on a wide variety of small animals. Although it remains common in Africa, this species has disappeared from many parts of the Middle East. Fortunately it is protected in some of the region's nature reserves.

The Dana Nature Reserve

In 1993 the Dana Nature Reserve was established in the south of the country. It is a system of wadis and mountains covering 320 square kilometres (124 square miles) and with a wide range of habitats from the wooded highlands at the top of the Rift Valley through to gravel plains and sand dunes.

A great variety of wildlife is found within the reserve, with nearly 700 plant species and over 280 animal species recorded. Rare animals include the grey wolf (*Canis lupus*), Nubian ibex (*Capra ibex nubiana* – which has declined rapidly throughout its range as a result of hunting), eagle owl (*Bubo bubo*) and the desert monitor lizard. Creation of the Dana Nature Reserve has benefited local people through the provision of new jobs. RSCN ensured that the Dana village was provided with a reliable water supply and local products are sold in the reserve shop. The revenue from tourism is a significant contribution to the running costs of the reserve.

Wadi Mujib Reserve

Another of Jordan's protected areas is the Wadi Mujib Reserve, created in 1987 on the eastern shore of the Dead Sea. The reserve consists of 220 square kilometres (85 square miles) of rugged terrain with arid sandstone mountains and deep river valleys. Animals found here include the caracal (*Felis caracal*), a rather tall, slender cat species with faint spots on its sandy-coloured skin, which lives in the rocky wadi areas, and the regionally rare striped hyena (*Hyaena hyaena*).

An oasis in decline

Located 85 kilometres (53 miles) east of Amman, the capital city of Jordan, is the Azraq Desert Oasis wildlife reserve and Ramsar site. It is an extremely valuable wetland, unique in Jordan and one of very few similar sites throughout the Arabian Peninsula. The oasis consists of a large spring-fed marshland and artesian pools. As an important source of water in the arid environment it forms a major crossroads for regional transport routes passing through Jordan, Syria, Saudi Arabia and Iraq.

There are two large settlements and a military base associated with the oasis, and the desert land around the wetland is extensively cultivated. Irrigation schemes and pumping of water for use in Amman have caused major changes in the wildlife reserve with many pools, marshes and water meadows now completely dried out. Overgrazing and the accumulation of rubbish have also caused degradation of the site. Sadly, the oasis has not been able to withstand the pressures of modern society, but there have been major attempts to rehabilitate the wetland reserve.

Socotra, Yemen's biodiversity jewel

Socotra is an island lying about 225 kilometres (140 miles) off the Horn of Africa, which belongs to South Yemen. This rugged, semi-arid island is renowned for its fascinating flora with unusual succulent plants. In total, Socotra has 216 endemic plant species found nowhere else, 85 of which are considered by the IUCN to be threatened with extinction.

Vulnerable plants and animals

One of the special plants is the Socotran cucumber tree (*Dendrosicyos socotrana*). It is a member of the cucumber family *Cucurbitaceae*, and one of the few tree species in this plant family. The cucumber tree grows on the coastal plains and foothills, particularly near the north coast of the island. It often grows alongside a tree *Euphorbia* that is also endemic to Socotra.

The main threat to the plants of Socotra, as on so many islands, is overgrazing by domestic animals. The entire plant of the cucumber tree, with its swollen, succulent trunk, is cut and pulped for livestock fodder. Current levels of exploitation are thought to be sustainable, but there is a potential risk of overuse as livestock numbers increase and *Dendrosicyos socotrana* is considered to be 'Vulnerable' by IUCN.

The dragon's blood tree (*Dracaena cinnabari*), another species to Socotra, is also under threat in the wild. The resin of this tree is thought to have provided

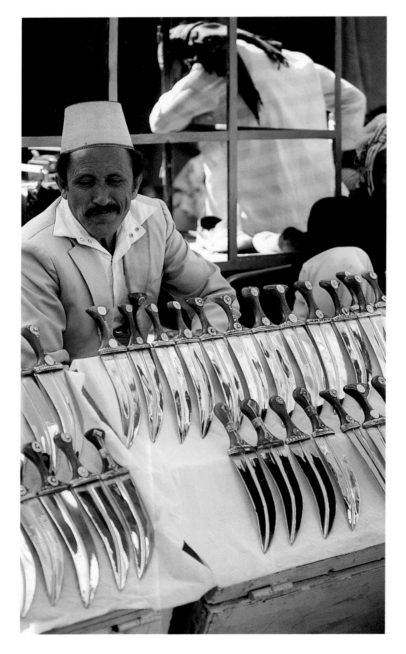

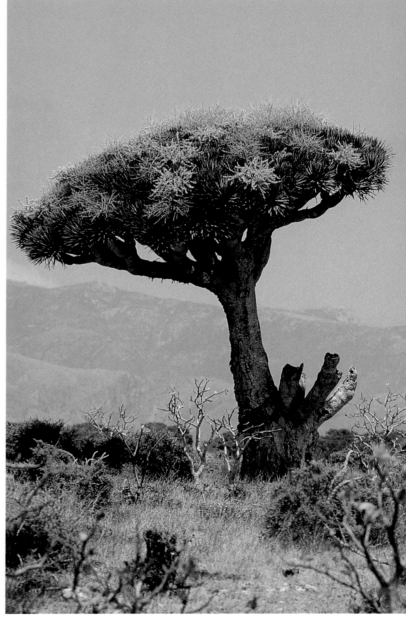

the original dragon's blood used historically by the Arabs as a medicine and red dye. Small-scale exploitation of the 'Endangered' Socotran dragon tree still takes place.

Socotra also has several endemic birds, incuding the Socotra bunting (*Emberiza socotrana*), the Socotra sunbird (*Nectarinia balfouri*) and the Socotra starling (*Onychognathus frater*). These three species are all considered to be 'Vulnerable', mainly as a result of habitat change through overgrazing.

Socotra remains relatively undeveloped but there are plans to build roads and port facilities which would radically change the nature of the island. Oil and gas exploration may also be a future threat to Socotra's unique biodiversity.

OPPOSITE LEFT: Traditional uses of rhino horn, as in these ceremonial daggers on sale in North Yemen, has been a major threat to the survival of African rhinos despite international protection.

OPPOSITE RIGHT: The Dragon's blood tree (*Dracaena cinnabari*) growing in its natural habitat on Socotra is one of the island's many endemic plants.

BELOW: Dried sap from *Dracaena cinnabari* produces dragon's blood – a red dye which gives the tree its English name. This tree is now considered 'Endangered' by the IUCN. Careful management of wild populations is required to ensure that any use of the tree is sustainable.

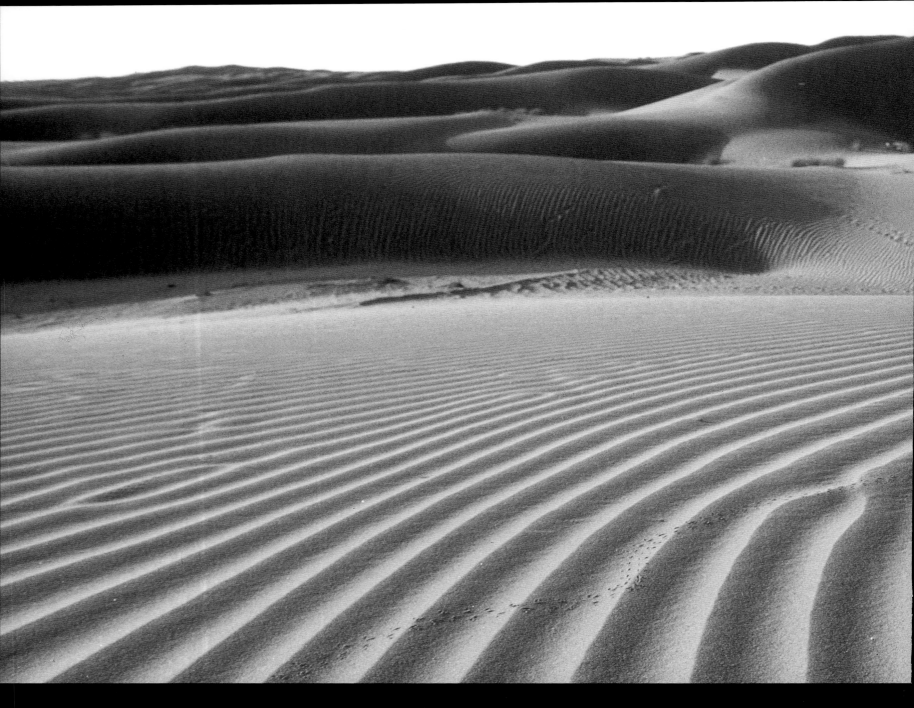

Asia
From Turkmenistan to Tibet

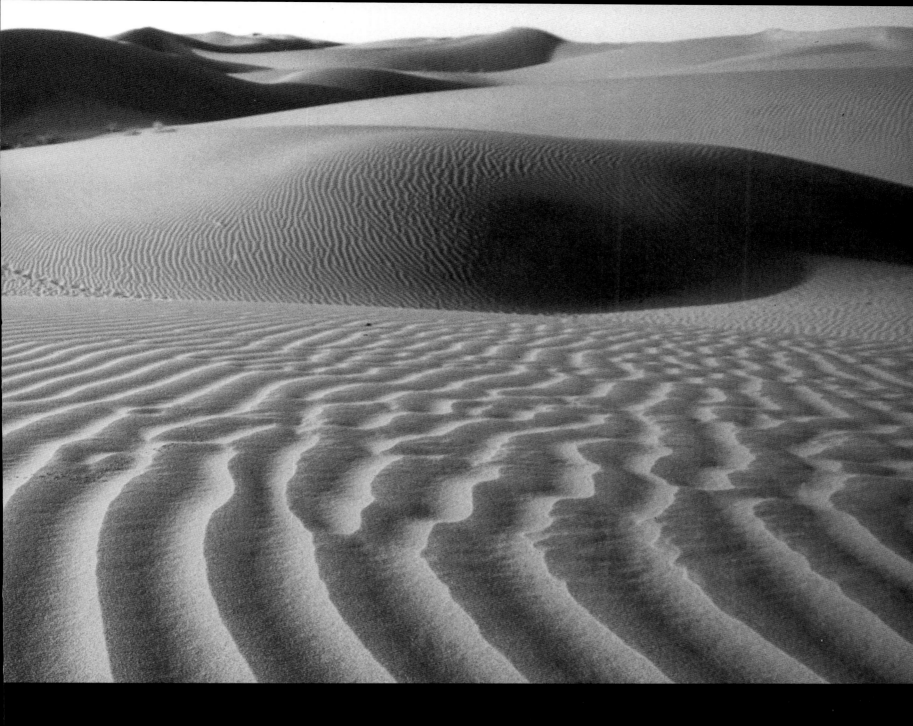

THE DESERTS OF ASIA SWEEP IN A BROAD BAND FROM THE MIDDLE EAST TO THE NORTHERN REACHES OF CHINA. TREKKED BY MARCO POLO IN THE 13TH CENTURY, THE INHOSPITABLE DRY STEPPES AND SAND DESERTS INCLUDE SOME OF THE MOST DESOLATE PLACES ON EARTH. THE ANCIENT SILK ROAD, SKIRTING THE TAKLIMAKAN DESERT AND OTHER DRY EXTREMES, ENABLED GOODS AND IDEAS TO TRAVEL BETWEEN EAST AND WEST. THE ASIAN WILDERNESS AREAS RETAIN A FASCINATING ALLURE – STEEPED IN HISTORY AND ANCIENT TALES – AND CENTURIES-OLD NOMADIC CULTURES SURVIVE TODAY. THEIR RELIANCE ON BACTRIAN CAMELS AND HORSE-RIDING SKILLS ARE LEGENDARY – BUT CHANGES ARE UNDERWAY THROUGHOUT THIS VAST DRYLAND REGION.

The deserts of Central Asia

Central Asia is a region characterized by cold winters and baking hot summers. Vast sand deserts include the Kyzyl Kum (Red Sands) of Uzbekistan, the Kara Kum (Black Sands) of Turkmenistan, and the Muyunkum and Barsuki Deserts of Kazakhstan. The combined area of the Kyzyl Kum and Kara Kum (around 640,000 square kilometres, or 397,440 square miles) forms the fourth largest desert in the world.

Stony deserts of Central Asia include the large plateau area of Ustyurt (spanning parts of Kazakhstan and Uzbekistan, between the Caspian and Aral Seas) and the semi-desert of Betpak-Dala, to the west of Lake Balkhash in Kazakhstan. There are also smaller areas of clay desert, which in northern parts of Central Asia support mainly wormwood or sagebrush vegetation, dominated by *Artemisia* shrubs. Southern clay deserts have more ephemeral vegetation, much of which flowers and dies in spring before the onset of the relentless summer heat. The salt-rich solonchak deserts occur in relatively small areas along the terraces of Central Asia's main rivers, the Syr-Darya and Amu-Darya, and further south along the Tedzhen and Murgab Rivers.

Kazakhstan, the largest of the five republics of Central Asia, has huge areas of desert. Turkmenistan, which extends from the Caspian Sea in the west to Uzbekistan and Afghanistan to the east, is also predominately a desert country; about 80 per cent of the land area is covered by desert or semi-arid plains. It is thought that in ancient times forests were more widespread in Turkmenistan than today, but felling for farming and the construction of ancient cities contributed to their decline.

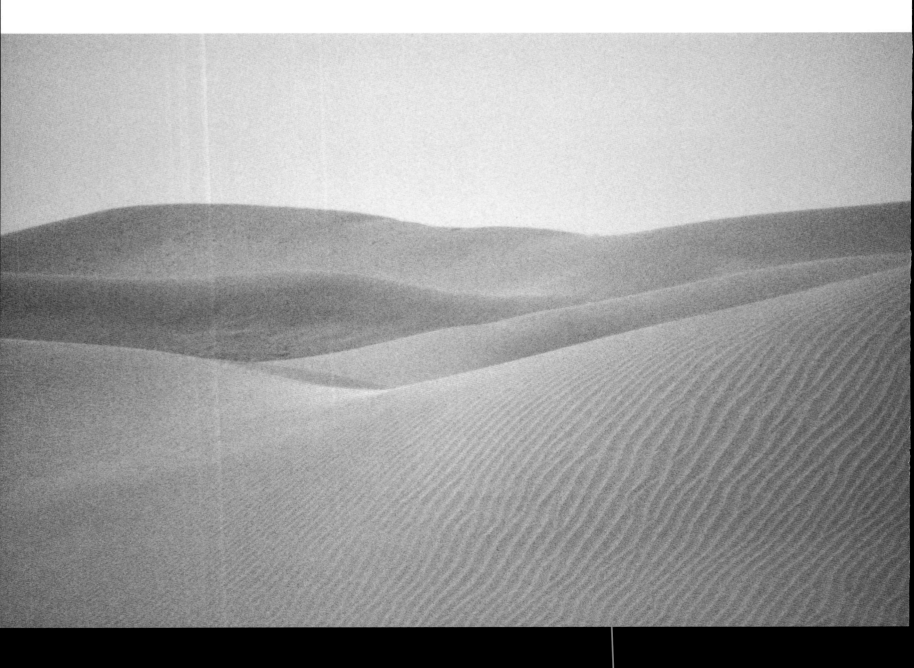

Extraordinary animals of Asian deserts

Animals of the Central Asian deserts include two groups of mammals found almost exclusively here, the gerbils and the fast-running, keen-hearing jerboas. About 20 species of jerboas extend from the Sahara to the Gobi Desert. Dwarf or pygmy jerboas of Central Asia include the very rare *Salpingotus heptneri*, known only from one small area near the south of the Aral Sea, and *Salpingotus crassicauda* which lives in the deserts of Kazakhstan and in the Gobi. The cute-looking *Salpingotus crassicauda*, with its large head and long ears, lives in areas with small patches of vegetation on sand or clay plains. They make permanent burrows with nesting chambers and various exits.

Asian mammals

Larger mammals include various species of cat, including the African wild cat (*Felis libyca*), the Pallas's cat (*F. manul*) and the caracal (*F. caracal*), all of which are now uncommon in the region. The magnificent and endangered Asiatic race of the cheetah (*Acinonyx jubatus venaticus*) has suffered greatly from hunting over the centuries, and now survives precariously in the desert plateau of Ustyurt and southern Turkmenistan.

Another distinctive mammal is the kulan or Asian wild ass (*Equus hemionus kulan*), one of at least six subspecies of *Equus hemionus*. About 2,000 kulans exist in Turkmenistan and Kazakhstan, feeding on a wide variety of plants and relying on watering places for its survival. The kulan has been threatened by hunting, but fortunately is protected in several areas within the region, including the island of Barsakelmes in the Aral Sea.

Reptiles

Reptiles are well represented in the deserts of Central Asia. Characteristic species include Horsfield's tortoise (*Testudo horsfieldi*), the toe-headed agamid (*Phrynocephalus mystaceus*) and the desert monitor (*Varanus griseus*). The large desert monitor can reach 1.6 metres (5¼ feet) in length and weigh up to 2.5 kilograms (5½ pounds). It feeds on small mammals including gerbils, birds, snakes and insects, and travels as far as 500 metres (550 yards) from its home each day in search of food. In the winter the desert monitor hibernates in deep burrows. The geographic range of this species extends from the deserts of Northern India through Central Asia and the Middle East to North Africa.

A much rarer reptile is the gecko (*Eublepharis turkmenica*) which was first described in 1977. This species is found in the stony desert foothills of the Kopet-Dag Mountains of south Turkmenistan.

Desert birds

The birds of the Central Asian deserts include some species that are specially adapted to the arid environment. The greater sand plover (*Charadrius leschenaultii*) breeds in the clay, gravelly and salt deserts, and can withstand periods without water. After breeding, however, these birds move to the banks of rivers or lakes to feed. Another desert speciality is the Pander's ground jay (*Podoces panderi*), which feeds mainly on seeds and insects.

PAGES 76–77: Impressive sand dunes dominate the landscape of Desert National Park, Rajasthan, India.

OPPOSITE: The Thar Desert, or Great Indian Desert, extends from north-west India and into Pakistan. Forested until 2,000 years ago, now large areas are covered by sand dunes.

BELOW: The Mongolian gerbil (*Meriones unguiculatus*) is the most commonly kept pet gerbil. First described in 1867, captive-bred animals are ancestors of wild gerbils captured in 1935. In the wild, this burrowing creature eats roots and seeds.

Mismanagement of the desert ecosystem

Parts of the fragile drylands of Central Asia suffered major ecological problems during the 20th century. An ill-conceived irrigation and agricultural scheme begun in 1954 has created problems of water supply and soil degradation in large areas of Uzbekistan and Turkmenistan. The plan was to deploy water from the major Amu-Darya, Murgab and Tedjen Rivers, diverting part of the flow into a new 1,000-kilometre (620-mile) canal to link up with the Caspian Sea. The Kara Kum Canal was never completed, but associated irrigation systems brought large areas into cotton cultivation.

Cotton has been grown in the region since the 19th century, with increasing intensification during the Soviet era. The crop requires a lot of water and irrigation schemes have significantly drained the Amu-Darya, reducing its flow to a relative trickle.

Much of the land in the irrigated areas has been contaminated by salt rising to the surface of the naturally saline desert soils. To compensate for this and to maintain productivity, large amounts of inorganic fertilizers have been used; the soils have been effectively poisoned by heavy applications of fertilizers and pesticides, which find their way into domestic water supplies.

The loss of water from the Amu-Darya and also the Syr-Darya Rivers has in turn had severe consequences for the Aral Sea. Until 1960, the Aral was the world's fourth largest inland water body. Since that time diverting water for irrigation has disturbed the balance between evaporation and inflow, resulting in the loss of over half the volume of water, and a dramatic increase in salinity. Without the regulating effects of the sea local climate has changed; summers are hotter and winters colder. It is difficult to envisage a solution for ecological problems of this scale, but internationally supported efforts are underway to improve natural resource management in the region.

BELOW: The Afghan or Horsfield's tortoise (*Tetudo horsfieldii*) has a natural range from southeast Russia through to India, Pakistan and Afghanistan. It is now considered 'Vulnerable' in the wild as a result of exploitation for food, export for the pet trade and habitat destruction.

Conservation in the post-Soviet era

Biodiversity conservation in Central Asia is constantly evolving, with a shift towards the inclusion of people within protected ecosystems and engagement with the wider public. There has been a dynamic growth within the region of NGOs committed to conservation and ecological restoration. Unfortunately financial resources to cover these aims and invest in nature conservation remain limited in economies struggling to make the transition into a post-Soviet economic climate.

A positive example of ongoing conservation research occurs in the Repetek Biosphere Reserve in Turkmenistan. This reserve covers 340 square kilometres (131 square miles) of the eastern Kara Kum Desert. Created initially in 1928, a desert research station has been in operation at the reserve since 1965, with a focus on restoring overgrazed pasture and halting sand encroachment. Now the emphasis is on how to demonstrate approaches to sustainable resource management and development on a regional scale. Such approaches need to be extended through the entire Asian desert region.

BELOW: The goitred gazelle (*Gazella subgutturosa*) was once widespread in arid lands from the Middle East to the Gobi Desert; however, numbers have declined significantly in recent decades largely due to hunting pressures.

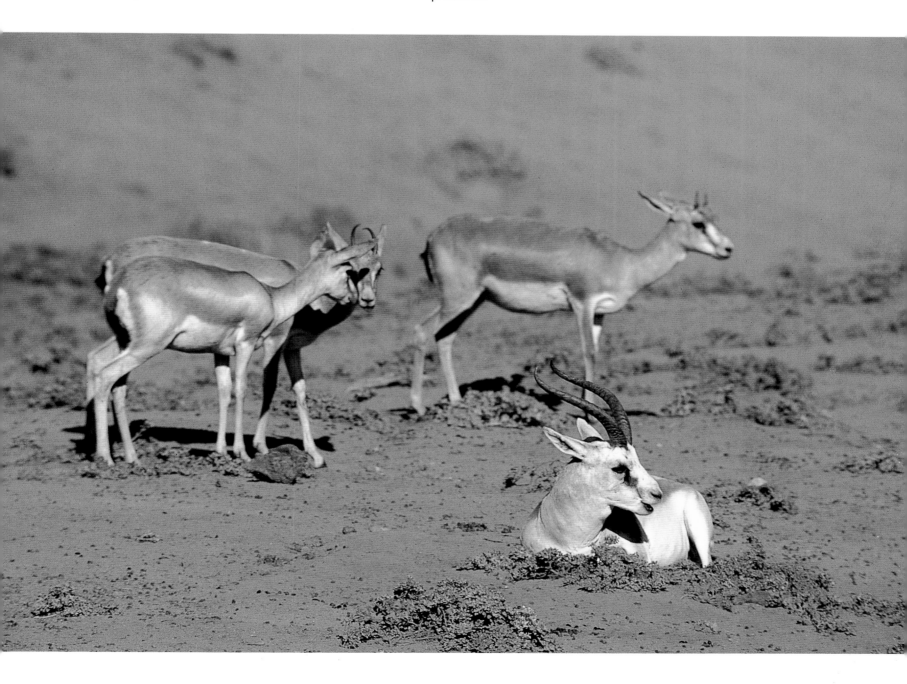

Iranian deserts

A large part of central Iran consists of desert, covering in total about 60 per cent of the country. In the north lies an area known as Dasht-e Kavir, or the Great Kavir, the largest salt desert in the world. This extraordinary area has no vegetation. Different coloured polygonal salt crusts lie over mud and deep underground channels for much of the year. Part of the Dasht-e Kavir Desert is included in the Touran Protected Area, established in 1971 and declared a Biosphere Reserve in 1976. When first declared, the reserve covered a total area of 10,000 square kilometres (3,860 square miles), but there have since been plans to reduce this. Aside from the salt desert, the rest of the protected area is semi-desert with trees only found in the most sheltered places.

Despite the harsh conditions, this area of Iran has a remarkable diversity of animals and plants. Animals include the Persian wild ass (*Equus hemionus*), goitred gazelle (*Gazella subgutturosa*), cheetah (*Acinonyx jubatus*), leopard (*Panthera pardus*), striped hyena (*Hyaena hyaena*) and golden jackal (*Canis aureus*). This area is an important breeding site for the houbara bustard. Land use has been mainly small-scale agriculture with seasonal camel, goat and sheep grazing from November to May.

Further south in Iran is the Dasht-e Lut Desert, consisting of stony desert pavement and loose sand. Iran shares deserts along its border with the neighbouring country of Afghanistan.

Deserts of Afghanistan

The large desert known as Dasht-Margo makes up much of southern Afghanistan, extending across into Iran to the west and Pakistan in the southeast. Most of Afghanistan – away from the mountain areas – has a low rainfall of less than 100 millimetres (4 inches) per year and extremely hot summers. Much of the barren countryside has been degraded through centuries of overgrazing and wood-cutting, and more recently political strife and warfare. Grazing by sheep and goats is the main land use over much of the country, and cultivation only takes up a small proportion of land. As the country recovers, there may be a possibility to protect some areas for the conservation of biodiversity, but there are no currently legally protected national parks.

The low-lying area in the southwest of Afghanistan includes the Seistan Basin, which is dominated by salt plains. In the past the Seistan Basin drained major rivers flowing from the Hindu Kush. Extensive wetlands occurred here, but most of these have dried up as a result of damming the rivers.

One area of the basin remains very important as a wetland site in this generally arid area: Hamun-i-Puzak, a large shallow lake surrounded by the Seistan Desert.

Around the margins of the permanent lake are extensive *Phragmites* reed-beds. The Hamun-i-Puzak wetland is estimated to hold up to 1 million wildfowl in winter and is a wetland of major international importance. It is one of 17 Important Bird Areas of Afghanistan identified by Birdlife International. Globally threatened bird species found here include the marbled teal (*Marmaronetta angustirostris*), which has a range from Spain to Pakistan but is declining everywhere; the cinereous vulture (*Aegypius monachus*), which has a similar status, and the imperial eagle (*Aquila heliaca*).

Little is known of the largest desert area of Afghanistan – the Registan Desert, which lies to the south of the city of Kandahar. In this remote area of sand dunes, gravel plains and desert scrub, historic reports record large herds of goitred gazelle and onager. The cheetah also occurred here, but it is not known whether any of these animals survive today.

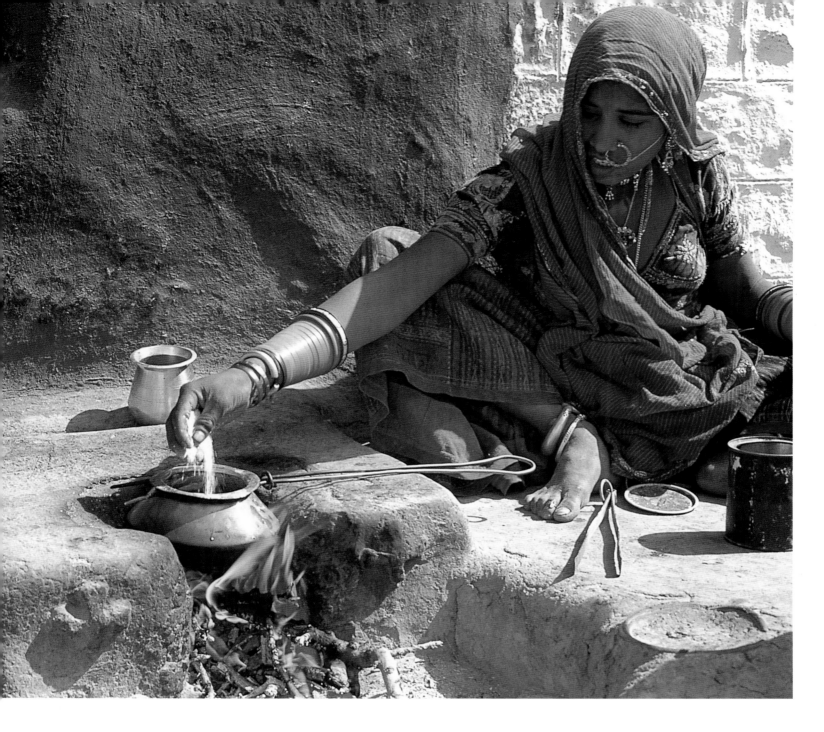

ABOVE: The Thar Desert is one of the most densely populated arid areas of the world. Cultivation takes place wherever there are patches of soil.

RIGHT: Water is precious in the Thar, and various traditional wells have been developed to tap underground supplies.

PAGE 84: Animal tracks in the sand of the Thar Desert.

PAGE 85: The Indian wild ass or khur is a subspecies of *Equus hemionus*, the Asiatic wild ass which once roamed the lowland deserts and steppes of much of Asia. The khur is now restricted to the seasonally flooded salt flats of the Little Rann of Kutch.

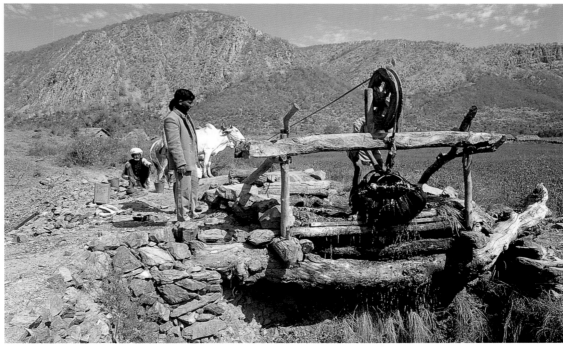

The Thar Desert

The Thar Desert lies in the northwest of India in the states of Rajasthan, Gujarat, Haryana and the Punjab. Across the border the desert continues in the Pakistani states of Punjab and Sind. Also known as the Great Indian Desert, this arid area covers approximately 440,000 square kilometres (169,840 square miles). This area was not always desert; two millennia ago it was covered in forest, but the effects of felling, farming and grazing have taken their toll – in a process which continues today as the Thar Desert expands.

The climate is extremely harsh, with summer temperatures of up to 50°C (122°F) and very strong winds, especially in May and June. Rainfall ranges from about 100 millimetres (4 inches) in the east to 500 millimetres (20 inches) in the west. There are very limited groundwater deposits. Despite the harsh conditions, the Thar Desert is relatively densely populated compared with other desert regions of the world. Subsurface water and patches of useful soil among the sands help to support a human population density of around 84 people per square kilometre.

Irrigation projects over the past 20 years have enabled the development of more intensive farming and pastoralism. Camels are highly valued as livestock, and each year up to 300,000 people congregate in the village of Pushkar, in Rajasthan on the edge of the desert, for a religious ceremony and huge livestock sale. The camels are carefully groomed and bedecked with jewellery and brightly coloured cloth.

People of the Thar

Remarkable among the people of the Thar Desert are the Bishnoi, who believe in the total protection of wildlife. Founded over 500 years ago the Bishnoi cult is a form of Jainism which teaches that all forms of nature have a right to life. Since 1778, when 363 people were killed in an attempt to prevent the cutting of a khejri (*Prosopis cineraria*) tree, the cutting of any tree in a Bishnoi village is totally prohibited. As elsewhere in its range the khejri provides the Bishnoi with a vital source of fodder for livestock, as well as edible pods for their own use and wood for fuel.

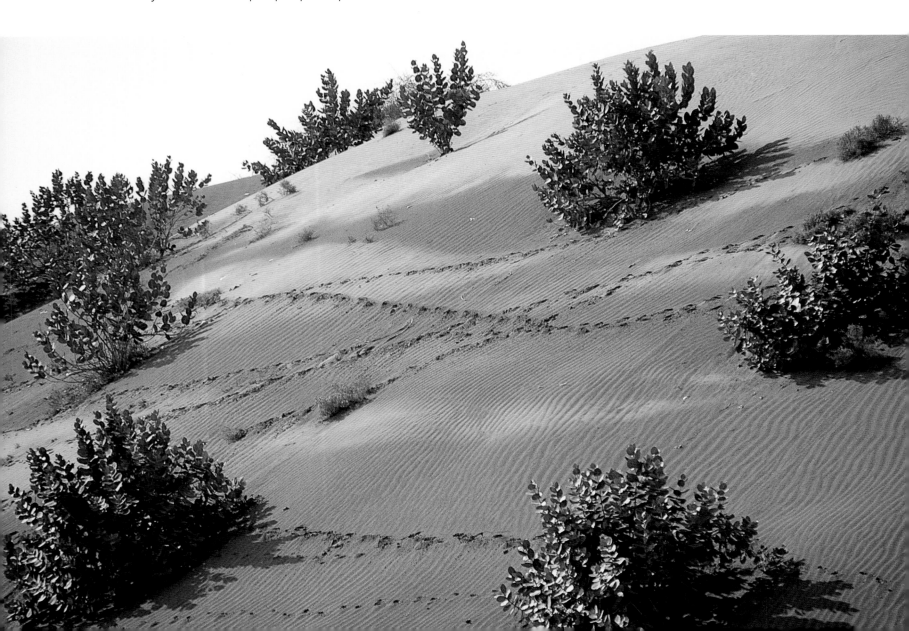

Animals of the Thar

The animals of the Thar Desert and its margins include desert gerbils, the long-eared hedgehog, desert cat and fox, and the Indian wild ass (*Equus hemionus khur*). The wild ass has become increasingly rare, but a small population survives in the seasonally flooded salt flats of the Little Rann of Kutch. Around 80 per cent of the chinkara or Indian gazelle (*Gazella bennettii*) population of India is found within the Thar Desert, and this animal is particularly abundant around the Bishnoi villages of Rajasthan and Haryana. The chinkara can survive without drinking water, and avoids dehydration by resting in the shade during the hottest times of the day. The animals browse on flowers and leaves, including the leaves of the highly toxic *Calotropis procera*, and graze on new shoots of grass.

Blackbuck and nilgai

Drylands of the Thar and adjacent areas are also home to the blackbuck (*Antelope cervicapra*) and nilgai (*Boselaphus tragocamelus*). With high temperatures and low rainfall the vegetation in this area consists of thorny, xerophytic shrubs, succulents, scattered trees of gum arabic, *Acacia* and *Mimosa*, and sparse grass cover. Blackbuck are almost exclusively grazers and can survive the hottest months without water. Once abundant throughout India, with herds of thousands, much of the species' open plain habitat has been lost to agriculture and hunting has also reduced numbers substantially. Today small herds consist of females and young led by a single male, or of 'bachelors'. The males have blackish-brown coats, with pale underparts, and spiral, twisted horns. Females have sandy brown coats. According to Hindu mythology, blackbuck are sacred, and where they occur near villages on the desert edge local people protect them. Blackbuck breed well in captivity, and animals bred in the USA have been reintroduced to the Cholistan Desert of Pakistan.

Nilgai, or blue bulls, are horse-sized antelopes, which browse in trees as well as grazing on the sparse ground cover. They are found in arid sandy areas and dry deciduous forests but avoid the driest desert areas.

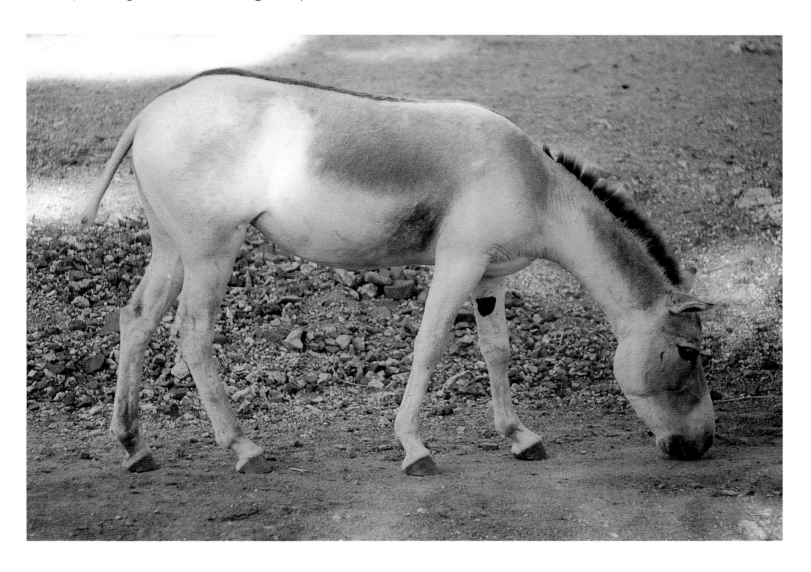

Like the blackbuck, they are protected for religious reasons, and are expanding their range in the irrigated parts of the Thar Desert.

Thar animals under threat

Nilgai and blackbuck were once the prey of the Asiatic lion and Indian cheetah. The latter was once common in India and survived well into the 20th century. Trained cheetahs were used for hunting by Indian royalty. The decline of prey species such as the blackbuck contributed to the decline of the Indian cheetah, and the last individual was shot in 1947. The lion is also close to extinction in India. The Gir National Park, India, a semi-arid area of scrub and dry forest, provides the last refuge for the Asian population of lion, which in the early part of the 20th century ranged from Arabia across the Middle East to India.

Endemic bustards and sandgrouse

A charismatic bird of Indian drylands is the great Indian bustard (*Ardeotis nigriceps*). A large heavy ground bird, this species stands over 1 metre (3 feet) tall and weighs up to 18 kilograms (40 pounds). It mainly eats insects and will also take lizards and small snakes, together with some plants. The great Indian bustard occurs in Pakistan and India, with Rajasthan its main area of distribution. Hunting and trapping have been the main threat; the species is now protected but is considered 'Vulnerable' and in need of sanctuary in protected areas and from local communities. Probably around 1,000 individuals remain within the Thar Desert.

The houbara bustard also survives here, as well as the imperial or black-bellied sandgrouse (*Pterocles orientalis*). Like its relatives in the deserts of Africa, the imperial sandgrouse, a pigeon-like bird in shape and size, feeds on seeds picked from the ground, other forms of vegetation and occasional insects. They need to drink regularly, will fly considerable distances to find water, and are highly gregarious at waterholes.

Desert National Sanctuary of Rajasthan

A good place to see the wildlife of the Thar Desert is in the Desert National Sanctuary of Rajasthan. Established in 1980, this large reserve covers over 3,000 square kilometres (1,158 square miles). It has shrubs and trees in addition to rolling sand dunes.

The wildlife wealth here includes desert fox, desert cat, hare and the reptile spiny tail uromastyx (*U. hardwicki*). Thousands of birds migrate to the area in winter with overwintering imperial sandgrouse, bustards, falcons and eagles. The best time to visit is September to March.

BELOW: Indian blackbuck (*Antilopa cervicapra*) live in small herds led by a single male. This species is now considered to be 'Vulnerable' in the wild as a result of hunting and habitat loss.

OPPOSITE: Communities of Saiga antelopes once extended from the Ukraine eastwards through the steppes of central Asia.

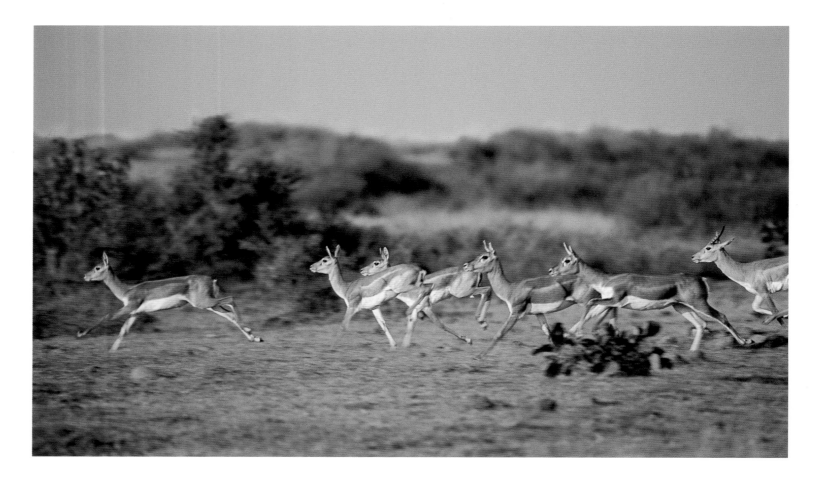

The Gobi Desert

Stretching from the Tien Shan Mountains in the west, across southeast Mongolia and Northern China, the Gobi Desert covers over 1 million square kilometres (386,000 square miles) and is the fifth largest desert in the world. The lack of rainfall in this huge continental area results from the rain shadow effect of the Himalaya and Tibetan plateau to the south.

The Gobi Desert is made up of various distinct desert areas. The Taklimakan Desert in the west is a vast area of sand dunes on a hilly elevated plain. Salty dry lakes occur between the dunes, and some lie in fields of wind sculptures known as yardangs. To the northeast of the Taklimakan Desert lies the Junggar Basin; travelling east, the Alashan Desert lies in the

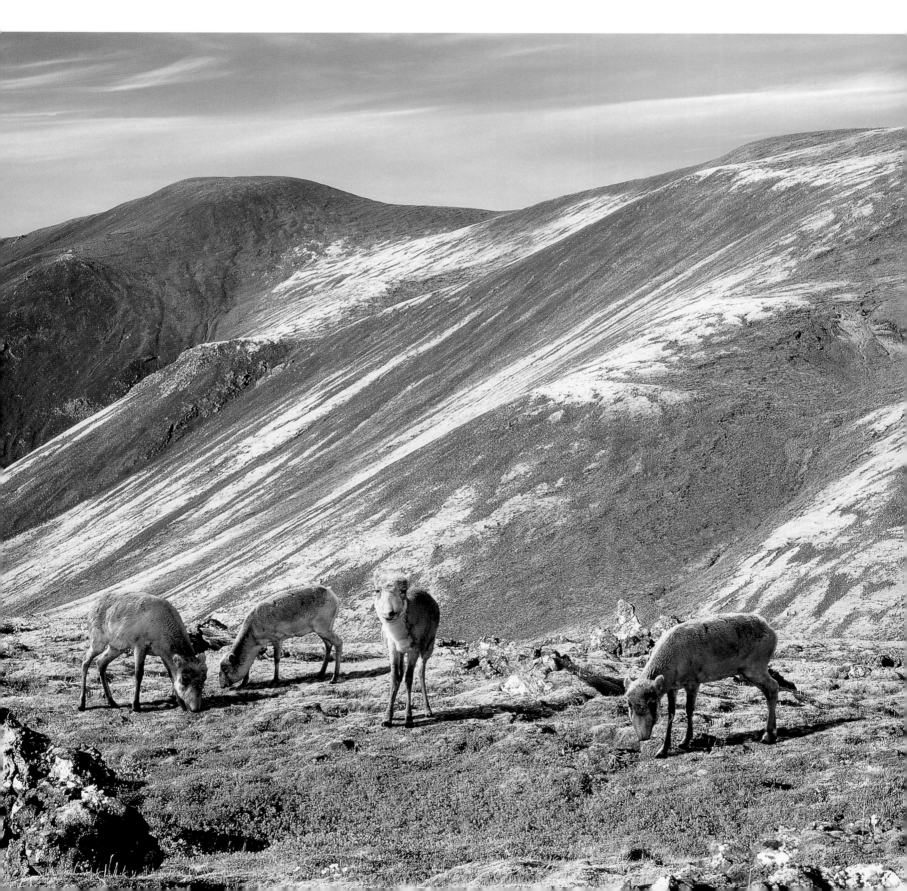

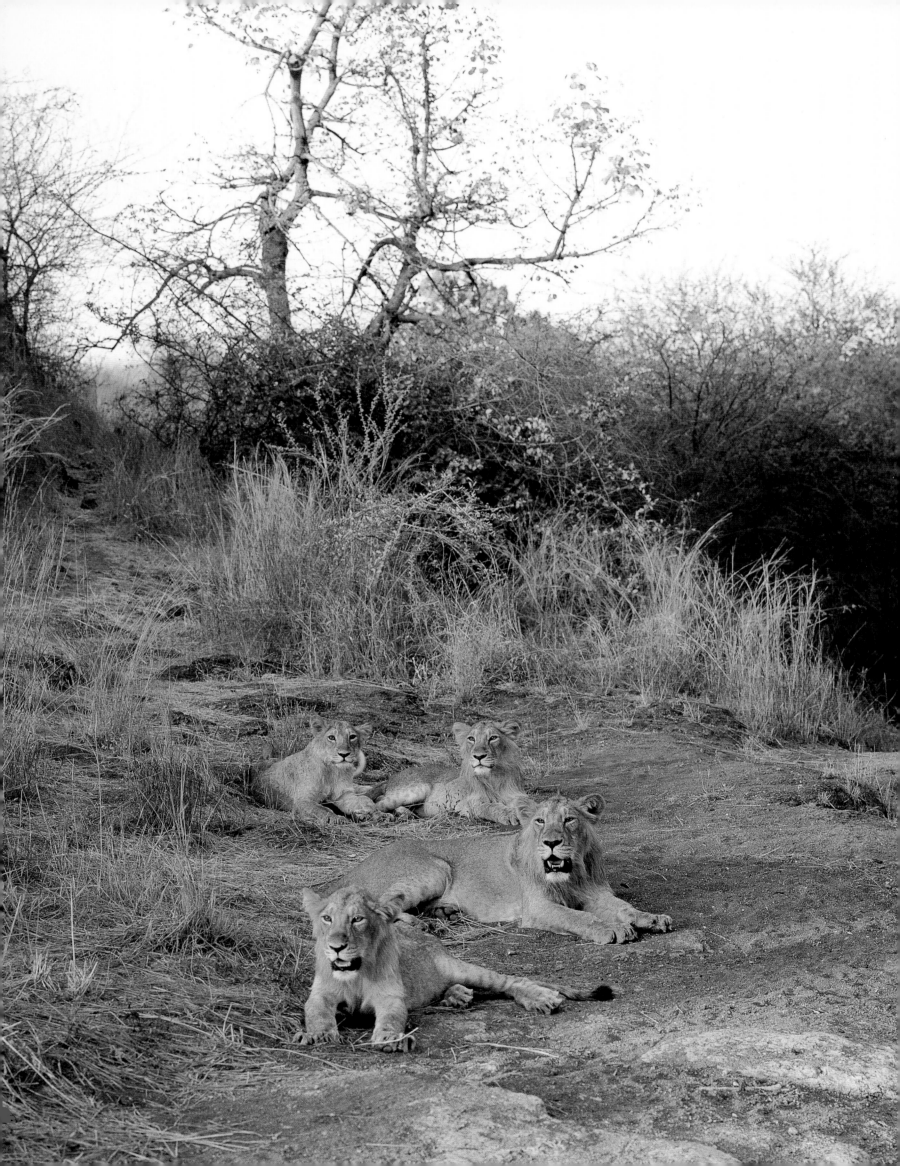

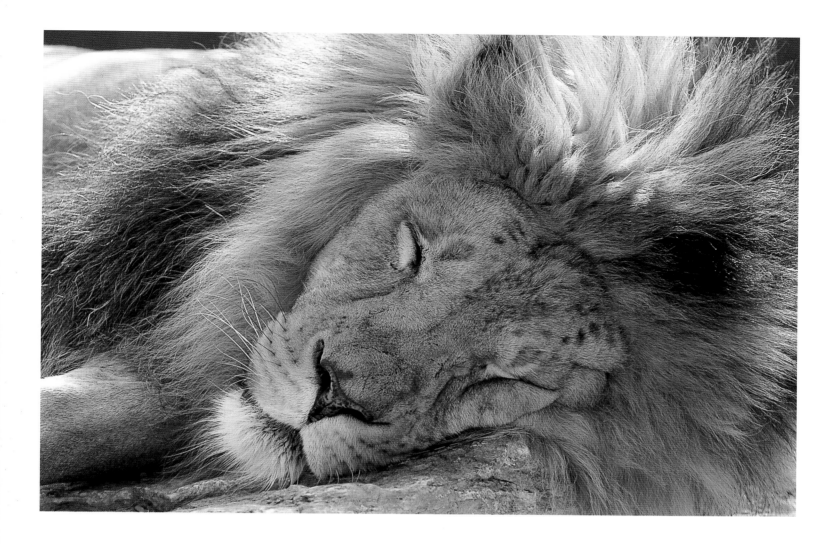

central part of the Gobi, separated from the Ordos Desert of China by the Huang He River. Most of the rivers in the Gobi Desert flow intermittently in times of summer rainfall.

The bactrian camel

The Gobi Desert has some animal species in common with the deserts of Central Asia as well some animals unique to the region. Perhaps the most famous of all is the bactrian camel (*Camelus bactrianus*). The two-humped camel was domesticated by about 2500BC for use as a pack animal. It remained widespread and fairly common in the wild until the beginning of the 20th century. Now only about 1,000 bactrian camels survive in the wild in the arid lands of the Gobi Desert. In Mongolia, wild bactrian camels are confined to the Great Gobi National Park, where there are less than 500 individuals.

In China, the bactrian camel survives in the western provinces of Xinjiang and Gansu, mainly in the east Taklimakan Desert. There are thought to be around 650 wild camels in the country.

Three nature reserves have been established in China to protect the bactrian camel: the Annanba Nature Reserve in Gansu, the Altun Mountain Nature Reserve in Xinjiang Province, and the recently created Lop Nur

OPPOSITE: The lion is close to extinction in India where the Gir National Park provides its last refuge. The remnant population is carefully managed to ensure its survival.

ABOVE: The future of this magnificent animal is entirely dependent on human will.

Nature Reserve, also in Xinjiang. Since its establishment in 1999, the 150,000-square-kilometre (57,900-square-mile) Lop Nur Nature Reserve has been upgraded from a provincial to a national reserve by the Chinese government. The inhospitable, waterless wasteland of Lop Nur was China's former nuclear test site. The wild bactrian camels, which live in the reserve, have survived atmospheric and underground nuclear tests, and have also adapted to drinking salty slush from melted snow, which is unpalatable to other mammals (including domesticated bactrians).

The overall objectives of the Lop Nur Nature Reserve are to ensure protection for endangered species, and in particular the flagship bactrian camel; to protect the unique desert ecosystems and landforms; and to train personnel in biodiversity conservation management. The needs of local communities are being integrated into reserve management and a comprehensive educational programme has been developed.

The UK-based Wild Camel Protection Foundation, formed in 1997, has been instrumental in the establishment of the Lop Nur Nature Reserve through raising awareness of the plight of the wild bactrian camel, raising funds to support establishment of the protected area, and liaising with the major interest groups in China. In 2003 lobbying by the foundation helped to ensure that a major gas pipeline sited through the northern part of the reserve was rerouted. The future of the wild population of the bactrian camel is far from certain, however, and this important species is considered to be 'Critically Endangered' by IUCN. Animals are still occasionally killed for food when they stray beyond protected area boundaries and, in the north of its range, wolves remain a natural predator, particularly of newborn camels.

The Xinjiang ground jay

The Xinjiang ground jay (*Podoces biddulphi*) is another threatened species confined to the Gobi Desert. As its name suggests, it is known only from Xinjiang, Western China, where it is found in sandy desert, and in the scrub of the Taklimakan Desert. It remains locally common but may be declining because of the degradation of habitats through the intensive grazing of goats and camels, extraction of wood for fuel and the conversion of huge areas to irrigated land.

Nomads of the Gobi

The harsh Gobi Desert is sparsely populated but, as in other desert areas of the world, human ingenuity has enabled people to survive through traditional lifestyles that capitalize on the scant natural resources. The Khalkha Mongols are semi-nomadic. They depend traditionally upon the domestic herds of the bactrian camel which have been used in the region for around 4,500 years. Camels continue to provide a source of transport for the Khalkha people who move to new areas of grazing about 10 times each year. Motorized vehicles are becoming more common but have not yet replaced the traditional form of transport. The bactrian camels are also sheared to provide thick wool, which is used to make the felt for construction of lightweight tents known as ger. Sheep and goats are also herded.

There are few settlements in the Gobi Desert; those that do occur are associated with cultivated oases along the caravan trails and the more modern communication routes such as the railway from Ulan Bator to Beijing.

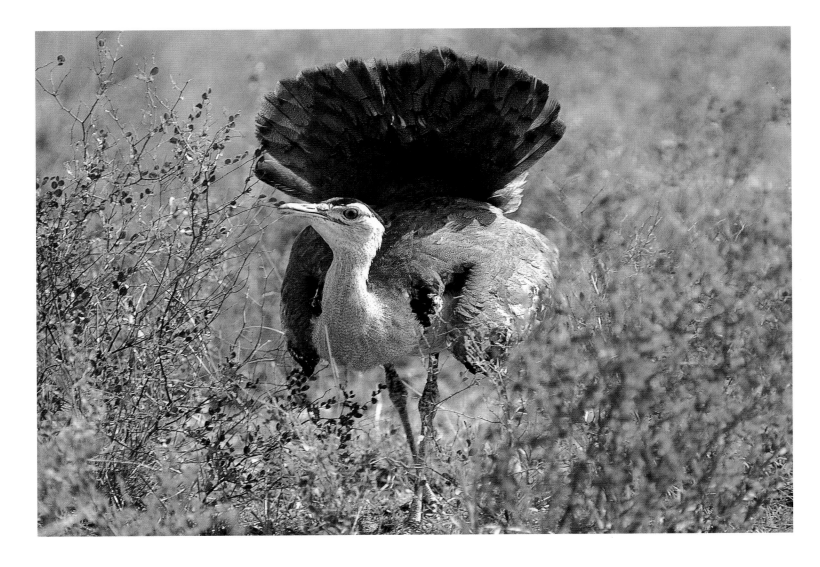

Tibet

Much of the former kingdom of Tibet, ruled as an autonomous region of China since 1956, is high-altitude desert situated in the rain shadow of the mighty Himalayan mountains, which lie to the south. To the north of Tibet are the Taklimakan and Gobi Deserts. The climate of Tibet is harsh, with rainfall of less than 250 millimetres (10 inches) per year, long cold winters and short mild summers. Throughout the year strong desiccating winds blow through the land.

The vegetation of the plateau mainly consists of alpine meadow, alpine steppe and desert steppe. The plants of the harsh steppe environment tend to be low growing, with dwarf shrubs and cushion plants, which can survive the strong winds. The dwarf shrub *Ceratoides compacta* is a dominant species. The alpine and desert steppe have many species in common, but the vegetation is sparser in the desert steppe which extends north from Tibet into Xinjiang

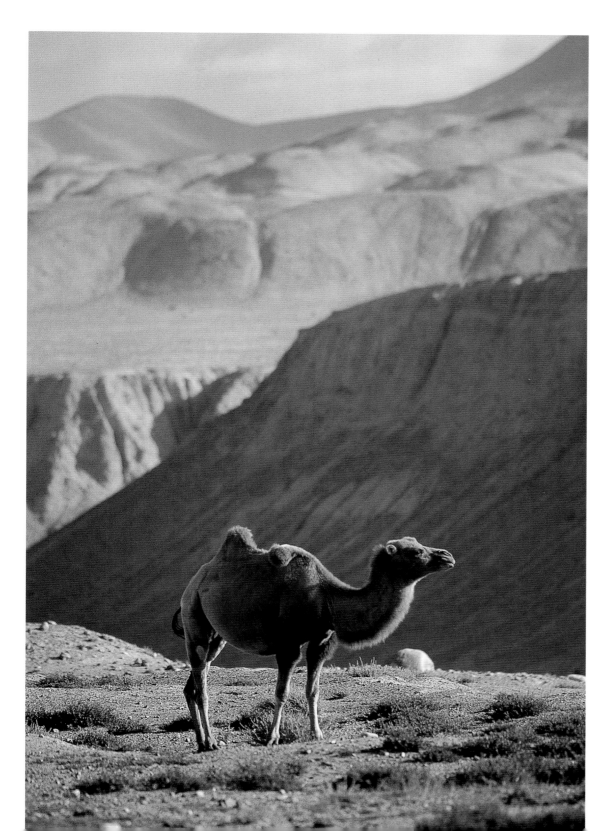

OPPOSITE: There are over 20 species in the bustard family generally associated with dryland areas. The Great Indian bustard (*Ardeotis nigriceps*), one of the world's largest flighted birds, is the rarest bustard. It is found only in a few arid areas of India and is considered by the IUCN to be 'Endangered'.

LEFT: The two-humped bactrian camel is now very rare in the wild. Only about 1,000 individuals remain in the desert areas of Mongolia and China.

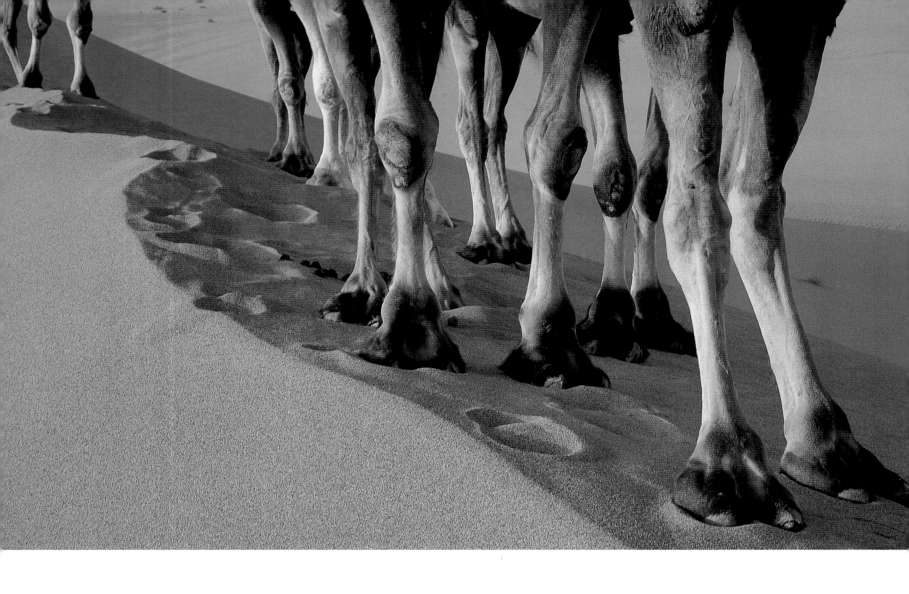

Province, China. Large areas of the bleak desert steppe have very little vegetation at all, and are largely unoccupied by people.

The people of Tibet

Agriculture and nomadic pastoralism are the main forms of land use in this cold, arid land. Pastoralism in the harsh upland steppes has been recorded since the 9th century, and was almost certainly enabled by the domestication of the yak. Over recent centuries the nomads owed allegiance to the monasteries and aristocratic families of Tibet. Each household was allocated a certain amount of grazing land for its own animals, and was required to pay annual taxes of butter and wool. Initially under Chinese government, the nomads continued their traditional way of life largely unchanged. Subsequently, in the Cultural Revolution of the late 1960s, private ownership of livestock was abolished and communes were established. Religious practices were outlawed. The lives of the nomads were abruptly changed again in 1981 when the policies of the Cultural Revolution were overturned. Despite all these events, the Tibetan nomads retain many aspects of their traditional lifestyle.

Livestock – mainly cattle, yaks, sheep and goats – are generally grazed on upland pastures between the months of April and October. Dairy produce is very important in the local diet which consists mainly of meat, milk, yoghurt and tea. Another staple food is tsamba, made from roasted barley which is ground to a fine flour, mixed with a little tea and rolled into lumps, sometimes flavoured with butter, sugar and curds.

Animals in decline

The yak (*Bos mutus*) was domesticated in Tibet over 1,000 years ago. There are millions of domesticated yaks today, but only a few hundred wild animals remain on the Tibetan Plateau at altitudes of 4,000–6,000 metres (13,000–19,700 feet). The wild yak is considered to be 'Endangered' by IUCN. Specially adapted to high altitudes where the air is thin, the yak has a unique form of haemoglobin in its blood. It is a very efficient food converter and can survive on the sparse vegetation of the cold Tibetan Desert. Valued for its meat, hide, coat and abilities as a beast of burden, one animal can carry up to 68 kilograms (150 pounds) of load, and with well-adapted small, split hooves can follow trails too rough for horses.

Another 'Endangered' species is the Tibetan antelope or *chiru* (*Pantholops hodgsonii*), which is endemic to this region. The main habitat of this upland

species is alpine meadow and alpine steppe. The *chiru* generally avoids arid areas of desert steppe, but may occupy these areas seasonally. There has been a dramatic decline in numbers over recent years as a direct result of demand for the *chiru's* soft underfur or *shatoosh* – 'king of wool'.

Shatoosh is smuggled from Tibet into India and then woven into fine shawls in Kashmir. The wool has been traded for centuries, but in recent years a demand for this precious commodity has developed in Europe, the USA and Japan, where shatoosh has become a fashion status symbol. Traders from Tibet are reported to barter *shatoosh* for tiger bones, another illegally traded endangered species commodity which is used in traditional medicine. Efforts to stop the trade are intensifying with international organizations including FFI, WWF and TRAFFIC campaigning to promote awareness and save the species.

The wildlife of the Tibetan Plateau was generally largely depleted in the 20th century, a time of rapid change and political upheaval even in this remotest of regions. European travellers in the Victorian era were impressed by the large herds of wild yak, the *chiru*, and the *kiang* (*Equus hemionus kiang*), the largest of the wild asses which is found in the most arid areas of Tibet as well as the more alpine parts. Populations of

these magnificent animals have subsequently declined as a result of competition for grazing with increased levels of domestic livestock and, in the case of chiru, large-scale illegal hunting.

Fortunately there are plans to conserve large areas of the arid lands of Tibet. The Arjin Shan Reserve covers 45,000 square kilometres (17,370 square miles); the Xinzia Reserve covers 40,000 square kilometres (15,440 square miles); and the huge Chang Tang Reserve, created in 1993, covers 284,000 square kilometres (109,624 square miles). It has been established as a multiple-use area, where nomads can manage their livestock and where wildlife can be conserved. The northern portion of the large reserve is virtually unoccupied by humans, as the grazing for domestic livestock is so poor. This area is important for wild yaks and *chiru*, and may become a special zone for wildlife conservation where grazing is restricted or banned.

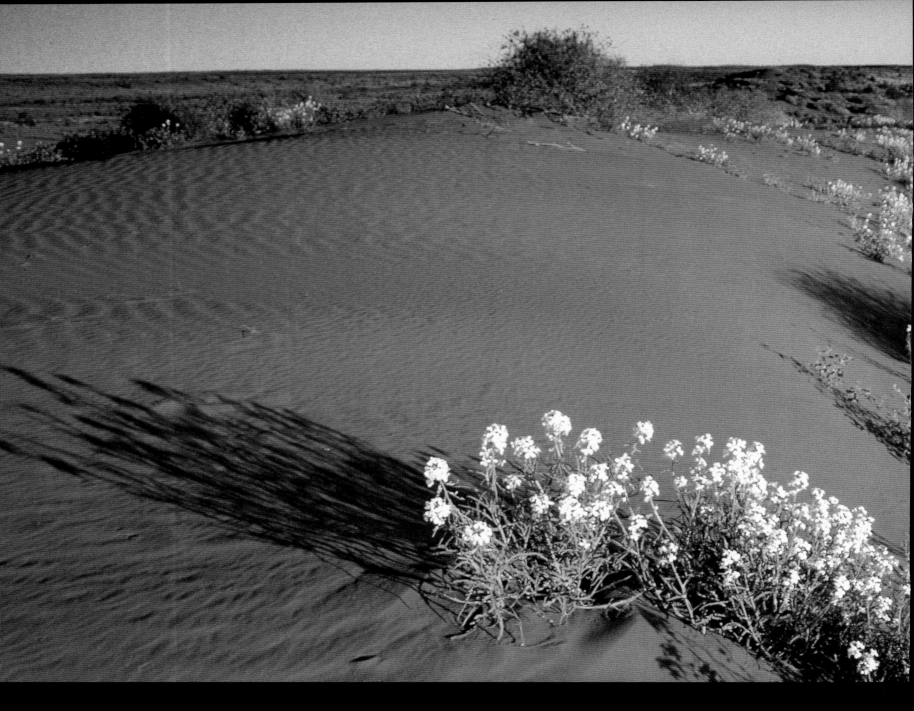

CHAPTER FIVE

Australia
Continent of extremes

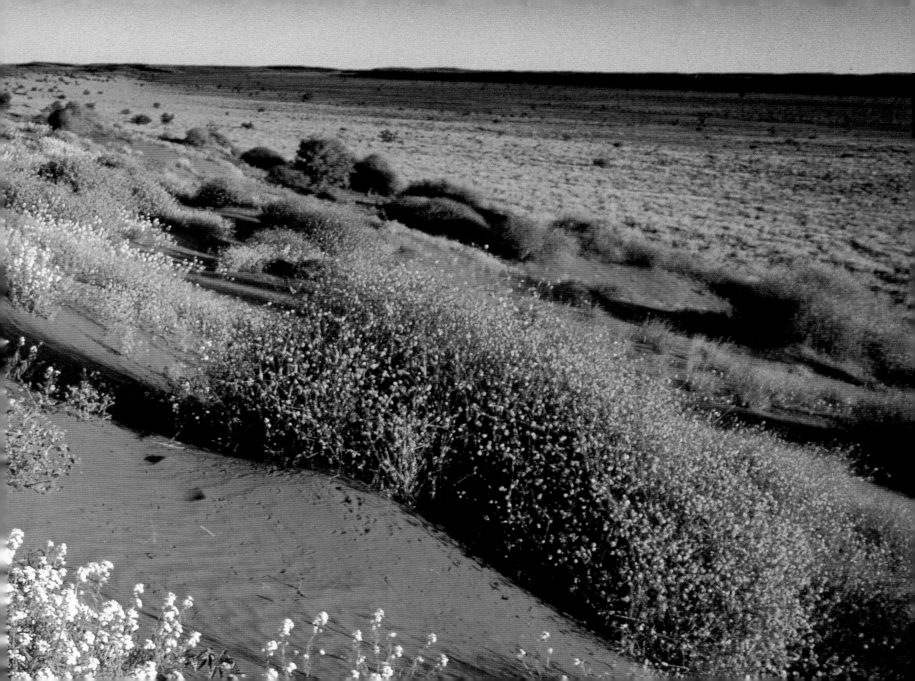

Sand deserts and ancient landforms

Australia's arid ecosystems reflect current and past climatic conditions. Many of the country's unique landforms date from different climatic periods, millions of years ago. In the Davenport Ranges, about 400 kilometres (248 miles) north of Alice Springs, the land surface is believed to be the oldest continuously exposed rock surface on earth, dating back 500 million years. Some of these surfaces show signs of glaciation from the Permian geological period, when Australia was located to the west of the South Pole.

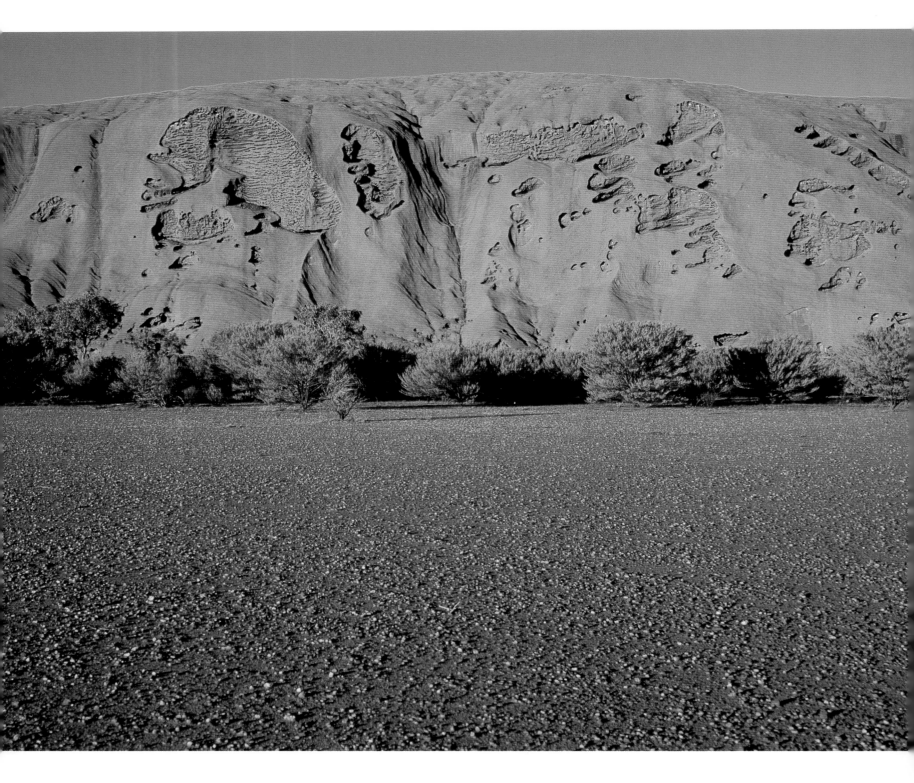

Uluru

Uluru (or Ayers) Rock, the world's largest monolith and an Aboriginal sacred site, situated in Uluru National Park, is Australia's most famous natural landmark. This extremely ancient inselberg landform is composed of steeply dipping, feldspar-rich sandstone, and has been exposed as a result of folding, faulting, erosion of surrounding rock and infill. Ayers Rock was already a landscape feature by the late Mesozoic or early Tertiary geological period. Surrounding the huge rock structure, the flat desert ecosystem includes extensive sand plains, dunes and alluvial desert.

Desert landscapes

The Australian desert landscape is conspicuously flat, with an altitude generally between 150–300 metres (500–1,000 feet). There are two central highland areas, the Macdonnell and Musgrave Ranges, which rise to peaks of around 1,500 metres (5,000 feet). To the east of these parallel ranges is an area known as the Channel Country, and to the west a shield of ancient rock with landscape features including a series of dry lake beds, thought to represent ancient fossilized drainage systems. In the west of the arid region, the

PAGES 94–95: Sand dune vegetation in the deserts of the Australian Northern Territory.

OPPOSITE: Uluru or Ayers Rock is an Aboriginal sacred site and a world-famous landform in the heart of the Australian desert.

BELOW: Uluru at sunrise – one of the best times to view this spectacular site.

BOTTOM: The Devil's Marbles, or 'eggs of serpent dreaming' in Aboriginal mythology, are close to the Stuart Highway, between Darwin and Alice Springs.

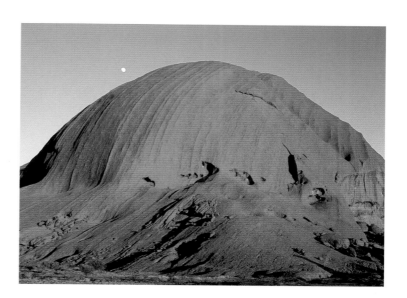

Hammersley Range rises to around 1,000 metres (3,000 feet).

The arid interior of Australia has many unique landscapes, the formation of which is not yet fully understood. In general terms there are three broad categories of desert: sandy deserts, such as the Great Sandy Desert of Western Australia and the Simpson Desert; the stony 'gibber' deserts of Queensland and South Australia; and clay plain deserts.

Sand dune systems cover around half the total desert area of Australia – a higher proportion than in any other desert region of the world. Simple longitudinal sand ridges are characteristic. Rising to less than 30 metres (100 feet) in height these simple ridges with single crests are lower and less complex than the dunes of the Sahara Desert. Areas of actively forming dunes occur in the Great Sandy and Simpson Deserts, but generally the dunes of Australia are fixed and support grasses and shrubs on their flanks.

The stony gibber deserts are made up of angular fragments of silcrete, broken down from ancient duricrusts. These rock fragments – known as gibbers or billy – litter vast expanses of the Australian drylands. Silcretes that have remained undisturbed since their formation are the source of precious opals in parts of South Australia.

Crescent-shaped clay dunes, known as lunettes, are a feature of the clay plain deserts. These are situated at the downwind end of ephemeral lakes and are relic landforms resulting from variations in climate which date back over 45,000 years. Lunettes are also found in the fascinating and relatively rarely visited Willandra Lakes region of New South Wales – a World Heritage site.

The earliest human remains in Australia, dating back 30,000 years, have been preserved in this semi-arid area of ancient lake beds and huge eroded clay dunes. Lunettes at Lake Tandou and Lake Menindee within the World Heritage site contain the fossils of extinct fauna, including the giant kangaroos *Protemnodon* and *Procoptodon*, and the marsupial lion *Thylacoleo*. The Willandra Lakes dried out around 15,000 years ago and provide virtually unmodified landscapes of great scientific importance.

Wetlands

Wetlands, which still exist in the Australian deserts, include the Coongie Lakes, situated in the Strzelecki Desert of northeast South Australia. Lake Coongie is a permanent water feature, whereas other lakes and waterholes are generally dry. When there are periods of flood, the Coongie Lakes support large numbers of

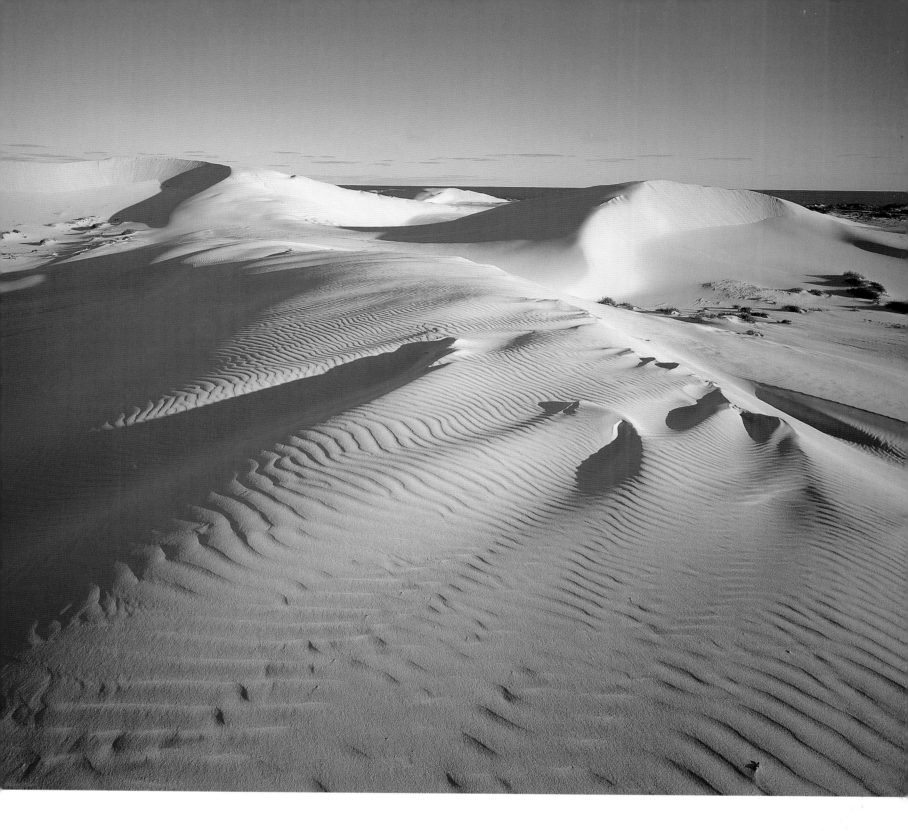

waterfowl. In times of major flooding, water may move south as far as Lake Eyre, the largest lake in Australia.

Lake Eyre is situated in the driest part of Australia where rainfall is around 100–150 millimetres (4–6 inches) per year. Lake Eyre has an area of 9,300 square kilometres (3,590 square miles) and lies about 12 metres (40 feet) below sea level. This lake, together with Lakes Frome, Callabonna, Blanche and Gregory, once formed a vast inland sea covering over 100,000 square kilometres (38,600 square miles). Major floods have filled Lake Eyre three times during the past hundred years.

OPPOSITE: Vegetation helps to stabilize the dune systems in the Petermann Ranges.

ABOVE: Sand dunes cover more than half the total desert area of Australia. These white dunes photographed in the evening light are in Western Australia.

Desert plants and animals

Most areas of the stony and clay plain deserts, as with the sand seas, support at least sparse vegetation of hardy plants. The greater part of the dry region of Australia is in fact relatively thickly vegetated. Reminiscent of the dry savannahs of Africa, tough species of spiny *Acacia* are characteristic of the so-called mulga vegetation which occurs between the dry

mallee *Eucalyptus* woodlands of moister areas and the bare stone plains and sand dunes of the desert proper.

Mulga shrublands

About one-third of Australia's arid zone is covered in mulga shrublands. The deep-rooted desert acacia trees and shrubs flower quickly following rain, unlike their

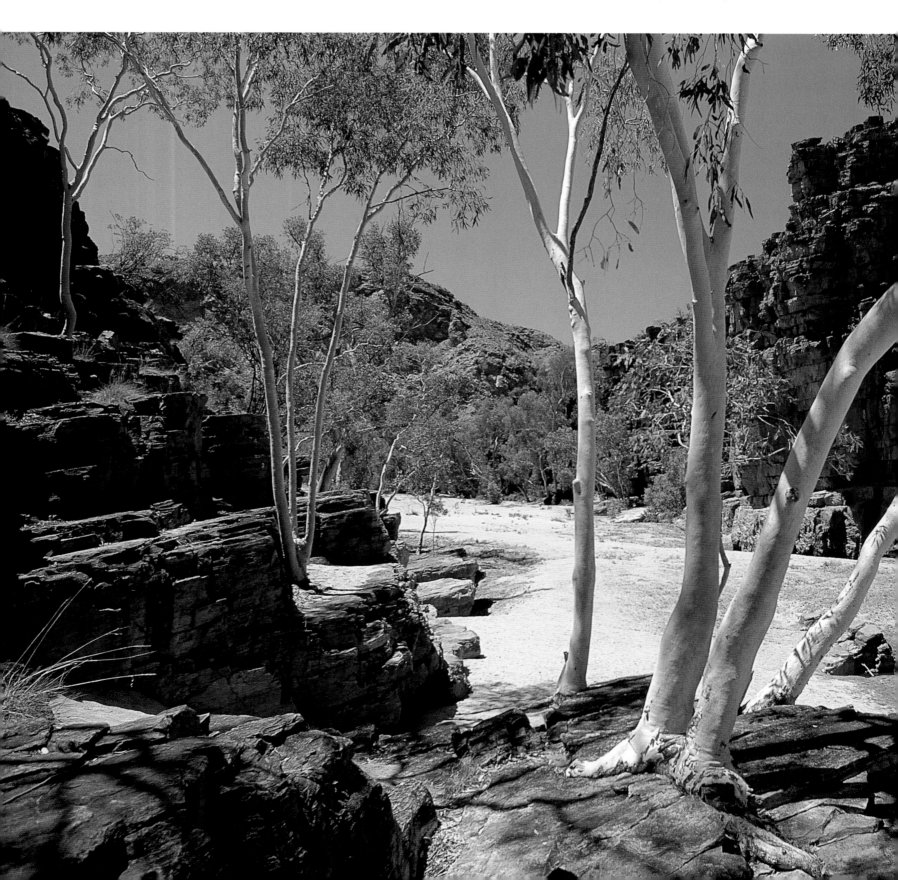

spring-flowering coastal relatives. Their tough seeds, which are generally dispersed by birds or ants, can remain in the sun-baked soils for years and then germinate when the rain eventually falls. Nearly 120 *Acacia* species are found in arid areas of Australia, most occurring in the mountain ranges or tablelands. Relatively few grow on the sand dunes and open plains,

LEFT: The ghost gum (*Eucalyptus papuana*) is an elegant, medium-sized tree that grows in open woodlands. It provides excellent firewood, and the leaves are used traditionally by Aborigines as a fish poison.

BELOW: Blue mallee (*Eucalyptus gamophylla*) is a species which grows in the sand plains and dunes of the Northern Territory, Queensland and Western Australia. Here it can be seen growing with *Acacia* species.

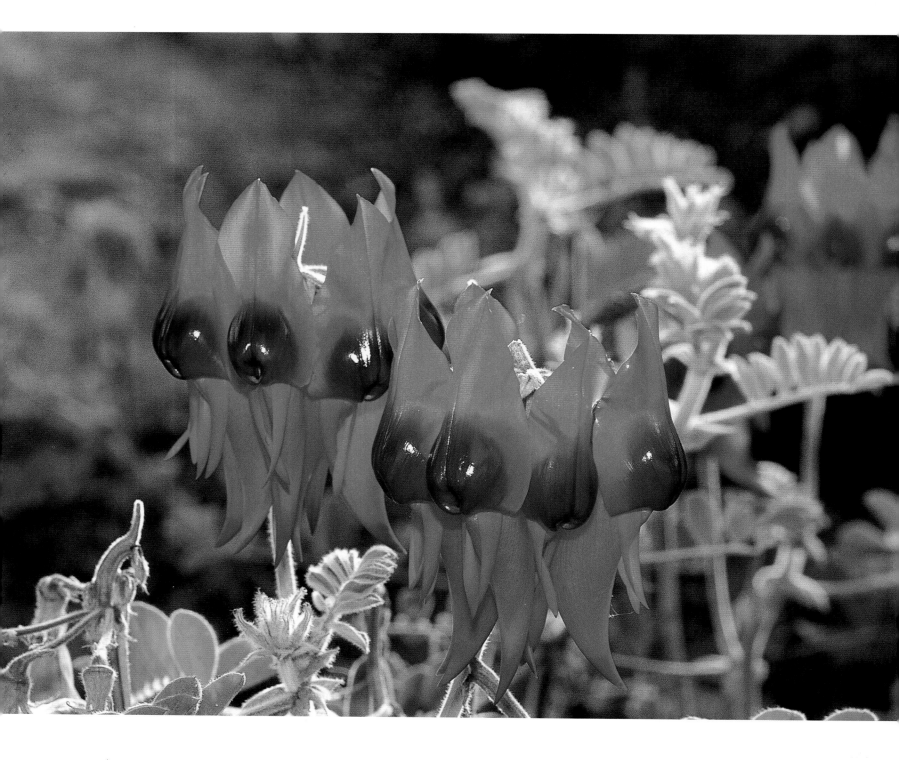

but one species that does is *Acacia aneura* (commonly known as mulga). The silvery-blue-green, narrow leaves (or phyllodes) of this tree are held vertically to reduce water loss through transpiration from the surface; the leaf pores or stomata are sunken to reduce transpiration further; abundant leaf hairs help to conserve water. The whole shape of the tree – like an inside-out umbrella – appears designed to catch water from the scanty rainfall and channel it down towards the roots.

The mulga country is particularly attractive when the ephemeral everlasting flowers are in bloom. A carpet of flowers of *Helipterum*, *Helichrysum* and *Cephalipterum* covers the hard red soils underneath the widely scattered acacias.

Ants, spiders and scorpions

The abundance and diversity of ants and termites living within the vegetation and the soils heavily influence the ecology of the mulga country. These creatures help in seed distribution, the breakdown of organic material and recycling of nutrients, and provide food for species higher up the desert food chain.

The three main genera of Australian ants are *Iridomyrmex*, *Campanotus* and *Melophorus*. The abundant iridescent *Iridomyrmex* ants are inquisitive and aggressive. Typical colonies, based on mounded nests covered with gravel or twigs, consist of one or more wingless, egg-laying queens, and winged male and female workers. When weather conditions are suitable, the winged ants disperse to form new

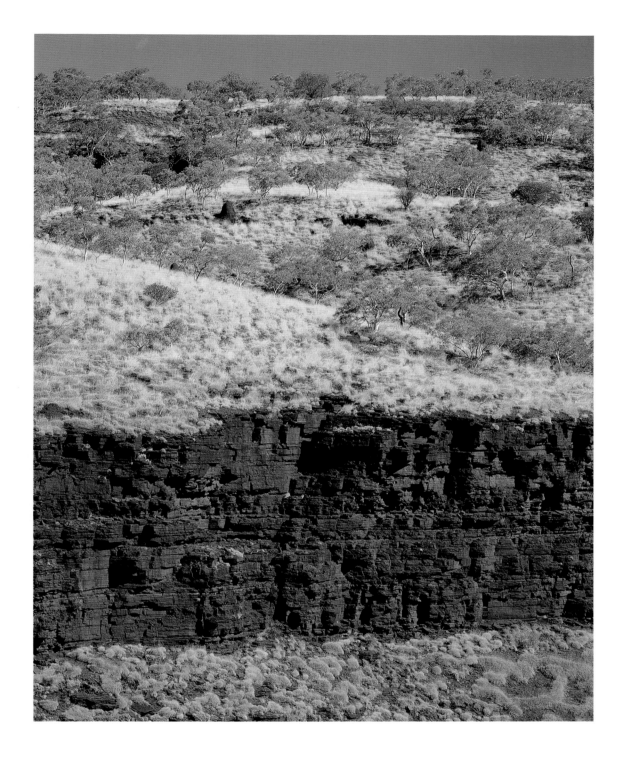

OPPOSITE: **OPPOSITE:** A dryland plant species of the Australian desert is Sturt's Desert Pea (*Clianthus formosus*), which has become well known as a garden plant around the world. A low-growing shrub with red flowers and grey foliage, this is one of the most distinctive plants of the Australian interior and has been adopted as the floral emblem for South Australia.

LEFT: The Hammersley Range National Park of Western Australia has various vegetation types and some of Australia's oldest exposed rock formations. Snappy gum (*Eucalyptus leucophloia*) trees grow among the spinifex.

colonies. The *Iridomyrmex* ants do not forage in the hottest parts of the day, and while they are inactive their ecological niche is filled by *Melophorus* ants. These ants can remain active when the desert ground is hotter than 65°C (149°F). Different species of *Melophorus* ants are specialized seed harvesters, termite predators and nectar feeders. *Campanotus* ants have devised various strategies to avoid predation by the dominant *Iridomyrmex* species. Some species forage at different times to the *Iridomyrmex* ants and others mimic the more aggressive genus – but even so the mimics steer clear of the aggressors wherever possible.

Many of the desert spiders found in Australia feed on termites and ants. Others, such as the barking

spider (*Selenocosmia stirlingi*), also eat beetles and small vertebrates. This mouse-sized spider supplements its diet by foraging, and is unusual in not waiting by the mouth of its burrow for prey to arrive. Typically spider burrows are located in the litter under mulga trees where there is an abundance of insect prey species.

The formidable scorpions are another group of insects that have adapted to life in the Australian deserts. The scorpions of one endemic genus, *Urodacus*, shelter by creating deep spiral burrows in the sand, so providing a relatively humid environment. Another scorpion, *Isometroides vescus*, preys on burrowing spiders and then makes use of the vacated spider burrows.

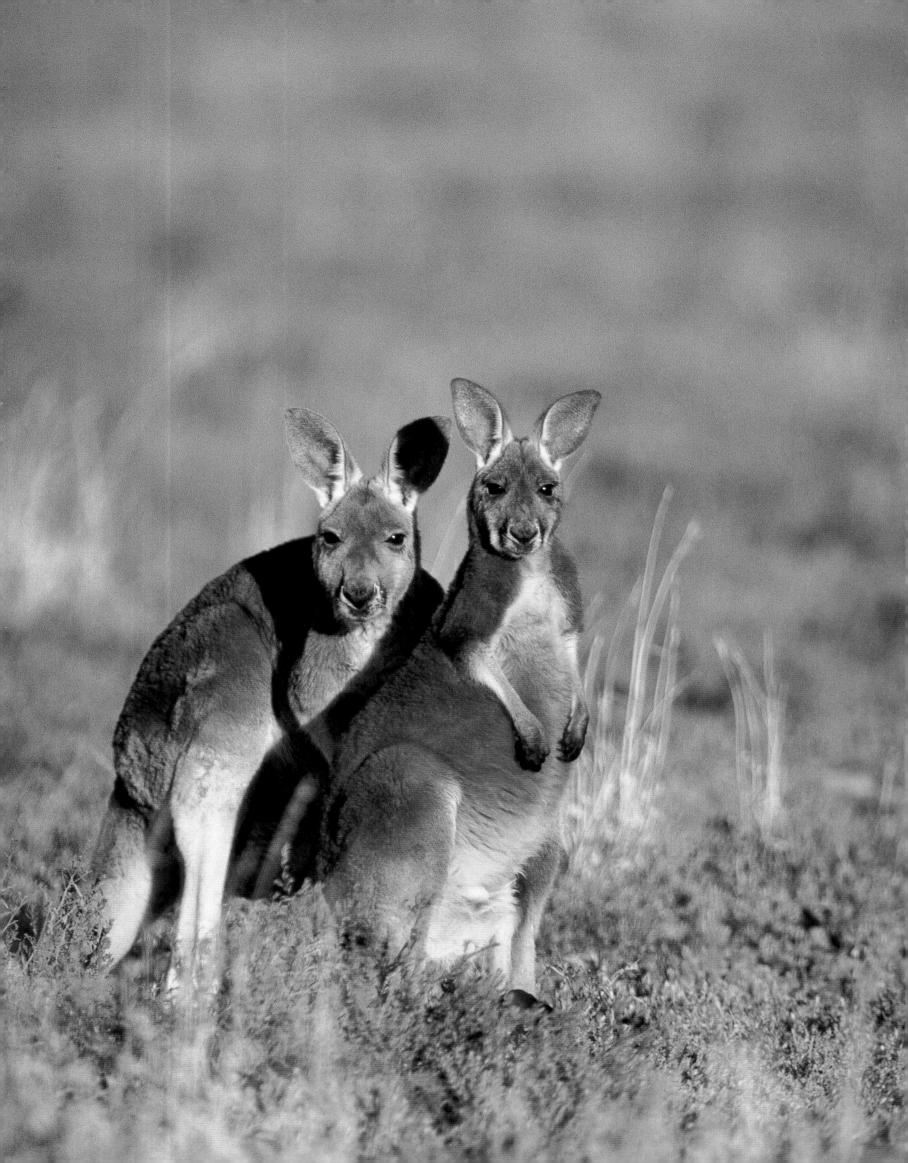

Spinifex grasses

Perhaps the most characteristic desert plants of Australia are the spiky, perennial spinifex grasses, which form hummocks of long, closely branched stems, supported by deep, spreading roots. The most drought-resistant species of these uniquely Australian grasses is *Triodia basedowii*, which grows in the Simpson, Victoria and Great Sandy Deserts, as well as the Channel Country of Queensland. The desert oak tree *Allocasuarina decaisnea* is one of the tree species associated with spinifex grasslands and has been a feature of inland Australia since the land was covered by rainforest. The spinifex hummock grasslands dominate large areas of infertile soils in the sandy desert and plains, providing grazing for wild animals – including termites, which in turn provide food for Australia's rich reptile fauna – but play no part in Australia's cattle industry. In total, spinifex grasslands cover around 22 per cent of the land surface of Australia.

Kangaroos and wallabies

The desert-adapted red kangaroo (*Macropus rufa*), such a characteristic mammal of the Australian drylands, has an extensive range and remains an abundant species. Since European settlement the provision of pasture and water for domestic livestock has led to an increase in the red kangaroo population. Reduction in numbers of their main natural predator, the dingo, has also enabled the red kangaroo to flourish. In common with some other kangaroos this species is now considered a pest, and an annual culling programme is carried out.

Competition for sparse resources is intense in the desert environment. During the daytime the red kangaroo finds whatever shelter it can and becomes more active at dusk, feeding on grass. Although it needs to drink, it can manage without water for long intervals. The red kangaroo and its relatives have all evolved from forest-dwelling ancestors that inhabited Australia in a wetter period 10–15 million years ago.

Other species of macropod (a collective name for kangaroos and wallabies) are much rarer in the wild. The rufous hare wallaby or mala (*Lagorchestes hirsutus*)

OPPOSITE: The red kangaroo, the largest of the marsupials, thrives in the deserts of Australia and numbers are now controlled. During the day, it avoids the heat in the shade of trees and bushes, and appears in groups at dusk.

BELOW: Cattle and other domestic livestock introduced by European settlers have dramatically changed the arid ecosystems of Australia.

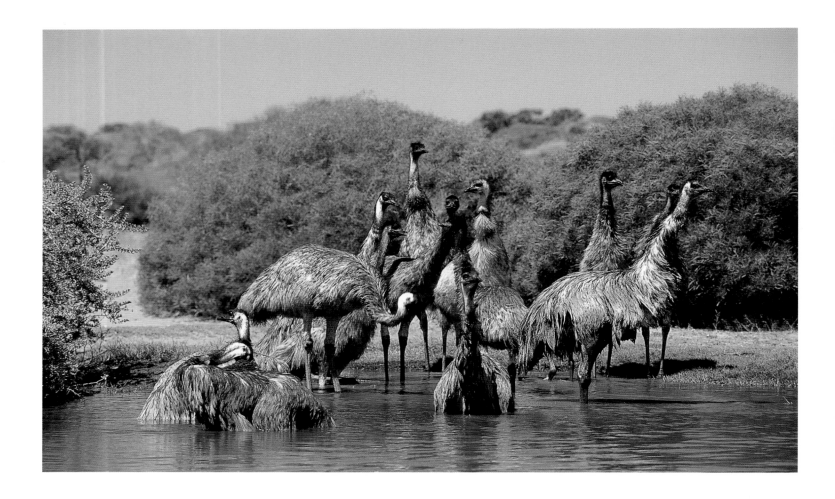

is now considered by the IUCN to be 'Vulnerable'. Once widespread throughout arid inland areas of Western and Central Australia, this sandy-coloured, shaggy-coated species is now confined to the Bernier and Dorre Islands in Shark Bay, Western Australia, where it lives in protected spinifex habitats. Until quite recently two small populations also survived in the Tanami Desert of the Northern Territory, but these were lost through fox predation and fire. Fortunately some individuals were taken into captivity and have been bred for reintroduction to the wild.

The decline in the rufous hare wallaby resulted from changes in traditional land management. Nomadic Aborigines caught this species as a source of food, and their traditional regular burning of small areas of desert vegetation stimulated new growth of plants, so providing increased food for the wallabies. When the Aborigines were forced to take up a settled existence the fire regime changed. More extensive wild fires removed great swathes of vegetation, destroying the habitat of the rufous hare wallaby and other species.

Hopping mice

The Australian hopping mice (*Notomys* species) are well adapted for living in sand dunes and other arid areas. They are nocturnal, sheltering in burrows in the heat of the day and feeding on seeds, berries and leaves during the night. They are able to survive without any water.

ABOVE: Emus have benefited from the provision of permanent water for livestock and settlements. Found throughout Australia, they move into arid areas when rainfall encourages the growth of vegetation.

RIGHT: Fire-singed bark of a snappy gum (*Eucalyptus leucophloia*) in the Boodjamulla National Park – a protected area in the remote northwest highlands of Queensland.

Some species are widespread, but others are much more rare and threatened with extinction.

The dusky hopping mouse (*Notomys fuscus*) is now restricted to dune systems in southeastern Queensland and adjacent areas of South Australia. It used to be hunted for food by the Aborigines, but its numbers have declined because of changes in land management and the impacts of introduced species. Now the dusky hopping mouse is listed as 'Vulnerable' by the IUCN.

Other animals in decline

Although the arid interior of Australia is sparsely populated, it is in this part of the country that animal extinctions have been the highest. The effects of grazing by introduced livestock, the loss of Aboriginal land management practices, and the spread of uncontrolled wildfires, have contributed to the extinction of one-third of all known Australian desert mammals. The desert rat kangaroo (*Caloprymnus*

campestris) is one example of a small mammal that is now extinct. Other species which have been lost include the desert bandicoot (*Perameles eremiana*), central rock-rat (*Zyzomys pedunculatus*), and two species of hopping mice.

Birds, reptiles and frogs

The birds of the Australian drylands include various species of colourful parrot, parakeet and budgerigar, which have adapted to the arid conditions. One example is the scarlet-chested parrot or splendid parakeet (*Neophema splendida*). This brightly coloured bird lives in small groups or sometimes flocks and is nomadic, never staying in one place for long. The birds travel large distances in search of sufficient food, mainly seeds, and are only able to breed after rainfall. When the sporadic rains do occur, the female lays three to six eggs in a nest, often in a tree or sometimes a fallen log, and incubates her young for nearly three weeks.

The splendid parakeet is naturally rare and is not often seen in the wild because it travels such large distances through the arid saltbush vegetation and plains of Southern Australia. Capture of this lovely bird from the wild for aviaries may have depleted some populations, but fortunately birds bred in captivity can now supply the cage-bird trade.

The very rare night parrot (*Geopsittacus occidentalis*) is a mysterious bird of the Australian deserts. During the daytime this shy species hides in the spinifex grass or low shrubs, and emerges at dusk. Records suggest that numbers have dropped markedly over the past 130 years or so, but the reasons for its decline are unknown.

The Australian bustard (*Ardeotis australis*), sometimes known as the plains or wild turkey, remains common in parts of Central and Northern Australia. It is, however, threatened as a result of predation by foxes and cats, and loss of vegetation as a result of livestock grazing and introduced rabbits.

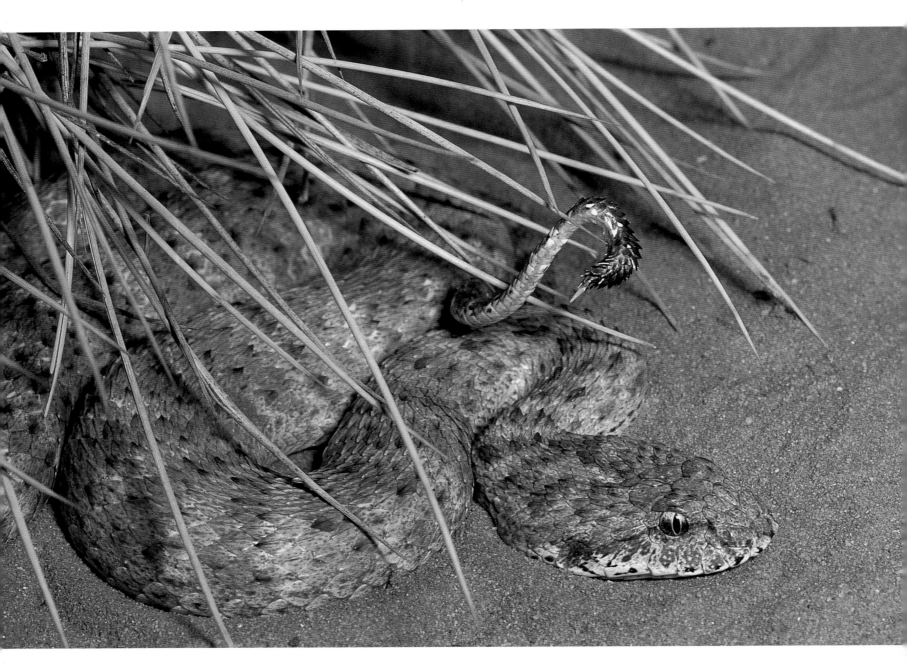

One of the world's largest birds, the emu (*Dromaius novaehollandiae*) occurs over much of Australia. Most commonly found in dry forest and wooded savannah, emus move into more arid areas when rainfall promotes new growth of vegetation. They seek the shelter of thicker vegetation when nesting. Populations have probably increased in arid areas through the provision of permanent water in dams and troughs. The emu lays its eggs on the ground on a roughly made nest of leaves, grass, bark and sticks. The male broods and escorts the family for up to 18 months.

In contrast to the emu, one of the smallest birds of Australian drylands is the rufous-crowned emu-wren (*Stipiturus ruficeps*), which lives and nests among the spinifex clumps. This species is widely distributed in the arid interior of Australia, but the birds are rarely spotted.

The reptile fauna of Australia's deserts is remarkably rich and varied. In total Australia has over 750 reptile species, the second highest number for any country in the world.

The mountain devil or thorny devil (*Moloch horridus*) is a slow-moving lizard that feeds entirely on ants. This species, in common with some other desert-living reptiles, is able to absorb moisture through its skin from night-time dew.

The water-holding frog (*Cyclorana platycephalus*) is another extraordinary species. It has developed an ingenious strategy to survive arid conditions. Between rains, this frog burrows underground, holding a store of water in its body. As the mud dries out, the frog survives, encased in hardened clay.

OPPOSITE: The desert death adder (*Acanthphis pyrrhus*) is one of the deadliest snakes of Central Australia. It uses its tail to lure prey.

BELOW: The extraordinary-looking thorny devil is one of the 72 reptiles found in Uluru National Park. It feeds on ants, which in turn graze on the spinifex grasses.

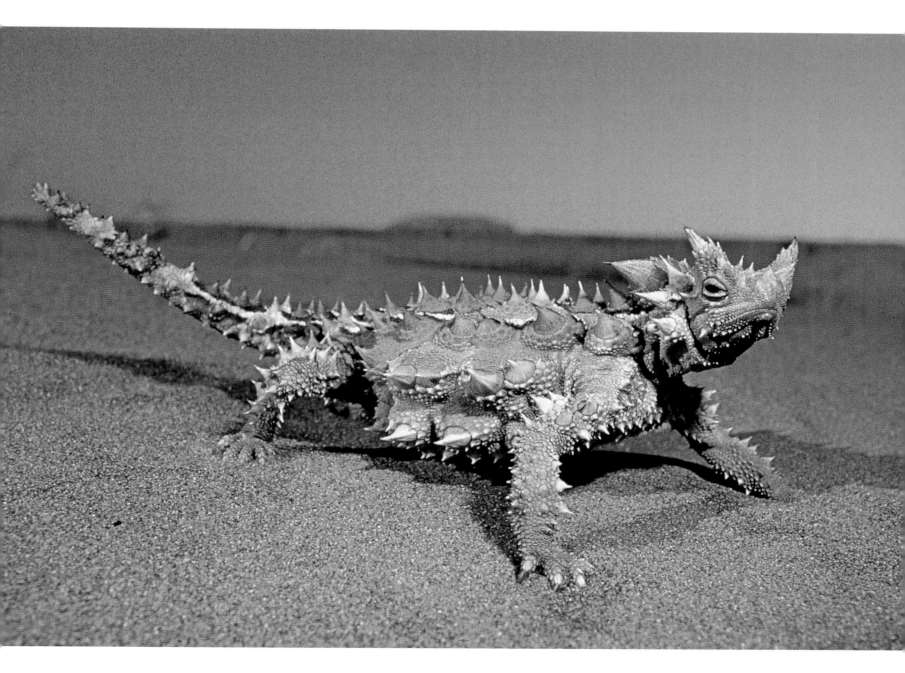

Traditional desert livelihoods

To the European settlers, parts of the Australian desert remained impenetrable well into the last century. The first successful crossing of the Simpson Desert by a settler was undertaken by E. A. Colson in 1936, travelling with an Aboriginal companion, P. Ains, and five camels. The first motorized crossing was not made until 1962.

The Australian Aborigines, on the other hand, arrived in the arid interior of Australia at least 22,000 years ago, bringing with them fire. Fire has been used traditionally by Aboriginal communities for warmth, cooking, to aid hunting, to regenerate staple food plants – many of which are annual 'fire weeds', benefiting from burning – to clear tracks, to produce smoke signals and to dispel ancient spirits. Aborigines continue to burn their land today, and the seemingly random process is in reality based on considerable knowledge of the environment and on traditional skills.

The desert Aborigines have an intimate knowledge of the land on which they are dependent and have developed extraordinary survival strategies. The early European settlers had no comprehension of the rich social and spiritual life of the original people of Australia and treated them with callous disregard – in a similar way to the Bushmen of southern Africa. In Aboriginal life, the acquisition of material wealth is generally held in lower regard than having a rich religious and social life. Many of the religious practices are related to the need to secure plants and animals for food.

A traditional diet

Female Aborigines have traditionally been involved in the collection of wild plants and thus exerted considerable power through their role as providers of daily nutritional needs. Over 140 different wild plant species continue to provide food in the arid interior of Australia, in the form of tubers, fruits and seeds.

Yandying, undertaken by women, is an important process in food preparation. In this process a long wooden dish – a coolamon – is used to separate edible food parts from general plant material, which is returned to the soil.

Acacia seeds continue to be eaten, and with grass seeds form an important component of the Aboriginal diet. Fresh acacia pods are collected from the trees and roasted to separate the seed and destroy the bitter juices that deter insects and other animals from eating the unripe seeds. More generally, dry pods are collected and the seeds released by yandying.

The Australian Aborigines also used insects as food, medicine, and as part of their cultural beliefs. A desert species that was considered a delicacy was the witchety grub, the larva of *Xyleutes leucomochla*, which when cooked is reputed to taste like almonds. Witchety grubs are found in the roots of Acacia bushes. Women and children generally collected the grubs by digging up the roots. Honeypot ants, *Melophorus bagoti* and *Campanoyus* species were also highly valued food that provided a source of sugar. Worker ants of these species gather honeydew from scale insects and psyllids, and feed it to other workers, whose sole task becomes the storage of nectar in their greatly enlarged abdomens. To obtain the ants the vertical shaft of the nest is located and the insects dug out from horizontal chambers several metres below the surface.

Bound to the land

Plants, insects and other forms of wildlife feature strongly in the stories and art forms of the Aborigines. The traditional stories bind the people socially, spiritually and historically to the land. At the time of European settlement, at the end of the 18th century, there were around 300,000 Australian Aborigines speaking 500 different languages. The Aboriginal population now numbers about 160,000, with many living in the northern parts of Australia. About two-thirds of Aborigines now live in cities and have adopted a suburban way of life.

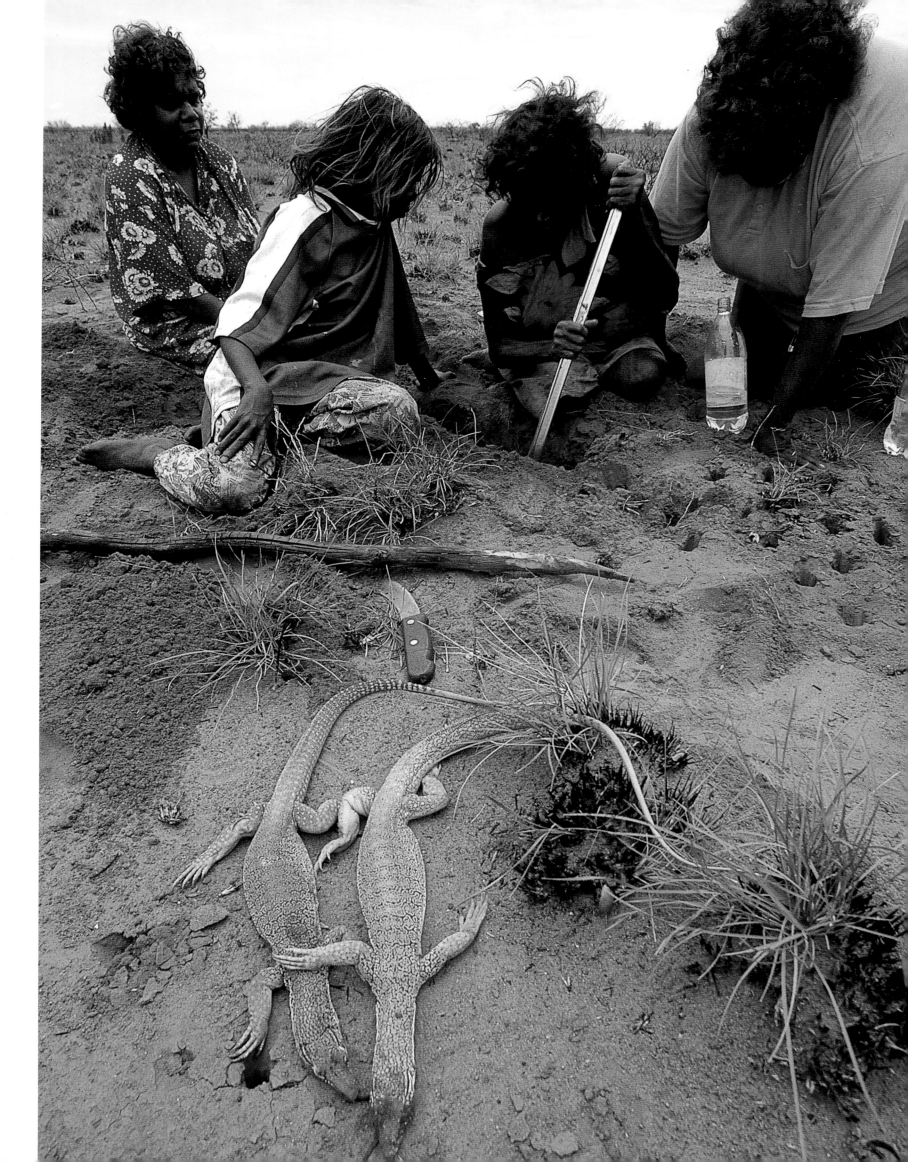

Conservation

The Aborigines generally lived in a sustainable way, which respected the wild plants and animals of the Australian deserts and ensured their long-term survival. Sacred sites have provided traditional sanctuaries for wildlife. Since European settlement, about half the arid lands have been significantly degraded, largely as a consequence of grazing pressures and extensive burning. The unique biodiversity of Australia's deserts, as with other drylands of the world, needs to be actively protected.

Nature conservation in Australia is now generally organized at state level. Large areas of desert are designated as national parks or other forms of protected area within the country. The Uluru National Park is one of two protected areas designated under the federal National Parks and Wildlife Conservation Act, as it falls within the Northern Territory, which does not have the same powers as the Australian states. Freehold title to the park land is held by an Aboriginal land trust, with land leased back to the federal government. In 1994 the park was nominated as a World Heritage site. About 150 Pitjantjatjara and Yankuntjatjara Aboriginal people live in a settlement close to Uluru Rock and are involved in the management of the park. A fire-control programme based on traditional burning practices has been introduced, and access is restricted to sacred sites within the national park.

The Simpson Desert

The Simpson Desert, which lies across the corners of three states – South Australia, Queensland and the Northern Territory – enjoys different degrees of protection according to individual state legislation. The Simpson Desert National Park covers an area of 10,000 square kilometres (3,860 square miles) in the state of Queensland. Adjacent to this in South Australia there are three protected areas: Simpson Desert Conservation Park, Simpson Desert Regional Reserve and Witjira National Park. The idea of a unified desert protected area across the three states, which was first suggested in 1966, has not yet come to fruition.

Species in the protected areas of the Simpson Desert include small marsupials, such as the dunnart and mulgara, and the dingo. More than 150 species of birds inhabit the desert, including the Eyrean grasswren (*Amytornis goyderi*), once thought to be extinct. First discovered in 1874, this bird was not recorded again until 1931. Small populations have subsequently been found and the species occurs within the Simpson Desert National Park. Reptiles include the military dragon (*Ctemophorus isolopus*), the perentie (*Varanus giganteus*), goannas, western brown snakes, woma pythons and banded skinks, which are sometimes known as sand swimmers.

National Parks have now given protection to a significant proportion of Australia's deserts. In addition there is now Commonwealth and state legislation to protect threatened populations or ecosystems.

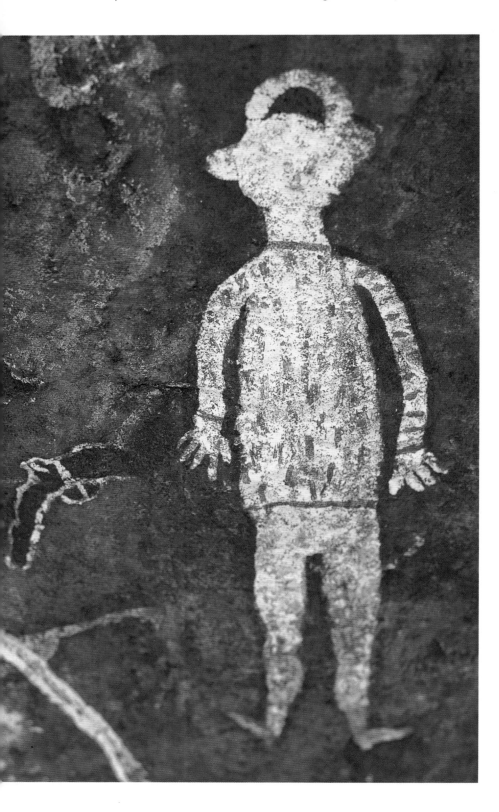

PAGE 110: The water-holding frog (*Cyclorana platycephalus*) is adapted for life in the desert. Between the sparse rains it lives in an underground burrow.

PAGE 111: Cooked goanna is a popular traditional Aboriginal meal. Aborigines have a detailed knowledge of the plants and animals of the Australian deserts and a strong spiritual attachment to the land.

FAR LEFT: Contemporary Aboriginal art now enjoys critical acclaim. The ancient traditions of rock art can be seen, for example, in Uluru National Park, as with this detail of a man at Lightning Brothers' Rock.

RIGHT: The perentie (*Varanus giganteus*) is Australia's largest species of lizard. It is a traditional source of food for Aborigines.

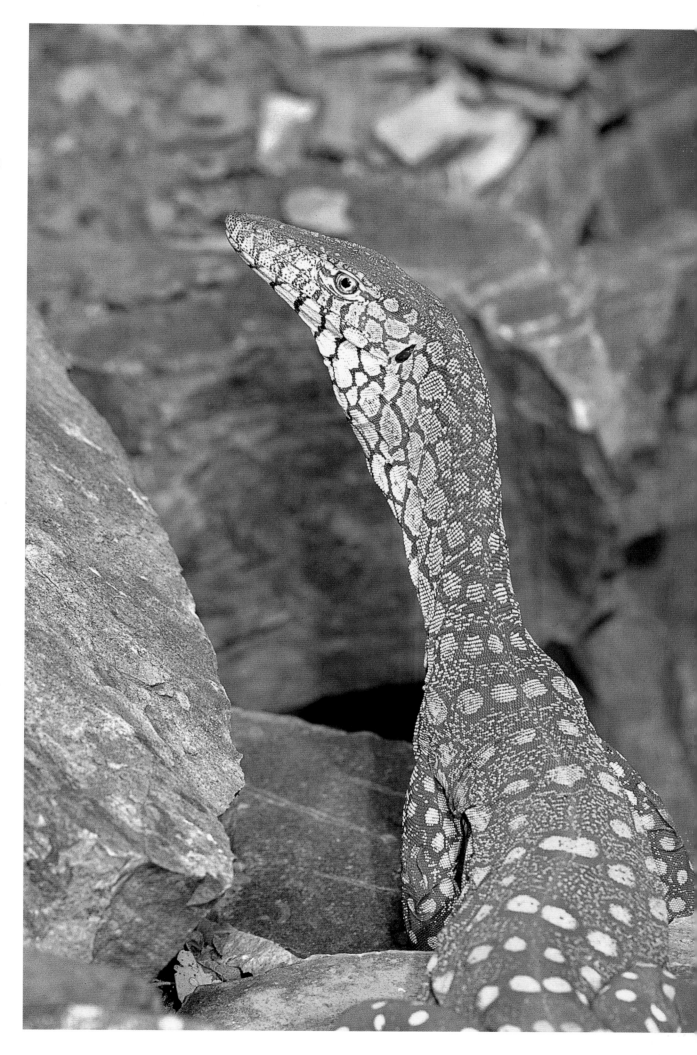

The Americas

From the Sonora to the drylands of Brazil

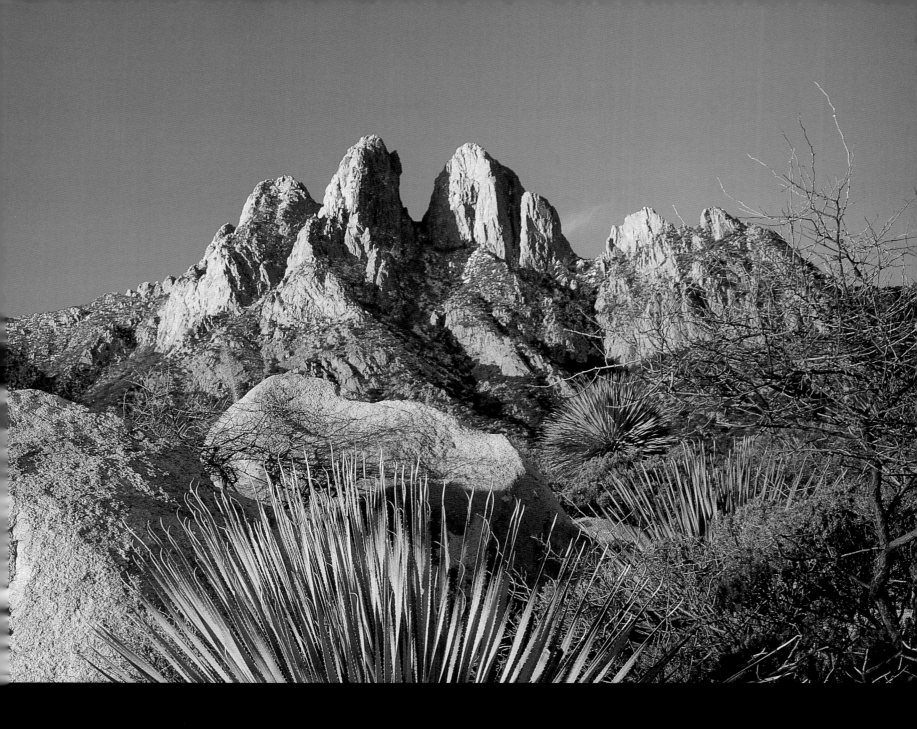

THE DRYLANDS OF THE AMERICAS RANGE FROM THE LARGE AREA OF DESERT

AND SEMI-DESERT IN THE SOUTHWEST OF THE USA AND MEXICO, A 3,500-

KILOMETRE/2,174-MILE DESERT STRIP STRETCHING ALONG THE COAST OF

SOUTHERN PERU AND CHILE, THE ARID LANDS OF NORTHEAST BRAZIL, AND

THE COOL DRYLANDS OF PATAGONIA TOWARDS THE SOUTHERN TIP OF SOUTH

AMERICA. EACH HAS UNIQUE FEATURES AND EXTREMES, WITH FASCINATING

STORIES OF SURVIVAL BY PLANTS, ANIMALS AND PEOPLE. THE DESERTS OF THE

USA INCLUDE THE GREAT BASIN DESERT, THE SONORA DESERT, THE MOJAVE

DESERT AND THE CHIHUAHUA DESERT. THE GREAT BASIN ARID REGION COVERS

MOST OF NEVADA AND UTAH, AND SMALLER PARTS OF ADJACENT STATES.

Arizona and California

California has an extraordinary diversity of ecosystems, and is considered one of the world's biodiversity hotspots. Deserts cover approximately one-quarter of the state, including the western fringe of the Great Basin and much of the Sonora Desert, which extends from southern California through southwest Arizona and into the northwest portion of Mexico and the Mexican state of Baja California. The Californian portion of the Sonora Desert is often known as the Colorado Desert. Further north in California is the Mojave Desert, which includes Death Valley, the lowest place in the USA. Different combinations of climate, topography, geology and soil types have given rise to rich and specialized vegetation in each of California's desert areas, and in total about 2,000 native plants occur in the desert ecosystems.

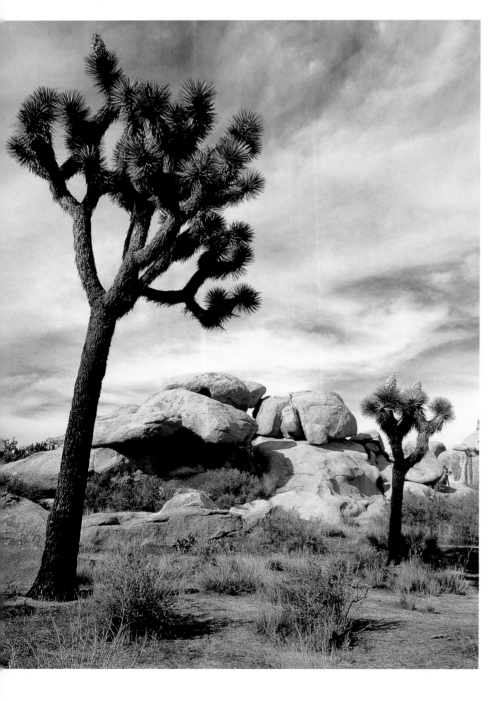

The Mojave Desert

The Mojave is a hot desert, dominated by extensive stands of the creosote bush (*Larrea divaricata*), a plant known as greasewood by the Papago Indians. The resins contained within the leaves of this common desert plant limit water loss from the leaf surfaces, help to prevent overheating of the internal leaf cells, and deter animals from nibbling the plant. The creosote bush is a very important medicinal plant for the Papago and has been used to cure a wide variety of ailments. The conspicuous Joshua tree (*Yucca brevifolia*), the tallest species of Yucca, is a distinctive plant adapted to the arid conditions of the Mojave Desert.

Death Valley

Death Valley is a deep trough running through the mountain ranges of California. Formerly the valley contained a deep lake, which became infilled with sediment eroded over the millennia from surrounding desert ranges. In 1994 the Death Valley National Park was created, protecting over 1.4 million hectares (3.4 million acres) of the northern Mojave Desert. Landscapes include dune systems, mountains and valleys. Despite the arid, inhospitable look of the terrain, Death Valley is surprisingly rich in plant life with over 900 flowering plants and ferns recorded, including 19 species, which occur nowhere else in the world.

PAGES 114–115: The Organ Mountains, New Mexico.

LEFT: The Joshua tree (*Yucca brevifolia*), is the largest of the Yuccas. It grows only in the Mojave Desert and can be seen in abundance at the Joshua Tree National Park, California, and Joshua Forest Parkway in western Arizona. In total there are about 35 different species of *Yucca* growing in the US, Mexico, Guatemala and Cuba. The fibrous leaves have many uses for rural people.

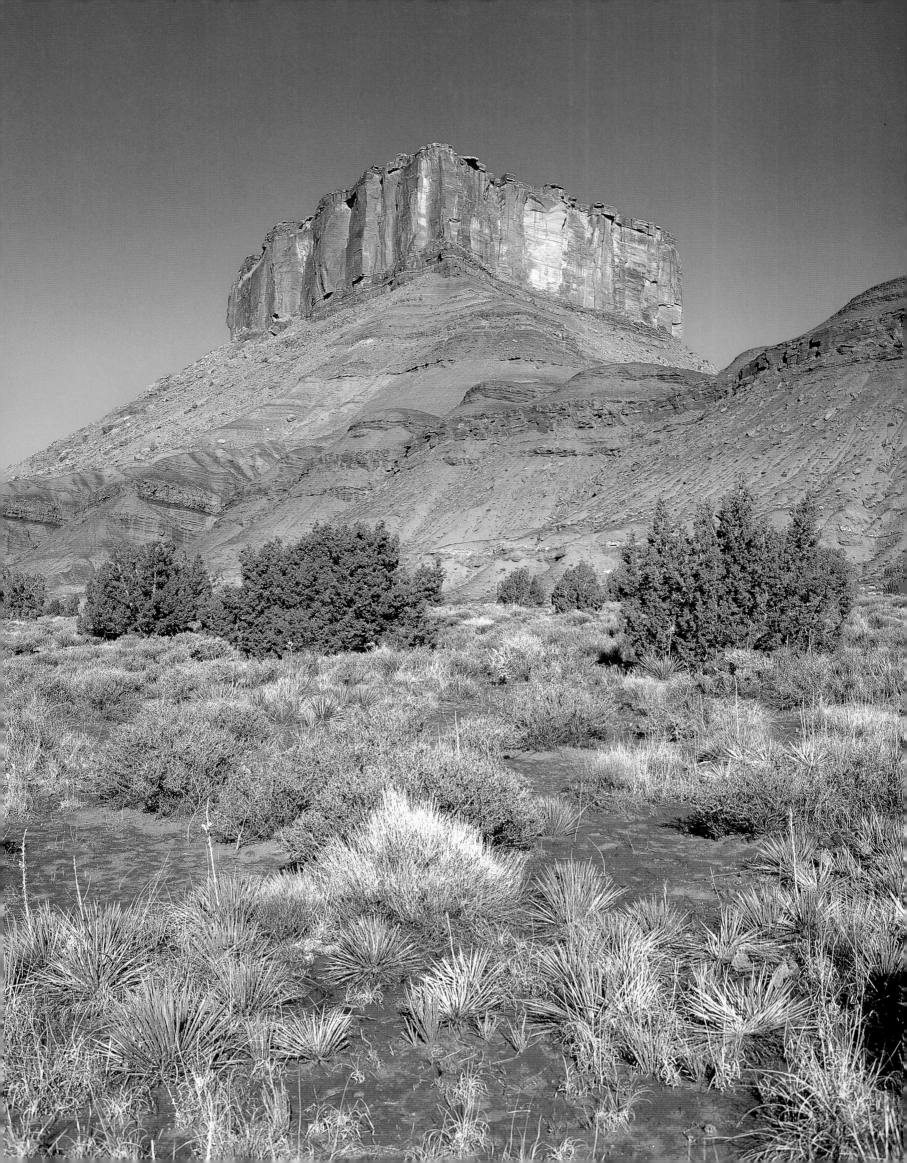

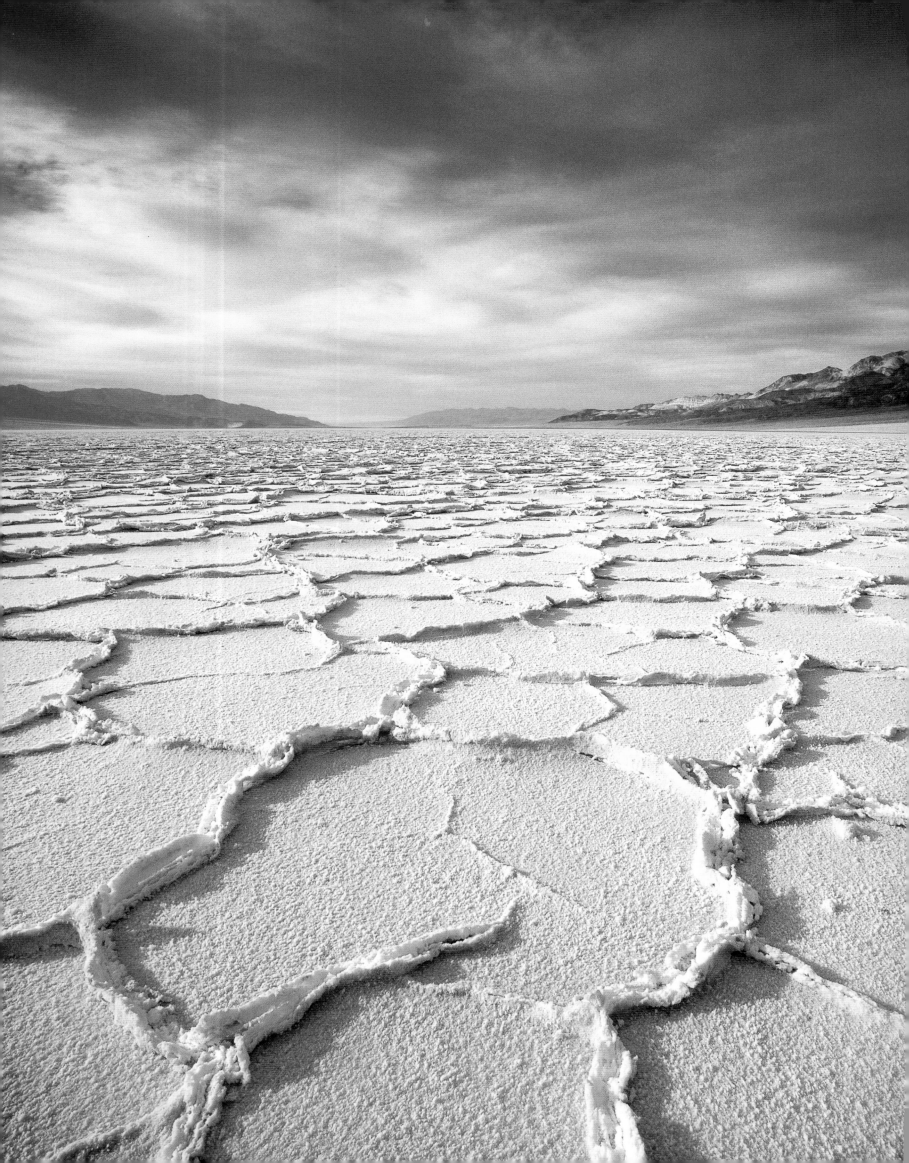

The Sonora Desert and endemic cacti

The Sonora Desert has more trees than the other deserts of North America and is characterized by large cacti and succulents. The saguaro cactus (*Carnegia gigantea*) is the classic cactus – a hero among plants – with its distinctive branched candelabra form silhouetted against the desert skyline. It is found nowhere other than the Sonora Desert, and perhaps the best place to see this flagship species is at the Saguaro National Monument in Arizona. At night the saguaro is pollinated by bats and probably moths, and during the day by birds (including the white-winged dove), bees and other insects. The cacti fruits are eaten by many birds; the sparrow-sized elf owl (*Micrathene whitneyi*) nests in abandoned woodpecker holes in the trunks.

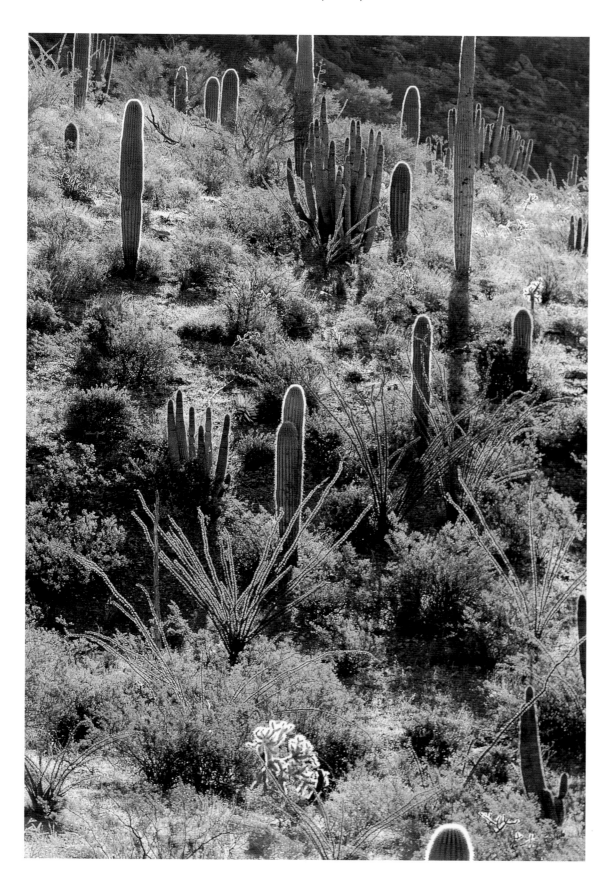

PAGE 117: Monument Valley, along the Arizona/Utah border, has stunning landscapes reminiscent of cowboy films. Isolated red mesa and butte rock formations arise from the sandy desert.

OPPOSITE: The Badwater salt flats in Death Valley National Park have the lowest altitude in the Western Hemisphere and some of the hottest recorded temperatures on Earth.

LEFT: Typical vegetation of the Sonoran Desert. The organ pipe cactus (*Stenocereus thurberi*) grows with a variety of other barrel and cholla cacti and the mesquite shrub. Animals which make their home in this vegetation include the coyote, black-tailed jack rabbit and a variety of small rodents including the Arizona cactus mouse.

The saguaro is an important plant for native people. The fruit is used to make conserves and drinks, and the seeds, which are rich in fats, are also eaten. The ribs of the woody carcass of the plant are used to make fences, shelters and furniture.

Another large cactus of the Sonora Desert is the organ pipe cactus (*Stenocereus thurberi*) which, like the saguaro, has a protected area – the Organ Pipe Cactus National Monument – dedicated to it. The fruit, known as 'pitahaya', is another very popular form of food for native people. The monument, established in 1937, covers over 1,300 square kilometres (500 square miles)

on the border of the USA and Mexico. The area protects a wilderness of stark mountains, rocky canyons and sweeping plains. Mammals found within the protected area include the bighorn sheep (*Ovis canadensis*), javelina (*Tayassu tajacu*), coyote (*Canis latrans*), ringtail (*Bassariscus astutus*) and bobcat (*Felis rufus*). The bird list includes 35 resident species, with cactus wrens (*Campylorhynchus brunneicapillus*), roadrunners (*Geococcyx californianus*) and curved bill thrashers (*Toxostoma curvirostre*), together with over 260 migratory visitors. The National Monument also has evidence of prehistoric cultures dating back 12,000 years.

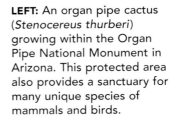

LEFT: An organ pipe cactus (*Stenocereus thurberi*) growing within the Organ Pipe National Monument in Arizona. This protected area also provides a sanctuary for many unique species of mammals and birds.

BELOW: The tiny elf owl (*Micrathene whitneyi*) is a common nocturnal desert species. Typically, it roosts by day in holes in the saguaro.

OPPOSITE: Desert vegetation with a diversity of cacti in the Ajo Mountains of Arizona.

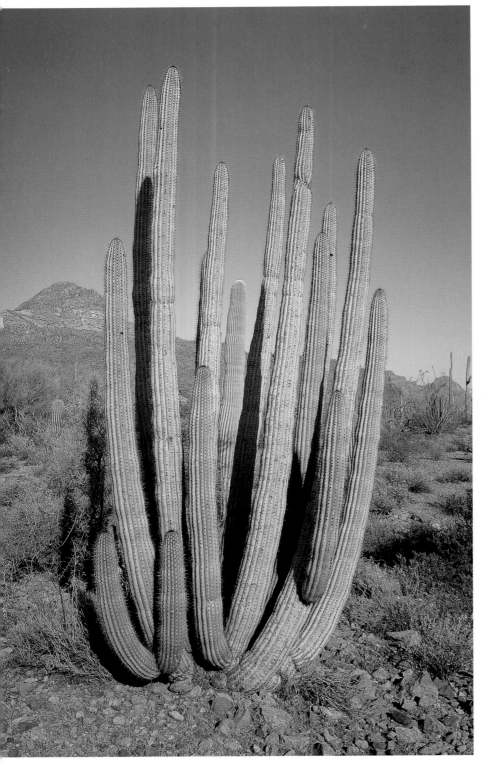

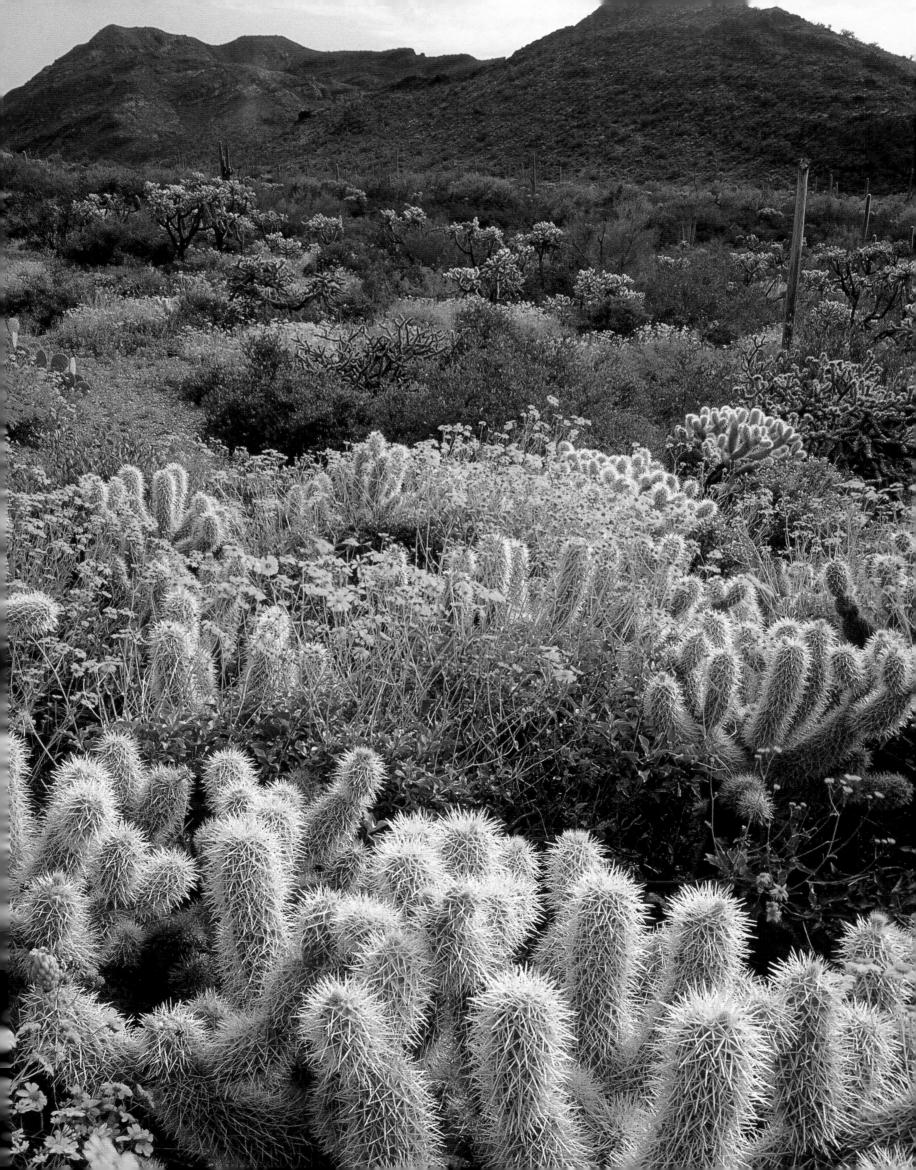

Desert animals of Arizona and California

Desert mammals of California and Arizona include the javelina or collared peccary (*Tayassu tajacu*), that occupies a variety of habitats in the southwestern USA and Mexico), the coyote, and the bighorn sheep (*Ovis canadensis*). Coyotes live throughout the USA and Canada and their range extends south to Costa Rica. They are opportunistic and have adapted to a wide range of habitats, from the Arctic tundra right through to the outskirts of major cities such as Los Angeles. While the ranges of most predators are shrinking, as a species the coyote is expanding its territory. The bighorn sheep has been less successful and is now extinct over a large part of its range. Until the mid 19th century it occupied a large area from southwest Canada to northern Mexico. Hunting, disease and competition with domestic livestock led to its decline.

Reptiles include the rattlesnake (genus *Crotalus*), the only venomous snake native to California. Although few people are bitten by rattlesnakes, the bite can be fatal. There are 16 species of *Crotalus*, all identified by the jointed rattles on the tail. The Pacific rattlesnake is found in a range of habitats in California, from sea level

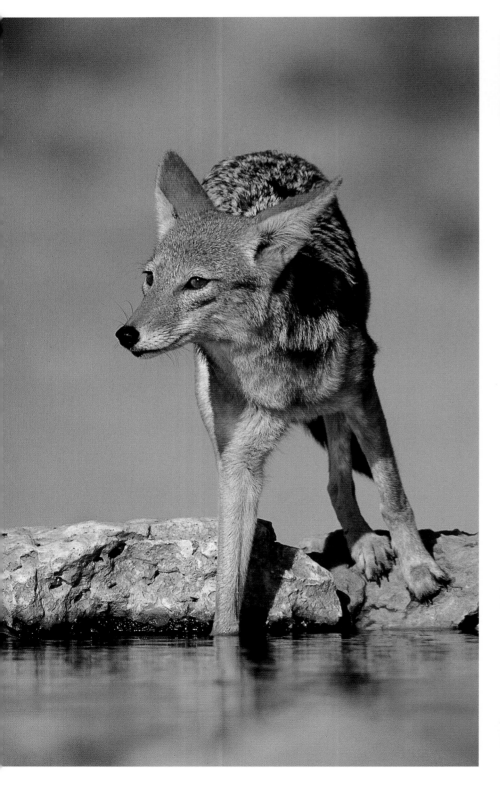

by the Pacific Ocean, the inland prairies and desert areas, to the mountains at elevations of more than 3,000 metres (10,000 feet). Other species include the Great Basin rattlesnake, which can be found, for example, in Death Valley; the Mojave rattlesnake and the sidewinder or horned rattlesnake (*C. cerastes*), both of which live in the Mojave Desert. *Crotalus cerastes* has a similar way of moving to the sidewinder snakes of the African deserts, minimizing body contact with the hot sands. This species is characterized by horn-like scales which can fold down over the snake's eyes when it burrows underground.

OPPOSITE: The coyote is at home in the North American deserts and in many other habitat types.

BELOW: The roadrunner, or ground cuckoo (*Geococcyx californianus*), is found in thorny scrub, sparse grasslands, and deserts of the southwestern USA and Mexico. The roadrunner can run at speeds of up to 24 kilometres (15 miles) per hour. It rarely flies and does not migrate. When in danger, it runs or crouches to hide.

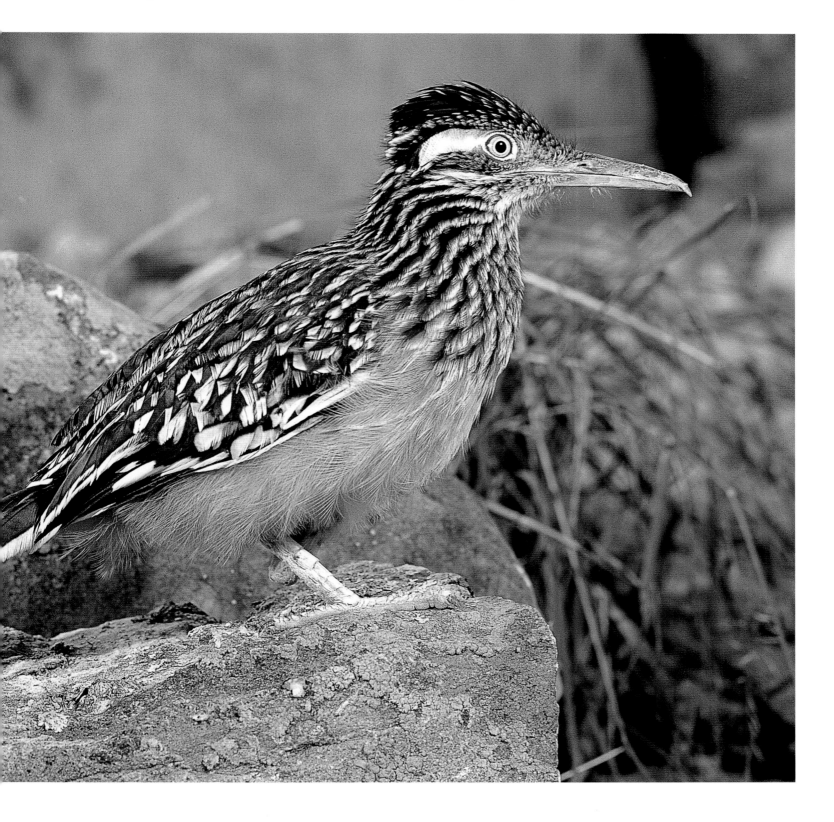

Rattlesnakes eat lizards and small rodents such as ground squirrels, rabbits, rats and mice. When the hollow fangs of the snake penetrate the flesh of the prey, venom is injected as if through twin hypodermic needles. Most small prey is immediately stunned. If a larger animal runs some distance before it dies, it is followed by the snake and swallowed whole.

The gila monster (*Heloderma suspectum*) is a venomous species of lizard found in the Mojave, Sonora and Chihuahua Deserts of southwestern Utah, southern Nevada, California, western Arizona and southwestern New Mexico into Mexico. Two subspecies occur in desert and semi-arid areas where they are found under rocks, in burrows of other animals and in self-dug holes. During warm weather the gila monster feeds at night on small mammals, birds and eggs. Fat stored in the tail and abdomen during this period is utilized during the winter.

The desert tortoise (*Gopherus agassizii*) is now a threatened species, confined to the Mojave and Sonora deserts. Within the fragile desert ecosystem, tortoise populations continue to decline. Losses have been caused by vandalism, predation by ravens, disease, collection for pets and habitat degradation. The habitat of the tortoise has been lost or damaged by mining and industrial operations, livestock grazing, development for agriculture, roadworks, and off-road vehicle use. Tortoise populations, with their low reproductive potential, are ill-equipped to cope with these challenges.

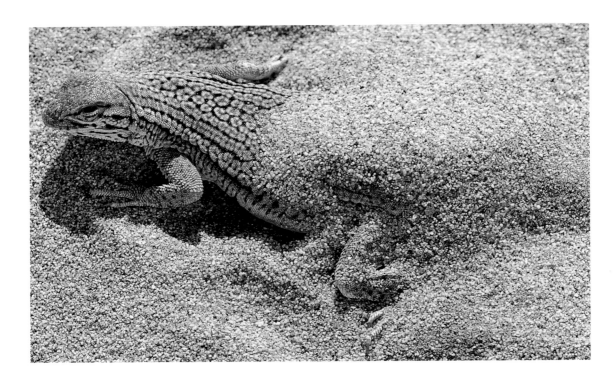

TOP LEFT: The fringe-toed lizard (*Uma notata*) is one of the reptiles that makes its home in the Mojave Desert.

BOTTOM LEFT: The gila monster (*Heloderma suspectum*) is a venomous species found in the deserts of the USA and Mexico.

OPPOSITE: Harris's hawk (*Parabuteo unicinctus*) attacking a rattlesnake. This common bird of arid areas usually preys on mice, lizards and small birds.

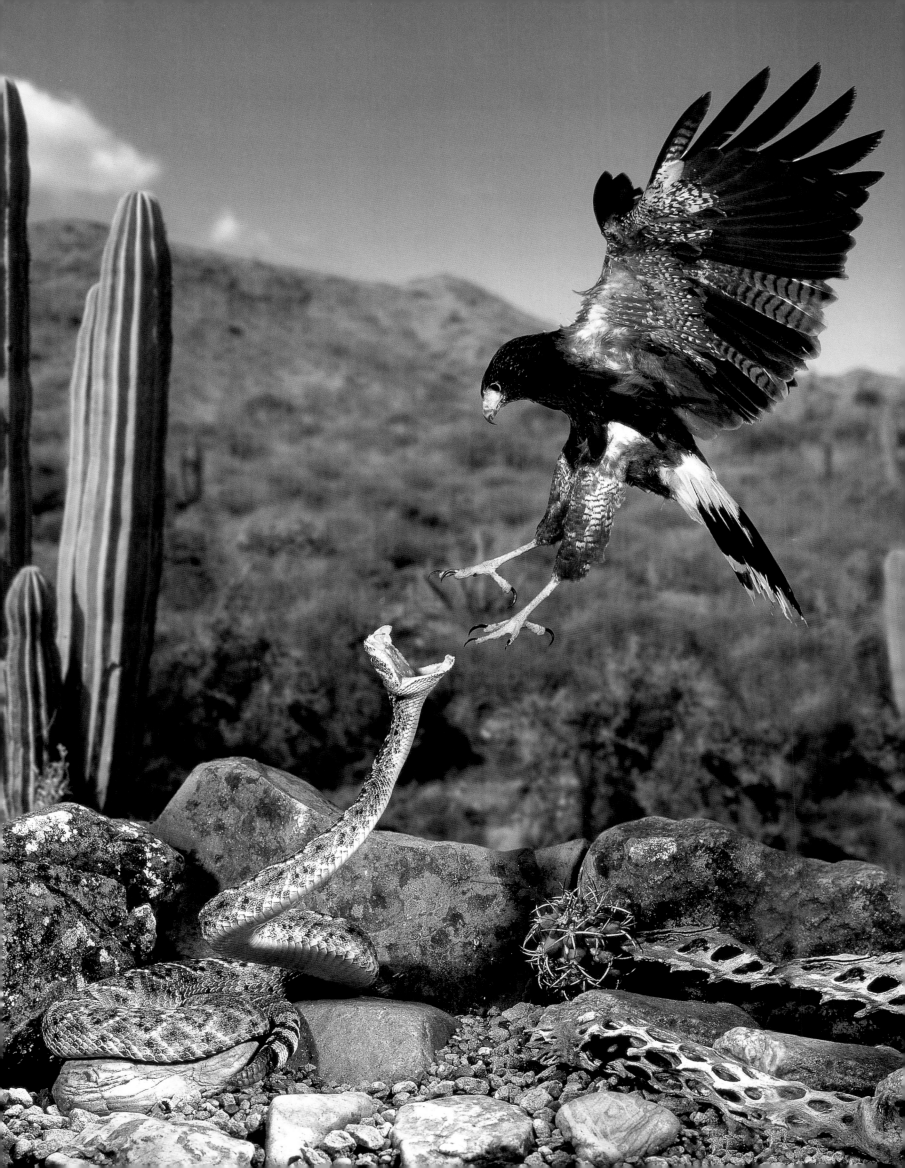

The deserts of Mexico

Arid lands cover nearly 40 per cent of the land area of Mexico. The deserts of the Baja California Peninsula, including the Vizcaíno Desert that spans the central portion of Baja California, are a southern extension of the Sonora Desert. The annual rainfall in Baja California is generally less than 80 millimetres (3 inches), mainly falling in the winter months. The cold marine current from California moderates the hot climate and causes regular fogs. In the central portion of Baja California there are extensive dune systems and salt deposits. Characteristic vegetation over much of the peninsula is dry scrubland with *Yucca*, *Agave* and cactus species, together with the elephant tree (*Pachycormus discolor*) and the extraordinary boojum tree (*Fouquieria columnaris*).

Animals of Baja California

Wild bighorn sheep live in the mountains of Baja California, together with a locally endemic and 'Critically Endangered' subspecies of the pronghorn antelope (*Antilocapra americana* subsp. *peninsularis*). Before Europeans colonized North America, there were over 35 million pronghorns ranging from Mexico through the western USA and living in a variety of open habitats. By the 1920s numbers were reduced to less than 20,000. Hunting and the spread of ranching were the main threats. Conservation measures in the USA have allowed populations to recover, but pronghorn numbers in Mexico are still declining.

Ecotourism is crucially important to the local economy in Baja California. The main attraction for

nature lovers – in addition to the sense of rugged wilderness, breath-taking landscapes and varied wildlife – is the grey whale (*Eschritchius robustus*), which migrates to the lagoons around Guerrero Negro to reproduce. Baja California is the only birthplace for the Californian or East Pacific stock of the grey whale, which may migrate over 200,000 kilometres (124,200 miles) each year to and from their summer feeding grounds in the Arctic. Many North American migratory birds can also be found periodically near the lagoons of Baja California. Tourists can view ospreys, cormorants, herons and gulls in the area. Ancient rock paintings in the rugged mountains of the region are an additional cultural attraction for visitors.

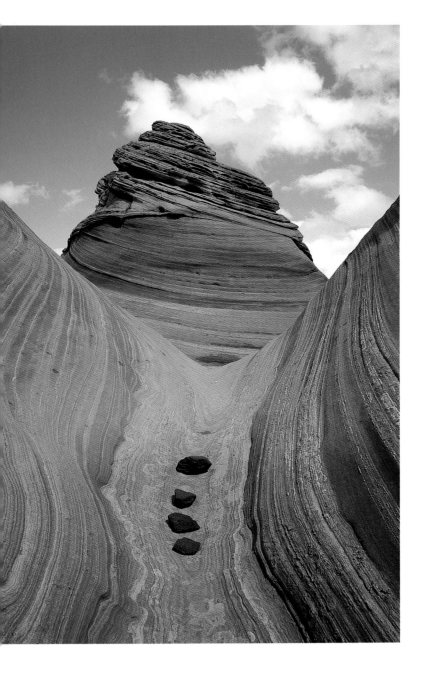

Threats to Baja California

Mineral exploitation, mining, increase in salt production – the salt pans of Guerrero Negro are among the largest in the world – expansion of irrigated agriculture and overgrazing by domestic animals are all threats to Baja California. Considerable habitat destruction is also occurring through the use of all-terrain vehicles. Fortunately a large portion of central Baja California is protected in the Vizcaíno Desert Biosphere Reserve. Established in 1993, this protected area covers over 25,000 square kilometres (9,650 square miles) and is one of the largest protected areas in the world.

The Vizcaíno Desert

The region of the desert of Vizcaíno is one of the most isolated parts of Baja California, but much of the land within the biosphere reserve is under some form of human use. Around 35,000 people live within the reserve boundaries and make a living from farming, fishing, livestock grazing, mining and tourism. The Guerrero Negro salt pans are also within the reserve. The challenge is to manage the reserve so that local people and visitors can benefit from the rich biodiversity in a way that is compatible with long-term conservation.

The Vizcaíno Desert Biosphere Reserve provides sanctuary for the pronghorn, and is also the habitat of the bighorn sheep, mule deer, and many resident and migratory birds. Along the coast are four species of sea turtle and many marine mammals, including the grey whale, elephant seals and sea lions. El Vizcaíno Biosphere Reserve's ecological uniqueness and global importance has been recognized by UNESCO, which has designated the cave paintings of the Sierra San Francisco and the calving lagoon of San Ignacio as World Heritage sites.

The Chihuahua Desert

The Chihuahua Desert predominantly lies in the northern states of Mexico but extends into southwest Texas, southern New Mexico and southeast Arizona. Much of the land is at high altitude. At the heart of the Chihuahuan Desert lie the arid highland plains of Mexico between the mountain ranges of Sierra Madre Occidental and Sierra Madre Oriental. Most of the rock

OPPOSITE: Arches National Park in Utah has over 200 natural sandstone arches, the largest of which is Landscape Arch, measuring nearly 100 metres (328 feet).

LEFT: Petrified sand dunes in the Paria Canyon, Vermillion Cliffs Wilderness Area, which spans the border of Arizona and Utah.

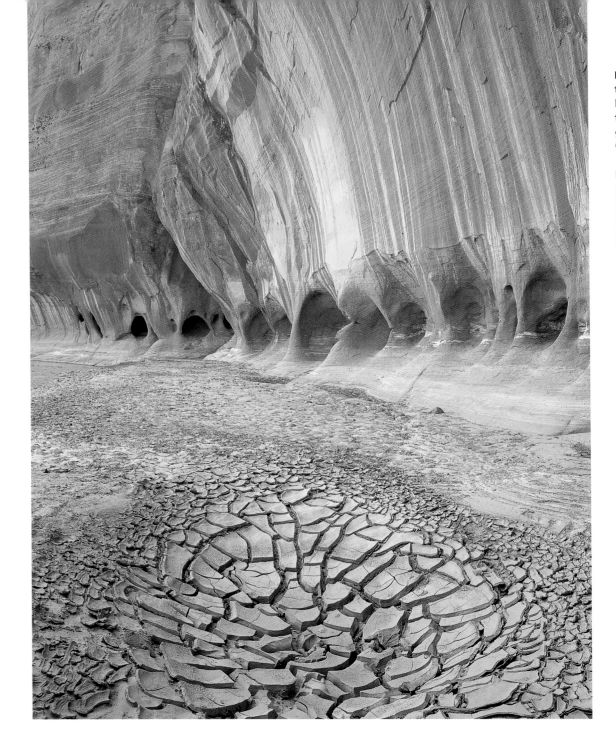

LEFT: The 'Windows' section of the 60-kilometre (37-mile) long Paria Canyon, which is carved through seven major geological features of the Colorado Plateau.

RIGHT: The Engelmann prickly pear (*Opuntia engelmannii*) is the largest and one of the best-known native prickly pears of southwest USA. It also grows in Mexico.

underlying this region is limestone, with grey gravel plains forming characteristic landscape features. Typical vegetation is desert scrub with low-growing shrubs including the creosote bush (*Larrea divaricata*).

Rare cacti

Over 1,000 plants are endemic to the Chihuahua Desert, including some very rare cacti, which have been popular with collectors around the world. This desert region has the largest concentration of endangered cacti in the Americas. Mexico has over 900 species of cacti, more than any other country in the world. It is estimated that around 75 per cent of these species are endemic to the country, and nearly 200 species are threatened with extinction in the wild.

All Mexican cacti have been protected by national legislation for over 60 years, but this has not prevented smuggling across the border into the USA and further afield to Europe and Japan. Some of the endangered species are known as living rock cacti. Small and slow growing, the cacti in the genus *Ariocarpus* are well camouflaged in their arid, rocky habitats of the Chihuahua Desert. Although demand for cacti has never reached the same pitch as the 19th-century orchid craze, avid collectors have long sought rare and unusual species. In 1832, one specimen of the rare *Ariocarpus kotschoubeyanus* was sold – by the collector Baron Wilhelm von Karwinsky – for 1,000 francs, a price far exceeding the value of the plant's weight in gold.

One of the most endangered species of living rock cacti is *Ariocarpus agavoides*, which grows in a very restricted area in the state of Tamaulipas at the edge of the Chihuahuan Desert. It has been heavily depleted by collection for the international market, and now the

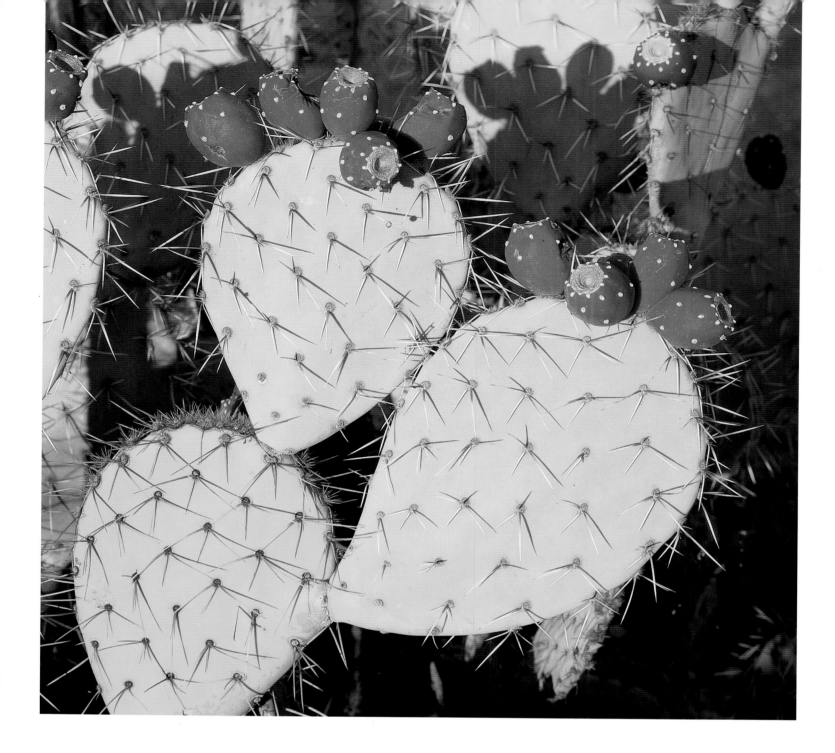

expansion of a nearby urban area and the dumping of rubbish threaten the survival of this precious little plant.

Another small cactus, *Aztekium ritteri*, grows only on limestone cliffs in the state of Nuevo Leon. It is believed to be the slowest growing of all cacti and is quite difficult to maintain in cultivation, and this in itself has provided a challenge to cactus enthusiasts. Collection is the main threat to this species, as the likelihood of habitat destruction is limited. In 1991 a second species of *Aztekium, Aztekium hintonii*, was discovered growing on gypsum rocks in the mountains of the Sierra Madre Oriental. Another new species, *Geohintonia mexicana*, was also discovered in the same locality. The following year both these new species were available for sale in European nurseries – in contravention of Mexican legislation and CITES, which gives protection to all species of cacti.

Agaves

The *Agaves* are another important group of Mexican succulent plants. These plants, with their succulent leaves, are important to the rural economy both as a source of fibres, such as sisal, and for the production of alcoholic drinks, the most famous of which is tequila.

The species *Agave tequilana* is cultivated in the states of Sonora, Nayarit and Jalisco to produce the popular drink. Some species are also harvested from the wild for the illicit production of mescal, another alcoholic beverage. Intense harvesting of *Agave* plants is thought to be one of the reasons for the decline of the Mexican long-nosed bat (*Leptonycteris nivalis*), an endangered species which feeds on nectar and pollen of *Agave* and other desert species, including the saguaro and organ pipe cactus.

The coastal deserts of South America

The narrow stretch of desert running along the Pacific coast of Peru and Chile includes the most arid area in the whole world. In the north is the Sechura Desert of Peru, which has flat sandy plains and dunes. Further south is the Atacama Desert, which straddles the border of Peru and Chile.

Climatic conditions which give rise to the extreme aridity of this coastal region result from the influence of the Humboldt Current. This brings cold water from the Antarctic which cools the surface of the Pacific, limiting evaporation so that fog and stratus cloud are produced along the coast – but not rain. The fogs are known as *garúas* in Peru and *camanchacas* in Chile. The Andes rise to the east, forming a barrier to any moist air from the Amazon Basin. There is virtually no rain at all in the coastal region, and when it does occasionally fall, it is as heavy downfalls, usually after many years of drought. The inland portion of the Atacama Desert scarcely benefits from the coastal fogs as it lies in a depression between the low coastal hills and the foothills of the Andes. The climatic conditions of the coastal drylands have remained the same for about 10 million years, making the Atacama one of the world's oldest deserts.

Plants of the coastal deserts

The vegetation of the coastal drylands of Chile and Peru is richest on the *lomas*, or fog oases, formed on small hills where moisture from the fogs collects. Very few plants are able to grow between the *lomas*. The *lomas* support small trees with mosses and lichens, cacti and terrestrial bromeliads such as *Tillandsia* and *Puya*. Along the few river valleys which cross the desert, bringing water from the distant Andes, there is scrub with *Salix* and *Schinus*, and cactus scrub on rocky upland slopes.

The Chilean desert region is rich in cacti, with over 60 endemic species including 25 species in the genus *Copiapoa*, which is restricted to this area. Many of the cacti are rare, but generally not threatened because of the remoteness of the region and the lack of human influence. There are exceptions, for example, as a result of mining and associated ore treatment activities. Another threat to the cacti has been collection for international trade. Species which have been severely reduced in this way include *Copiapoa laui* (one of the smallest cacti) and *Copiapoa rupestris*.

Another endemic plant of the Chilean drylands is the Chilean wine palm (*Jubaea chilensis*). Known locally as *palma de coguitos*, *Jubaea chilensis* is a palm tree of dry river valleys in the Andean foothills and of open hillsides. Populations were once relatively common, but are now confined to a few small areas. This species listed by the IUCN as 'Vulnerable' is felled as a source of palm wine, which is reduced to make honey. There is some small-scale local cultivation.

Birds and bats

Birds associated with the sandy, rocky areas and the cactus scrub include the cactus canastro (*Asthenes cactorum*), the slender-billed finch (*Xenospingus*

concolor) and the Chilean woodstar (*Eulidia yarrellii*). The latter is confined to a few arid valleys, which are cultivated, and this 'Vulnerable' bird now relies almost entirely on garden plants. Mammals found in the drylands include the guanaco (*Lama guanicoe*), a wild relative of the llama and alpaca, which in Chile now occurs in scattered groups in the coastal range and part of the Andes.

The coastal deserts of Chile and Peru have a very distinct bat fauna, with seven out of the 18 species found there endemic, such as *Platalina genovensium*, but with very small areas of distribution.

Protected desert regions

Important protected areas in the Chilean desert region include the Los Flamencos National Reserve which was created in 1990. It includes the Atacama salt flats, the biggest salt deposit in Chile, covering 300,000 hectares (121,500 acres), and the Valle de la Luna. Further south, where the climate is less arid, are the Pan de Azúcar and Fray Jorge National Parks. The Pan de Azúcar National Park has an area of 43,769 hectares (17,726 acres). It is characterized by its great richness of flora and fauna, and its Humboldt penguin colony on Pan de Azúcar island. It is also a zone of great archaeological and historical richness.

OPPOSITE: *Pachycereus pringlei* is a columnar cactus of Mexico.

ABOVE TOP: The village of Caspana, in the Atacama Desert.

ABOVE BOTTOM: A close-up look at the extraordinary cactus *Pachycereus pringlei*.

The arid lands of Brazil

The drylands of Brazil are found in the semi-arid northeast of the country where a large area of seasonally dry, deciduous thorn forest vegetation occurs. This low, dense vegetation is known as *caatinga*.

The *caatinga* region of Brazil has a complex climate, affected by the convergence of unstable winds and rainfall influenced by the equatorial Atlantic and the equatorial land masses. It remains poorly understood why this area has such low rainfall. The vegetation is a mixture of different types depending on local variations of climate, landscape and soils. Where the rainfall is highest and soils relatively deep, *caatinga* forest occurs. More typical is a form of shrubby *caatinga* known as *carrasco*. In drier areas cacti and succulent bromeliads form an important part of the vegetation. Some of the local cacti, such as *Cereus jamacaru*, *Pereskia grandifolia* and *Pereskia bahiensis*, are used to form living impenetrable fences for livestock, or to form hedges around homesteads.

Other species of cacti have become very rare in the *caatinga*. As well as facing threats from agricultural development, endemic species of *Discocactus*, *Uebelmannia* and *Melocactus* have suffered heavily as a result of commercial collection.

Endangered animals

The colourful macaws of the drylands of Brazil have also suffered because of collection for trade. One such species, the indigo or Lear's macaw (*Anodorhynchus leari*) is now 'Critically Endangered' in the wild. It had been known to science from museum specimens and birds in captivity of unknown origin for around 150 years when a wild population was found in 1978 in northeast Bahia. Lear's macaw has an extremely small population – with only around 150 known birds recorded in the wild – and its numbers are declining. This species occurs in arid *caatinga* where it nests in sandstone cliffs. It forages in trees and on the ground, largely for the fruits of the licurí palm (*Syagrus*). Livestock grazing has greatly reduced the extent of wild stands of this palm, in turn affecting the survival of birds that depend on it. Lear's macaw is protected under Brazilian law and is listed on Appendix 1 of CITES. The natural habitat is also partially protected within an ecological reserve, but protection in the wild needs to be strengthened to ensure the survival of the species.

The spix's macaw (*Cyanospitta spixii*) has been even more seriously threatened by the bird trade and may now be extinct in the wild. Despite intense vigilance and study, the single known wild bird almost certainly died

towards the end of 2000, and the only real hope for the survival of this species in the wild is by reintroduction from the captive population of around 600 birds.

The natural habitat of the spix's macaw was in gallery woodland near the São Francisco River in northern Bahia. Settlement along the river has resulted in clearance for crop cultivation, hunting for food and trapping for trade. Only 30 square kilometres (11½ miles) of gallery woodland remain. Habitat loss may have contributed to the decline of the bird, but hunting for trade has been the real threat, with wild birds still being traded illegally in the mid 1980s. Spix's macaw is protected by law in Brazil and is listed on Appendix I of CITES. The Brazilian government has established a permanent committee for the recovery of this species.

Conservation and protection

Some areas of the *caatinga* have been set aside for conservation, allowing for the protection of threatened plants and animals. The *caatinga* region, however, is densely populated and is an area of considerable poverty.

The Serra da Capivara National Park in the state of Piauí is an archaeological site, claimed to be the most ancient in the Americas. This, the only national park in the *caatinga* region, was declared a World Heritage site in 1991. It has numerous rock shelters decorated with cave paintings, some of which are more than 25,000 years old.

Nowadays the native plants – and palms in particular – provide an important resource for the local people. Oil is extracted from the babassu (*Orbignya phalerata*), carnaúba (*Copernicia prunifera*), and tucúm (*Astocaryum aculeatissimum*). About half the people who live in the states of Maranhão and Piauí rely on babussu as one of their major sources of income.

Irrigation schemes are being introduced to large parts of the *caatinga* region, especially in the São Francisco River valley. This enables the cultivation of fruit for export and is bringing prosperity to the area. There are, however, problems resulting from gradual salinization of the soils. Environmental management is complicated in this region of low rainfall and high population. Overgrazing, collection of wood for fuel and production of charcoal are all impacting on the natural vegetation.

FAR LEFT: Lear's macaw is one of the world's rarest birds. This beautiful species of the Brazilian *caatinga* faces an uncertain future and every effort must be made to ensure its survival.

ABOVE: Rugged landscape features in the Serra da Capivara National Park, Brazil.

An important biodiversity research and conservation initiative here is Plantas do Nordeste (PNE). This collaborative, interdisciplinary programme was established in 1992, and aims to promote the sustainable use of local plants for the benefit of local communities. More than 30 Brazilian organizations participate in PNE, including research agencies, universities, NGOs and grassroots organizations involved in alternative agriculture, forestry and community development. The Royal Botanic Gardens, Kew, is the UK partner. Botanists from Kew work with Brazilians on projects to study and conserve priority vegetation types and which promote the improved use and management of plant resources, such as providing better fodder for livestock, or medicinal plants.

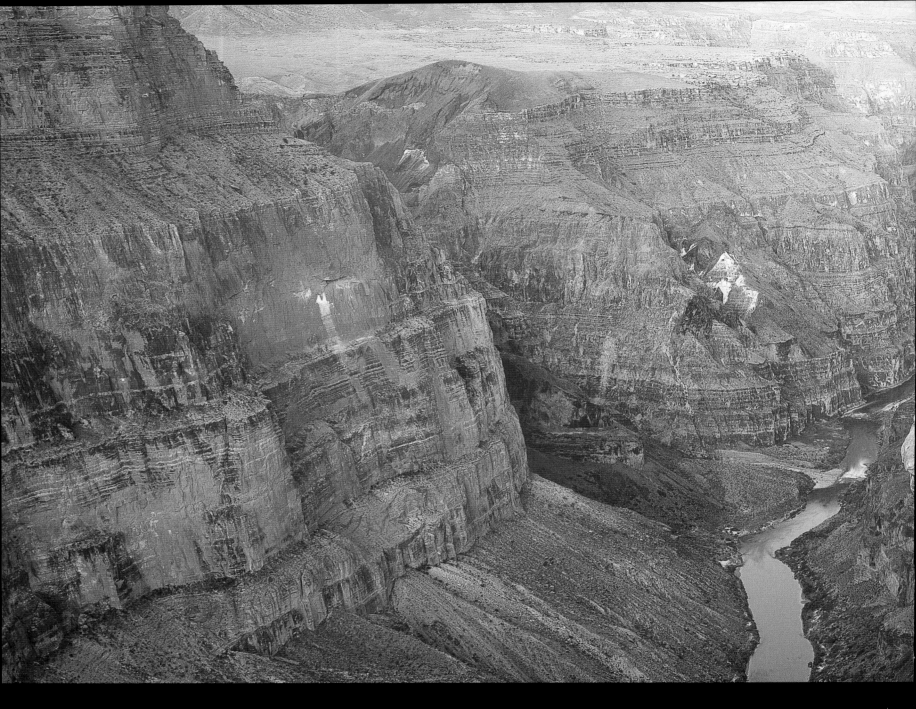

The dryland future

Protecting arid ecosystems

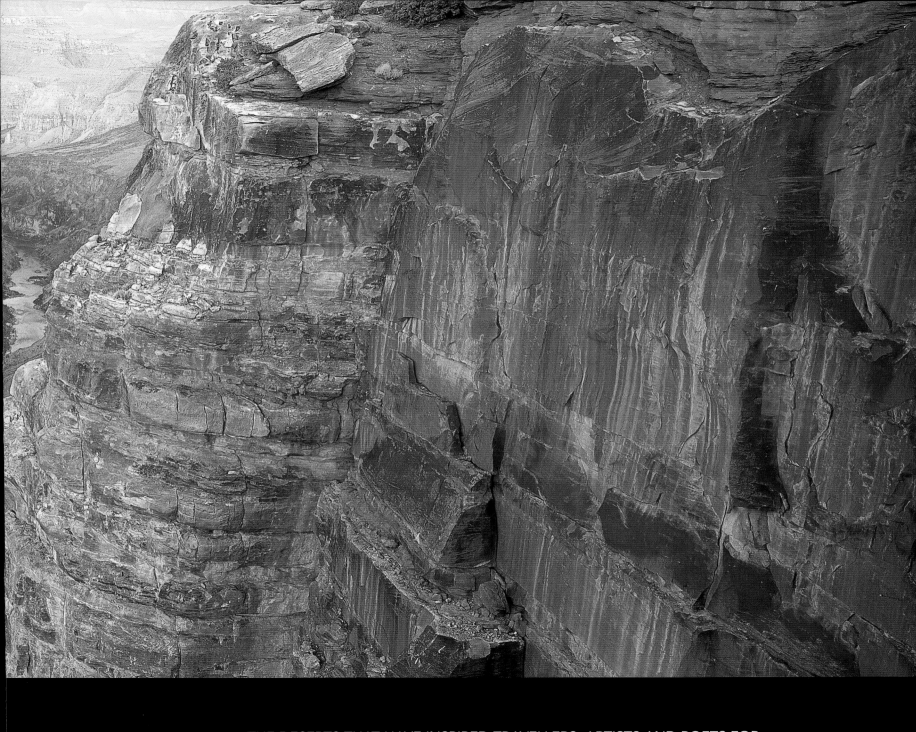

THE DESERTS THAT HAVE INSPIRED TRAVELLERS, ARTISTS AND POETS FOR

CENTURIES ARE CHANGING. THE CULTURAL AND NATURAL TREASURES THEY

Conservation

Desert ecosystems and species are in need of conservation attention worldwide. Changes in traditional land use and development pressures can have detrimental effects on the fragile ecosystems and, although desert plants and animals are adapted to survive in harsh conditions, they are vulnerable to human interference. The fine balance between man and the desert environment is easily upset when increasing numbers of people need to make a living from the marginal lands. Overgrazing is commonly the result. Modern exploitation of desert resources, such as mining and drilling for oil, can take their toll of fragile environments.

The Convention on Biological Diversity

Action to conserve the plants, animals and habitats of desert regions needs to be planned and carried out at a local level with the full involvement of those who depend on the land for their livelihoods. Regional and international agreements are also important to provide a framework for conservation in such regions. This requirement is acknowledged by, for example, the Convention on Biological Diversity (CBD). This international agreement was a major result of deliberations at the United Nations Conference on Environment and Development (UNCED), the global summit held in Rio de Janeiro in 1992. Commonly known as the Rio Conference, it is often used as a benchmark to measure international progress in this arena. The aims of the CBD are the conservation of biological diversity, the sustainable use of its components, and the fair and equitable sharing of the benefits arising from the use of genetic resources.

In 2000, member countries of the convention agreed a work programme for desert conservation, as part of its broader commitment to conservation of 'dry and

PAGES 134–135: The Colorado River flows through the awe-inspiring Grand Canyon.

LEFT: Overgrazed rangeland in Chihuahua, Mexico. Intensive grazing by domestic livestock is one of the main causes of desertification.

OPPOSITE: Cattle grazing in India – traditional pastoralism has generally been sustainable in arid regions but this is changing with increasing population pressures.

sub-humid lands'. The emphasis is on collecting information on biodiversity and the impact of its loss in dryland areas, defining priorities for action, the development of management practices, assessment of conservation measures carried out, and promotion of partnerships. The programme further aims to promote synergies and coordination between related conventions, in particular the United Nations Convention to Combat Desertification (UNCCD).

At national level, countries which sign up to the CBD are required to develop and implement a Biodiversity Strategy and Action Plan, and to report on its progress. Many of the desert countries of the world have drawn up plans which identify priorities for species and habitat conservation and detail how these will be undertaken. The plan for the tiny country of Djibouti was drawn up in 2000. Objectives and priority projects are outlined for various aspects of biodiversity conservation, including the protection of endangered species and

development of protected areas. The plan includes an increase in protected areas in Djibouti from 8.8 per cent of the country to 12 per cent, with the involvement of local people in protected area management and selection. For endangered species the plan outlines conservation measures for the 20 globally threatened species in the country, including the 'Vulnerable' Beira antelope (*Dorcatragus megalotis*) and the 'Critically Endangered' Djibouti francolin (*Francolinus ochropectus*). The latter – one of the most threatened birds of northeast Africa – is found only in Djibouti's relic forest, which is being rapidly degraded through overgrazing and trampling by camels and other domestic livestock. It is also planned to conserve species which are threatened at a national level. As well as maintaining or restoring wild populations of endangered species, the plan outlines the development of national legislation to protect species and to forbid exploitation of threatened species.

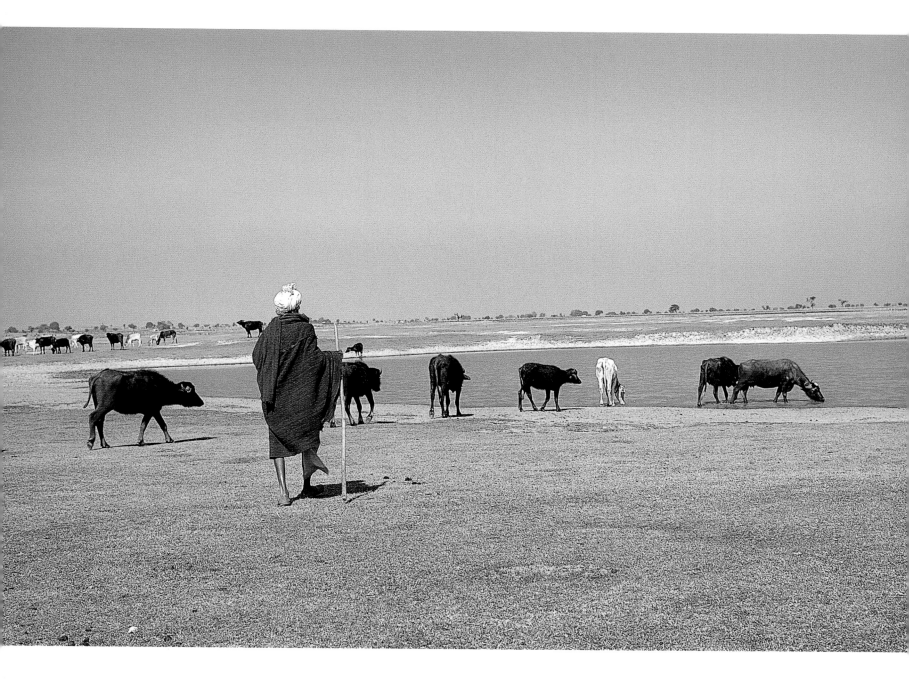

Desertification

The question of how to prevent the spread of deserts also needs to be tackled. Unlike the other major biomes of the world, deserts are expanding and are taking over areas of grassland and sparsely wooded dry savannah. This process is known as desertification, 'the diminution or destruction of the biological potential of the land, leading ultimately to desert-like conditions'.

Overgrazing and wood extraction

Overgrazing and excessive fuel wood extraction around the desert margins result in loss of vegetation cover and erosion of the thin soils. These 'man-made' deserts are usually barren and lifeless.

Traditionally people living in dryland areas have developed sustainable methods to manage natural resources and minimize risks to their livelihoods under conditions of high climatic variability and uncertainty. The nomadic lifestyles of pastoralists, patterns of shifting cultivation, and use of drought-resistant crops are examples of traditional ingenuity. These adaptations to the harsh dryland ecosystems are successful where human populations are low. With increasing population pressure and disruption caused, for example, by war, pressures on the fragile environments increase and new approaches to land management may be needed.

Unfortunately, there has been a history of colonial governments and development agencies imposing land management solutions in dryland ecosystems, but there is now general recognition that full community participation in development planning and management is required for success.

International agreements

International action on desertification is undertaken through UNCCD which, along with the CBD, was another outcome of the Rio Conference in 1992. The Convention to Combat Desertification came into force in December 1996. By January 2002, 178 countries and the European Union had ratified or acceded to it, which means that they are obliged to implement the provisions of the convention.

The objectives of this Convention are to combat desertification and mitigate the effects of drought, particularly in Africa, through effective action at all levels, supported by international cooperation and partnership arrangements. Achieving this objective will involve long-term integrated strategies that focus simultaneously, in affected areas, on improved productivity of land, and the rehabilitation, conservation and sustainable management of land and water resources, leading to improved living conditions, in particular at the community level.

LEFT: The Richtersveld National Park has a great diversity of succulent plants. Management of the park involves full participation by local people.

OPPOSITE: Quiver trees (*Aloe dichotoma*) can be seen within the Richtersveld National Park.

PAGE 140 TOP LEFT: Beetle species, adapted to survive in desert conditions, form an integral part of the desert biodiversity which needs to be conserved.

PAGE 140–1: Protected area status helps to conserve the precious water supplies within desert regions.

Protecting desert ecosystems and landscapes

National parks and other protected areas are very important for conserving the biodiversity of dryland areas, and can help to prevent the spread of deserts. Usually, protected areas have been selected for their landscape value and charismatic animal species, but others around the world have been selected to protect unique vegetation types and threatened plant species.

Consulting with local peoples

Increasingly it has become recognized that local people are important in the management of protected areas, and that their needs should be harmonized with those of wildlife conservation. Giving local people a role in the design and management of these areas and ensuring that they share in any benefits – such as income from ecotourism – will help to ensure the long-term success of areas set aside for conservation. The Richtersveld National Park in South Africa provides one example of modern thinking in protected area management.

Richtersveld National Park

In terms of global biodiversity hotspots, desert areas do not generally rank highly in comparison with Mediterranean and forest ecosystems. There is, however, one major exception – the Succulent Karroo region of Southern Africa, which is included in Conservation International's 25 biodiversity hotspots of the world. This area rates highly in terms of its stunning plant diversity.

The Richtersveld National Park is one of a number of protected areas in the region, and was established in 1991 after extensive local consultation. Management of the park, which covers over 1,600 square kilometres (617 square miles) is undertaken jointly by the local Nama people and South Africa National Parks. The Nama benefit from park income, employment and grazing rights.

The Richtersveld National Park protects an internationally important area of succulent plant diversity with special plants such as the quiver tree

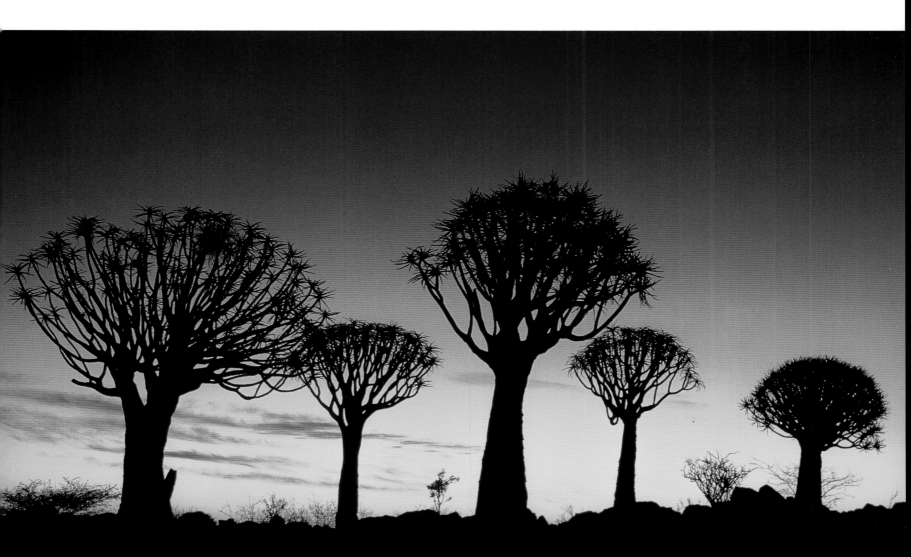

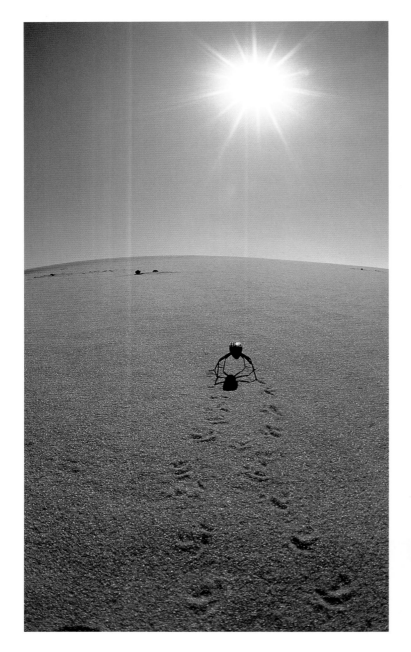

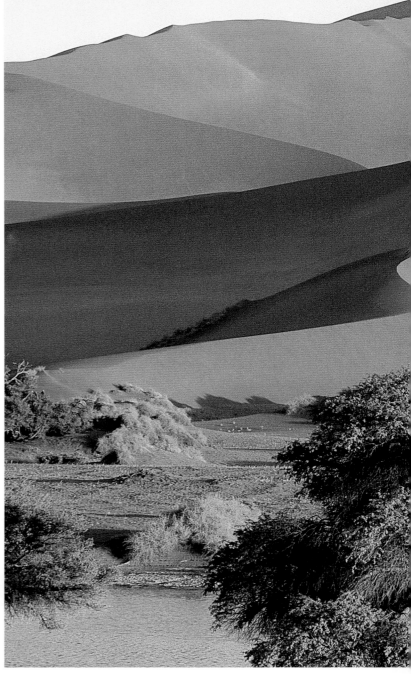

(*Aloe dichotoma*), the very rare *Aloe pillansii* and the halfmens (*Pachypodium namaquanum*).

Biosphere reserves

National legislation is usually the basis for developing protected areas. In addition, various forms of international designation are now in existence for protected areas around the world. Internationally recognized biosphere reserves have, for example, been designated in arid areas under the UNESCO Man and Biosphere Programme. These specifically allow for research into the interactions between people and the ecosystems in which they live.

Big Bend National Park

Big Bend National Park is one of nearly 50 biosphere reserves in the USA. This national park protects a large area of Chihuahua Desert in Brewster County, Texas. For 190 kilometres (118 miles) the Rio Grande – the

border between Mexico and the USA – also forms the park's southern boundary. South of the river (known in Mexico as Rio Bravo del Norte) lie the Mexican states of Chihuahua and Coahuila, and the new protected areas known as the Maderas del Carmen and the Cañon de Santa Elena.

Big Bend National Park is valued for its spectacular scenery, ecology, geology and archaeology, and an abundance of Cretaceous and Tertiary fossil organisms is found there. The Chisos Mountains lie in the centre of the park, and much of the rest is low-lying desert. Along the southern park boundary are the spectacular canyons of Santa Elena, Mariscal, and Boquillas, cut through limestone rock by the Rio Grande.

Within the boundaries of the park more than 1,200 species of plants have been recorded, with about 60 different cacti. Rare species include the bunched cory cactus (*Coryphantha ramillosa* – a tiny cactus

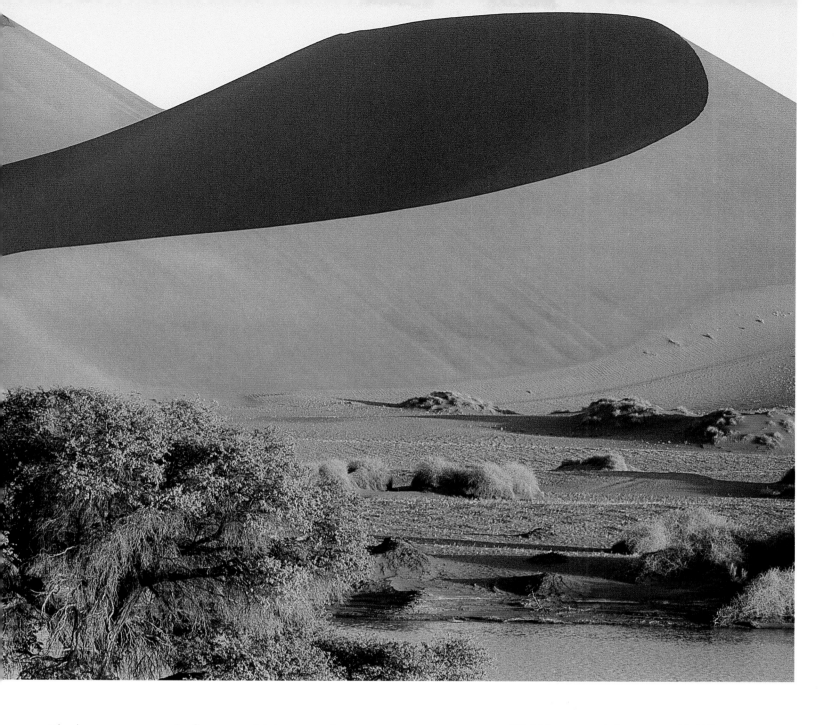

with deep rose-purple flowers which grows in limestone hills), the Chisos hedgehog cactus (*Echinocereus chisoensis*), and *Ancistrocactus tobuschii*. Research is being carried out on these and other rare species by park staff, and monitoring helps to ensure that illegal plant collectors do not poach the cacti. Animals range from more than 3,600 insect species to the mountain lion or puma (*Felis concolor*), which preys on mule deer (*Odocoileus hemionus*), pronghorn (*Antilocapra americana*) and javelina (*Tayassu tajacu*). There are 25–30 pumas within the park boundaries.

Mexican biosphere reserves

In Mexico there are also important desert biosphere reserves. The Pinacate Biosphere Reserve covers 480,000 hectares (194,400 acres) of Sonoran Desert adjoining the Organ Pipe Cactus National Monument in the USA. The Vizcaíno Desert Biosphere Reserve covers over 25,000 square kilometres (9,650 square miles) in Baja California, and the Mapimi Biosphere Reserve established in 1977 covers over 100,000 hectares (40,500 acres) of the Chihuahuan Desert in a large catchment area known as Bolson de Mapimi. The Mapimi Biosphere Reserve was created primarily to protect the 'Endangered' Bolson tortoise (*Gopherus flavomarginatus*) and the fragile arid habitats. The Bolson tortoise is the largest terrestrial reptile in North America and has been threatened by over-collection for food. Research on this and other desert species, and on human impacts on the desert environment, are carried out in the Mapimi Biosphere Reserve. The reserve is zoned for different types of management, with a core and buffer zone. Local people – including representatives of the cattle ranchers, small landowners and communities – are involved in a legally constituted association to assist in management of the reserve.

World Heritage sites

A selection of the world's elite dryland sites is listed under the World Heritage Convention, an international conservation agreement with over 170 countries as members. The convention is designed to give protection to areas of outstanding cultural and natural heritage. At present nearly 70 desert sites are listed (see page 154), ranging from the natural glories of the Grand Canyon of Arizona to the ancient pyramids of Egypt.

World Heritage sites deserve to enjoy international protection as areas for scientific study and global appreciation. Sadly, however, some dryland sites are listed in the World Heritage 'in Danger' category. Abu Mena, the early Christian Holy City in the Mariut Desert of Egypt, is one such example. The city of Timbuktu was designated as a World Heritage site in 1988, and in 1990 was placed on the list of sites in danger. The three great mosques of Timbuktu – Djingareyber, Sankore and Sidi Yahia – have been continuously restored, but are under threat from desertification.

The National Nature Reserve of Air and Ténéré in Niger, planned to take into account the needs of the local Tuareg people, is also now on the list of sites at risk. This magnificent reserve, the second largest protected area in Africa, was added to the World Heritage List in 1991. The following year it was placed on the World Heritage 'in Danger' list as a result of military conflict and civil unrest between the Tuareg and the national government. Fortunately, following the signature of a peace accord in 1995, most wildlife populations were found to have recovered. Some species continue to be threatened by poaching, and the ostrich, for example, may have become locally extinct.

BOTTOM LEFT: The Chisos Mountains at sunrise in Big Bend National Park. This protected area is an internationally designated Biosphere Reserve.

BELOW: The ostrich (*Struthio camelus*) has suffered from poaching in various parts of its range even within dryland areas set aside for conservation.

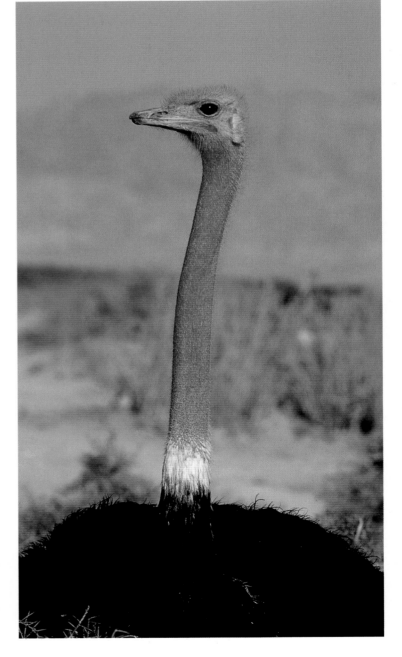

Ramsar sites

Wetland sites within desert regions are of immense social and ecological importance. As with wetland sites in general – and more so in areas where water is such a precious resource – many desert wetlands are under threat.

This threat is recognized internationally through the work of the Convention on Wetlands of International Importance Especially as Waterfowl Habitat. This international agreement was signed in 1971 in the Iranian town of Ramsar, and the convention is generally known as the Ramsar Convention. Its aim is to 'stem the progressive encroachment on and loss of wetlands now and in the future'. In order to do this, Ramsar promotes the wise use of all wetlands and special protection for wetlands included in the List of Wetlands of International Importance. Desert wetlands on this list include the Azraq Wildlife Reserve in Jordan, the Inner Delta of the Niger River in Mali, the Coongie Lakes in the Strzelecki Desert of South Australia, and the desert coastal sites of Banc d'Arguin National Park, where the Sahara meets the Atlantic Ocean in Mauritania.

BELOW: Water in arid areas is of great value to people and wildlife. The management of wetlands is a major conservation priority.

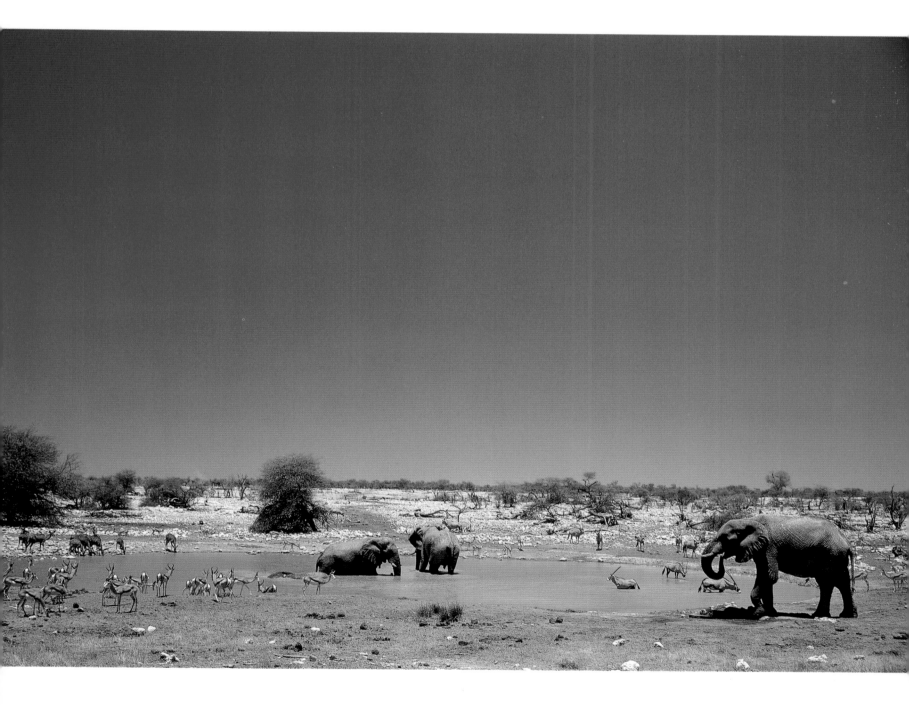

Tourism – the Grand Canyon and desert adventures

One of the main reasons for the establishment of national parks has been to promote recreation and an appreciation of wild places and wildlife. The US National Park Service was, for example, set up in 1916, 'to promote and regulate the Federal areas known as National Parks, monuments and reservations, which purpose is to conserve the scenery and the natural and historic objects and the wildlife therein, and to provide for the enjoyment of the same in such manner and by such means as will leave them unimpaired for the enjoyment of the future generation'.

Visitors to protected areas in desert regions rarely fail to be impressed by their haunting beauty and stark landscapes. Sensitively managed tourism can provide both much-needed income for desert conservation and increased understanding of the fragility of the desert ecosystems. But managing tourism without compromising the needs of wildlife and local people can be challenging in the more popular sites.

The Grand Canyon

The Grand Canyon of Arizona, a 1,500-metre (5,000-foot) deep canyon carved by the Colorado River, is widely regarded as the most spectacular gorge in the world. This area was first protected in 1893 as a forest reserve in which mining, logging and hunting were permitted. It was declared a national park in 1919, and extended considerably in 1975 to include adjacent national monuments and other public and private lands. The Grand Canyon National Park was listed on the World Heritage List in 1979. It covers an

area of 493,077 hectares (199,696 acres), of which a significant portion is administered by the Navajo Indian tribe.

Various different vegetation types are found within the park, including Sonoran Desert vegetation. Wildlife includes the endemic Kaibab squirrel (*Sciurus kaibabensis*), an endemic subspecies of rattlesnake (*Crotalus viridis abyssus*) and large mammals such as coyote (*Canis latrans*), mountain lion (*Felis concolor*), bobcat (*F. rufus*), mule deer (*Odocoileus hemionus*), elk (*Alces alces*), pronghorn antelope (*Antilocapra americana*) and desert bighorn sheep (*Ovis canadensis*). Birds associated with the national park include the 'flagship' species, the California condor (*Gymnogyps californianus*) and the bald eagle (*Haliaetus leucocephalus*).

Sensitive site management

From the outset, the Grand Canyon has been managed sensitively to accommodate visitors. In the 1920s and 1930s buildings were designed to blend with the surrounding environment and roads were developed taking into account the natural contours and the various 'user zones': accommodation, industrial, commercial and residential. The Grand Canyon Lodge Complex, built to accommodate visitors, is now itself a National Historic Landmark, and various other buildings have been placed on the National Register of Historic

OPPOSITE: Distinctive landforms in the Grand Canyon National Park.

BELOW: Spectacular scenery in the Grand Canyon National Park attracts nearly 5 million visitors each year.

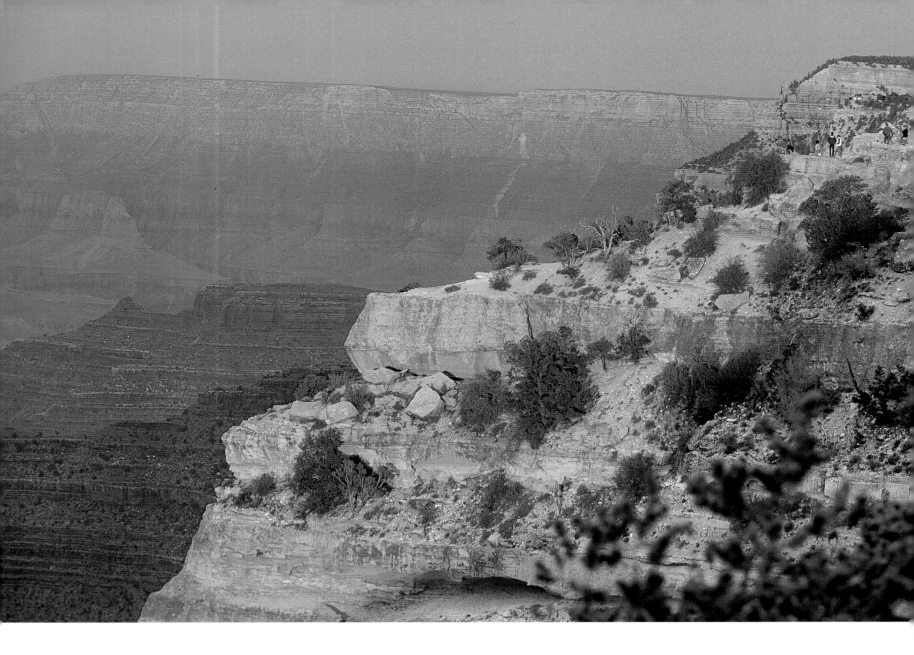

Places. Visitor facilities include lodges, campsites, horse and mule rides, bus tours and 580 kilometres (360 miles) of hiking trails.

The cost of tourism

Despite careful planning, however, the park's most serious management issue remains that of tourism. Each year nearly 5 million visitors visit the Grand Canyon – far more than could have been envisaged 80 years ago. The impact of this many people with private cars concentrated on the few developed areas along the canyon rim has contributed to the gradual degradation of the park's natural and cultural resources.

Management of the Grand Canyon National Park based on a plan published in 1995. This was developed following a four-year process of consultation involving local residents, American Indian tribes, conservation organizations and business interests. Under the plan the park is zoned for different uses, with over 90 per cent of the land managed as wilderness. To tackle the traffic problems, new transport systems are being developed. A public transport system and a 'greenway' section for bicycles and pedestrians are currently been built.

ABOVE: Powell Point, Grand Canyon. Management of protected areas needs to take into account the needs of local people together with visitor pressures.

OPPOSITE TOP: A columnar species of cactus. International trade in all species of cacti is controlled to prevent the threat of extinction to wild populations. Cactus smuggling has been a significant problem in Mexico which has the greatest diversity of species.

OPPOSITE BOTTOM: The brightly colored flowers of cacti contrasting with their sometimes bizarre growth forms have made them popular house plants. The beavertail cactus (*Opuntia basilaris*) is a species of the Mojave Desert.

Other dryland protected areas only attract more intrepid visitors and do not have the same intensity of tourism pressures. The Air and Ténéré National Nature Reserve, for example, is visited by only a few thousand tourists each year. Nevertheless tourism generally is increasing, and even the Central Sahara is being viewed as a potential major destination. The Tuareg want to see small-scale environmentally sustainable tourism rather than mass tourism which is already causing damage to their cultural heritage through, for example, deliberate looting of prehistoric paintings and ancient artefacts.

Species conservation

Setting aside areas for conservation is important, but this alone is often not enough. Even within protected areas, valuable species may be targeted by hunters or collectors, leading to their depletion. As the catalogue of endangered species increases worldwide (see page 152), measures are needed to reduce the specific threats and where possible restore habitats and develop species recovery plans.

Overexploitation

One specific threat faced by desert species is overexploitation. Hunting, harvesting and collection for trade have been a significant cause of decline for many naturally rare desert species, from the houbara bustard of North Africa and Asia to the living rock cacti of Mexico.

National legislation helps to limit the impact of this type of threat. In addition, governments have agreed to protect various overexploited desert species through the Convention on International Trade in Endangered Species of Wild Fauna and Flora (CITES). This agreement, which has been in force for over 25 years, is one of the oldest – and perhaps the most powerful – international conservation agreement. All cacti, various other succulent plants, spotted cats, birds of prey and parrots are given a degree of protection by CITES. International trade in particularly rare wild species listed under the convention is banned. For the majority of listed species, regulated and licensed international trade is allowed where this is in accordance with national legislation and is not damaging to wild populations.

The Arabian oryx – a success story

Desert ecosystems, with their sparse vegetation, do not usually support an abundance of wildlife, and the specially adapted species tend to be naturally rare – such as, for example, the desert gazelles and antelopes of Africa and Asia. The charismatic Arabian oryx, symbol of the international wildlife charity FFI, is one such species, which was hunted to extinction in the wild. Fortunately some animals were held in captive collections and through breeding programmes it has been possible to restore wild populations. The conservation of the Arabian oryx has been a major success story involving careful research, international collaboration and the cooperation of local people.

The range of the Arabian oryx once extended throughout most of the deserts of the Arabian

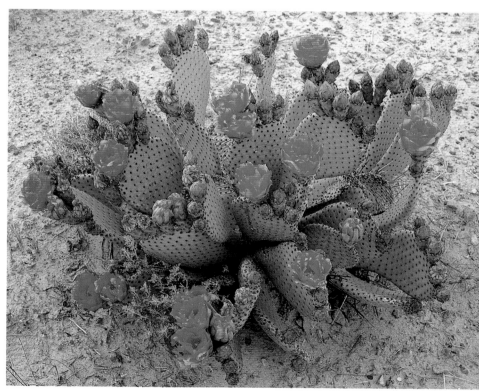

Peninsula and eastwards as far as the deserts of Iraq. Hunting has been the main threat to this species, and Iraq's last oryx was shot in 1914. Pressures increased on the Saudi Arabian populations as oil revenues dramatically increased the wealth of the kingdom in the second half of the 20th century. The Arabian oryx was increasingly sought out, both for meat and trophies, by hunters using automatic weapons and travelling in motorized fleets. The last wild oryx were recorded in Oman in 1972.

Fortunately, as keeping wild animals is an old tradition in the Arab world, they were held in private collections throughout the Middle East. The capture of a few of the last wild animals led to the establishment of 'Operation Oryx'. Donations of animals from private collections added to these captured individuals and led to the formation of the World Herd. Oryx reintroductions have been successfully undertaken in Oman since 1982, and in Saudi Arabia since 1990.

In Saudi Arabia there are now two protected areas with reintroduced populations of the Arabian oryx and further suitable sites have been identified. These are the Mahazat as-Sayd protected area – also a reintroduction site for the houbara bustard and the sand gazelle – and the Uruq Bani Ma'arid protected area at the western edge of the Empty Quarter. The Uruq Bani Ma'arid area is divided into three zones to allow for different uses. At the core is a Special Nature Reserve of approximately 2,000 square kilometres (772 square miles) where human settlement, grazing and other activities are forbidden. This strictly protected core is surrounded by a Resource Use Reserve covering about 5,000 square kilometres (1,930 square miles) and managed by wildlife rangers. The third zone, again covering approximately 5,000 square kilometres (1,930 square miles), is designated as a Controlled Hunting Reserve.

Elsewhere in the region, Oman has a well-established wild population of Arabian oryx reintroduced from

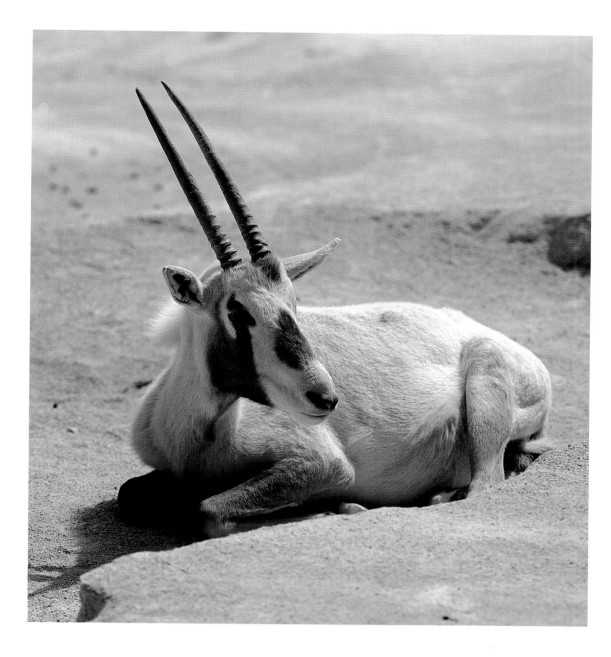

OPPOSITE: The African elephant has been the focus of much conservation attention. Protection of its habitats in drylands and elsewhere remains important, together with controls to prevent illegal hunting.

LEFT: The future of the endangered Arabian oryx is more secure as a result of captive breeding and reintroduction schemes, but poaching remains a threat.

BELOW: Reptiles, amphibians and insects have received less conservation attention than the 'flagship' mammals found in desert regions, but we should not forget the importance of these species in dryland ecosystems. Here, a graceful chameleon (*Camaeleo gracilis*) is shown in defensive display.

captive-bred animals. Jordan has a herd bred in semi-captive conditions in the Shaumari Wildlife Reserve, and Syria has a managed population within the Talila Reserve. The United Arab Emirates are also managing captive populations which could form part of a regional conservation strategy for this species.

Help needed

Governments on their own will not be able to save endangered desert species and habitats. NGOs have a major role to play. International organizations such as Birdlife International, the World Wide Fund for Nature (WWF), Conservation International, Fauna & Flora International and the World Conservation Union (IUCN) all make significant contributions.

Above all, local people are the most effective custodians of desert traditions and wildlife. These people deserve our respect and support in preserving some of the most inhospitable and awe-inspiring places in the world.

Sketch map of arid regions of the world

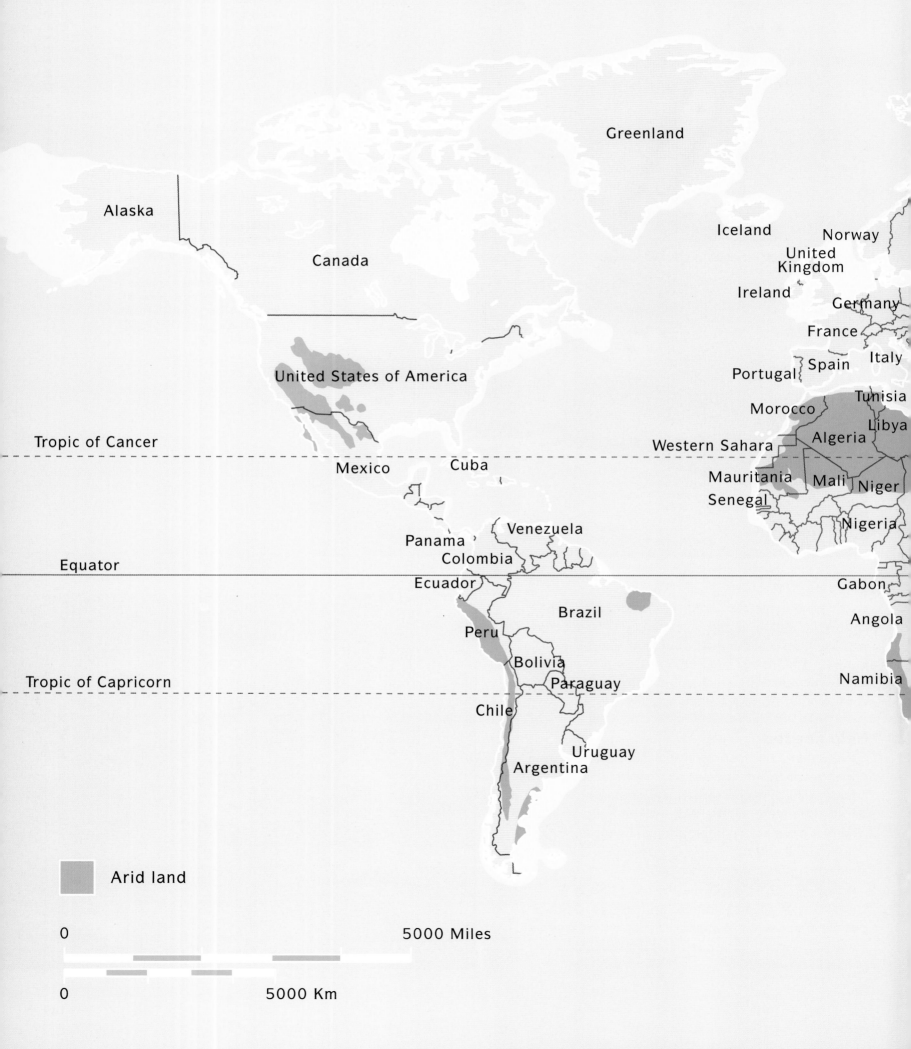

Greenland

Alaska

Canada

Iceland

Norway

United Kingdom

Ireland

Germany

France

Portugal Spain Italy

Tunisia

Morocco

Libya

United States of America

Western Sahara Algeria

Tropic of Cancer

Mexico Cuba

Mauritania Mali Niger

Senegal

Panama Venezuela

Colombia Nigeria

Equator

Ecuador

Gabon

Brazil

Peru Angola

Bolivia

Tropic of Capricorn Paraguay Namibia

Chile

Uruguay

Argentina

Arid land

0 5000 Miles

0 5000 Km

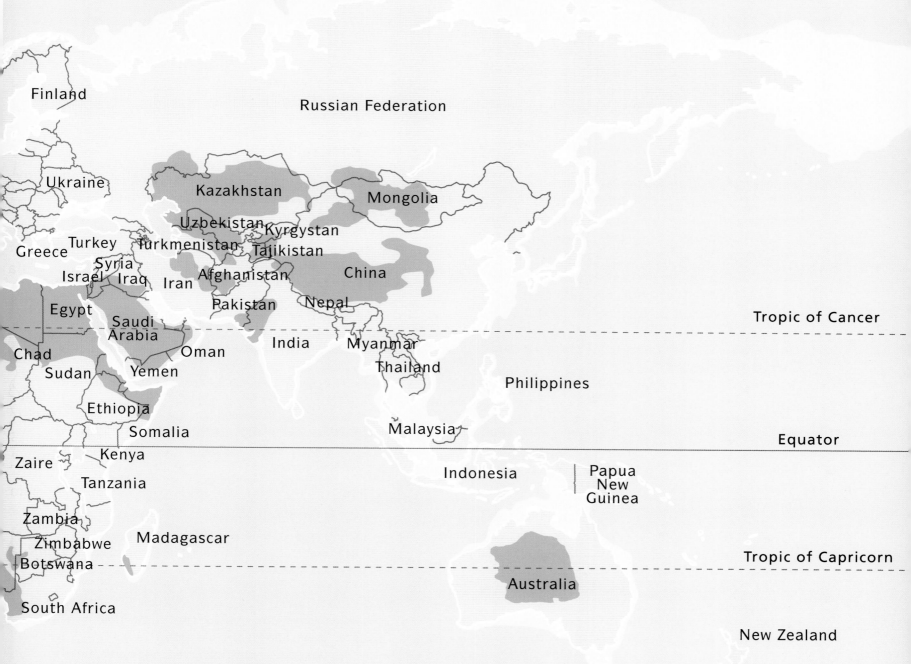

Finland

Russian Federation

Ukraine

Kazakhstan

Mongolia

Greece
Turkey
Uzbekistan
Kyrgystan
Turkmenistan
Tajikistan
Syria
Israel Iraq
Iran
Afghanistan
China
Egypt
Pakistan
Nepal

Tropic of Cancer

Saudi
Arabia
Chad
Oman
India
Myanmar
Sudan
Yemen
Thailand
Ethiopia
Philippines
Somalia

Malaysia

Equator

Zaire
Kenya
Indonesia
Papua
New
Guinea
Tanzania

Zambia
Zimbabwe
Madagascar
Botswana

Tropic of Capricorn

Australia
South Africa

New Zealand

Desert species of concern

Mammals and birds have been well studied around the world and there is good information on their conservation status. For other animal groups, such as reptiles, amphibians, fishes and invertebrates, there is often little agreement on how many species there are never mind their conservation status and reliance on deserts. For example, there are thought to be over 7,900 species of reptiles but the conservation status of over 85 per cent of these has yet to be assessed by IUCN – the World Conservation Union. For invertebrates, a group that includes 95 per cent of all animal species, the situation is even worse. In total there may be around 950,000 species of insects, but the status of over 99 per cent of the species has not been assessed and no one knows how many may occur in deserts. For these poorly studied groups, the degree of threat and the importance of deserts to their long-term survival may therefore currently appear small.

The species listed below are examples of desert species of concern, many of which are also referred to in the main text of the book. For each species the global conservation status according to IUCN and geographical distribution is given.

Threatened mammals

There are over 4,700 mammal species in the world and over 1,100 are considered threatened. Of these, around 3 per cent occur in deserts. Many of the larger desert and sub-desert species are threatened. The following threatened species occur in arid lands, although some, such as the African elephant, are found in various different habitats.

Carnivores

- Fennec fox *Fennecus zerda*, Data Deficient, North Africa, Middle East, Arabian Peninsula
- Cheetah *Acinonyx jubatus*, Vulnerable, Africa, Middle East, Arabian Peninsula, Asia
- Asiatic cheetah *Acinonyx jubatus venaticus*, Critically Endangered, Iran
- Sand cat *Felis margarita*, Near Threatened, North Africa, Middle East, Arabian Peninsula, Asia
- Pallas's cat or manul, *Otocolobus manul*, Near Threatened, Asia
- Lion *Panthera leo*, Vulnerable, Africa, Middle East, Arabian Peninsula, Asia
- Leopard *Panthera pardus*, not threatened but there are several subspecies that are of conservation concern such as the South Arabian leopard *Panthera pardus nimr*, Critically Endangered, Arabian Peninsula

Cattle, antelopes, sheep and goats

- Dibatag or Clarke's gazelle *Ammodorcas clarkei*, Vulnerable, Ethiopia, Somalia
- Blackbuck *Antilope cervicapra*, Vulnerable, Asia
- Beira *Dorcatragus megalotis*, Vulnerable, North Africa
- Indian gazelle *Gazella bennettii*, Conservation Dependent, Afghanistan, India, Iran, Pakistan
- Dama gazelle *Gazella dama*, Endangered, North and West Africa
- Dorcas gazelle *Gazella dorcas*, Vulnerable, Africa, Middle East, Arabian Peninsula
- Arabian gazelle *Gazella gazella*, Conservation Dependent, Middle East, Arabian Peninsula
- Rhim or slender-horned gazelle *Gazella leptoceros*, Endangered, North Africa
- Speke's gazelle *Gazella spekei*, Vulnerable, Ethiopia, Somalia
- Goitred gazelle *Gazella subgutturosa*, Near Threatened, Middle East, Arabian Peninsula, Asia
- Chiru *Pantholops hodgsonii*, Endangered, China, India, Nepal
- Yak *Bos grunniens*, Vulnerable, China, India, Nepal
- Nilgai *Boselaphus tragocamelus*, Conservation Dependent, Asia
- Aoudad or Barbary sheep *Ammotragus lervia*, Vulnerable, North Africa, Middle East
- Bighorn sheep *Ovis canadensis*, Conservation Dependent, Canada, Mexico, United States
- Addax *Addax nasomaculatus*, Critically Endangered, North Africa
- Scimitar-horned oryx *Oryx dammah*, Extinct in the Wild, North and West Africa
- Arabian oryx *Oryx leucoryx*, Endangered, Egypt, Middle East, Arabian Peninsula

Rodents

- Kangaroo rats *Dipodomys* species, out of 21 species, three Critically Endangered, one Endangered, one Vulnerable, two Near Threatened, one Conservation Dependent, Mexico, United States
- Heptner's pygmy jerboa *Salpingotus heptneri*, Near Threatened, Kazakhstan, Russia, Uzbekistan
- Thick-tailed pygmy jerboa *Salpingotus crassicauda*, Vulnerable, China, Kazakhstan, Mongolia
- Dusky hopping mouse *Notomys fuscus*, Vulnerable, Australia
- Central rock rat *Zyzomys pedunculatus*, Critically Endangered, Australia

Others

- Desert bandicoot *Perameles eremiana*, Extinct, Australia
- Desert rat kangaroo *Caloprymnus campestris*, Extinct, Australia
- Rufous hare wallaby *Lagorchestes hirsutus*, Vulnerable, Australia

- Brazilian three-banded armadillo *Tolypeutes tricintus*, Vulnerable, Brazil
- Mexican long-nosed bat *Leptonycteris nivalis*, Endangered, Central America, United States
- African elephant *Loxodonta africana*, Endangered, Africa
- Gobi kulan *Equus hemionus luteus*, Vulnerable, China, Mongolia
- Bactrian camel *Camelus bactrianus*, Critically Endangered, China, Mongolia
- Baja California pronghorn *Antilocapra americana peninsularis*, Critically Endangered, Mexico

Threatened birds

There are around 10,000 bird species in the world and almost 1,200 of these are threatened. The following are species which are found, in part, in arid lands.

- Marbled teal *Marmaronetta angustirostris*, Vulnerable, Africa, Middle East, Arabian Peninsula, Asia
- Cinereous vulture *Aegypius monachus*, Near Threatened, Europe, North Africa, Middle East, Arabian Peninsula, Asia
- Imperial eagle *Aquila heliaca*, Vulnerable, Europe, Africa, Middle East, Arabian Peninsula, Asia
- California condor *Gymnogyps californianus*, Critically Endangered, Mexico, United States
- Djibouti francolin *Francolinus ochropectus*, Critically Endangered, Djibouti
- Great Indian bustard *Ardeotis nigriceps*, Endangered, India
- Houbara bustard *Chlamydotis undulata*, Near Threatened, Europe, North Africa, Middle East, Asia
- Lear's macaw *Anodorhynchus leari*, Critically Endangered, Brazil
- Spix's macaw *Cyanopsitta spixii*, Critically Endangered, Brazil
- Night parrot *Geopsittacus occidentalis*, Critically Endangered, Australia
- Chilean woodstar *Eulidia yarrellii*, Endangered, Chile, Peru
- Socotra bunting *Emberiza socotrana*, Vulnerable, Yemen
- Xinjiang ground-jay *Podoces biddulphi*, Near Threatened, China
- Slender-billed finch *Xenospingus concolor*, Vulnerable, Chile, Peru

Threatened reptiles

There are over 7,900 species of reptiles and 293 are known to be threatened. The following are some of the threatened species found in deserts.

- Afghan tortoise *Testudo horsfieldii*, Vulnerable, Asia
- Bolson tortoise *Gopherus flavomarginatus*, Vulnerable, Mexico
- Desert tortoise *Gopherus agassizii*, Vulnerable, Mexico, United States
- Gila monster *Heloderma suspectum*, Vulnerable, Mexico, United States
- Coachella Valley fringe-toed lizard *Uma inornata*, Endangered, United States

Threatened plants

The conservation status of relatively few plants has been assessed by IUCN for the current Red List. Below are a few examples of threatened tree species that are found in arid lands. Earlier assessments by IUCN (using different Red List categories and criteria) indicated that an estimated 2,000 out of 10,000 succulent plant species are threatened with extinction in the wild. Many of these succulent plants including species of *Aloe*, *Agave*, *Euphorbia* and cacti are found in arid lands. There are about 2,500 species of cacti. A few examples of threatened cacti are given below.

- Bastard quiver tree *Aloe pillansii*, Critically Endangered, Namibia, South Africa
- Cucumber tree *Dendrosicyos socotrana*, Vulnerable, Yemen (Socotra)
- Dragon's blood tree *Dracaena cinnabari*, Endangered, Yemen (Socotra)
- Nubian dragon tree *Dracaena ombet*, Endangered, Djibouti, Egypt, Ethiopia, Saudi Arabia, Somalia, Sudan, Uganda
- Halfmens *Pachypodium namaquanum*, Near Threatened, Namibia, South Africa
- Argun palm *Medemia argun*, Critically Endangered, Egypt, Sudan
- Chilean wine palm *Jubaea chilensis*, Vulnerable, Chile
- Elephant tree *Pachycormus discolor*
- Boojum tree *Fouquieria columnaris*

Threatened cacti

- Tobusch fishhook cactus *Ancistrocactus tobuschii*, United States
- Tamaulipas living rock cactus *Ariocarpus agavoides*, Vulnerable, Mexico
- Pezuna de venado *Ariocarpus kotschoubeyanus*, Mexico
- *Aztekium hintonii*, Mexico
- *Aztekium ritteri*, Mexico
- Saguaro cactus *Carnegia gigantean*, United States, Mexico
- Organ pipe cactus *Stenocereus thurberi*, United States, Mexico
- *Copiapoa laui*, Chile
- *Copiapoa rupestris*, Chile
- Bunched cory cactus *Coryphantha ramillosa*, United States
- Chisos hedgehog cactus *Echinocereus chisoensis*, United States, Mexico
- *Geohintonia mexicana*, Mexico
- Peyote cactus *Lophophora williamsii*, United States, Mexico

Information sources

Groombridge, B. and Jenkins, M.D., 2000. *Global Biodiversity. Earth's Living Resources in the 21st Century.* World Conservation Press, Cambridge.

IUCN, 2002. *2002 IUCN Red List of Threatened Species.* IUCN, Gland, Switzerland (available at www.redlist.org).

Wilson, D.E. and Russell Cole, F. (2000) *Common Names of Mammals of the World.* Smithsonian Institution Press, Washington and London.

World Heritage sites located in arid environments

Tassili n'Ajjer, Algeria

M'Zab Valley, Algeria

Ischigualasto/Talampaya Natural Parks, Argentina

Quebrada de Humahuaca, Argentina

Uluru-Kata Tjuta National Park, Australia

Australian Fossil Mammal Sites, (Riversleigh/Naracoorte), Australia

Purnululu National Park, Australia

Willandra Lakes Region, Australia

Memphis and its Necropolis – the Pyramid Fields from Giza to Dahshur, Egypt

Ancient Thebes with its Necropolis, Egypt

Nubian Monuments from Abu Simbel to Philae, Egypt

Abu Mena, Egypt

Saint Catherine Area, Egypt

Lower Valley of the Awash, Ethiopia

Lower Valley of the Omo, Ethiopia

Persepolis, Iran

Hatra, Iraq

Masada, Israel

Petra, Jordan

Quseir Amra, Jordan

Rock-art Sites of Tadrart Acacus, Libya

Old Town of Ghadames, Libya

Timbuktu, Mali

Ancient *Ksour* of Ouadane, Chinguetti, Tichitt and Oualata, Mauritania

Whale Sanctuary of El Vizcaino, Mexico

Rock Paintings of the Sierra de San Francisco, Mexico

Archaeological Zone of Paquimé, Casas Grandes, Mexico

Serra da Capivara National Park, Brazil

Ksar of Ait-Ben-Haddou, Morocco

Air and Ténéré Natural Reserves, Niger

Bahla Fort, Oman

Arabian Oryx Sanctuary, Oman

The Frankincense Trail, Oman

Gebel Barkal and the Sites of the Napatan Region, Sudan

Site of Palmyra, Syria

Ancient City of Aleppo, Syria

State Historical and Cultural Parkl 'Ancient Merv', Turkmenistan

Grand Canyon National Park, USA

Old Walled City of Shibam, Yemen

Old City of Sana'a, Yemen

Historic Town of Zabid, Yemen

Useful addresses

Listed below are key organizations that are working to protect desert ecosystems and their threatened species around the world. Some of these are membership organizations (marked with an asterisk) and others are intergovernmental organizations. Also included are organizations that are concerned with the rights of indigenous people and which promote sustainable tourism.

BirdLife International*
Wellbrook Court
Girton Road
Cambridge CB3 0NA UK
Tel: +44 1223 277318
Fax: +44 1223 277200
Website: www.birdlife.net

CBD Secretariat
World Trade Center
393 Saint Jacques Street
Suite 300
Montreal, Quebec
H2Y 1N9, Canada
Tel: +1 514 288 2220
Fax: +1 514 283 6588
Website: www.biodiv.org

CITES Secretariat
International Environment House
15, Chemin des Anémones
CH-1219 Châtelaine
Geneva, Switzerland
Tel: +41 22917 8139/40
Website: www.cites.org

Conservation International*
1919 M Street
NW Suite 600
Washington DC 20036, USA
Tel: +1 202 912 1000
Website: www.conservation.org

Fauna & Flora International*
Great Eastern House
Tenison Road
Cambridge CB1 2TT, UK
Tel: +44 1223 571000
Fax: +44 1223 461481
Website: www.fauna-flora.org

The Ramsar Convention Bureau
Rue Mauverney 28
CH-1196 Gland, Switzerland

Tel: +41 22 999 0170
Fax: +41 22 999 0169
Website: www.ramsar.org

IUCN – The World Conservation Union
Rue Mauverney 28
CH-1196 Gland, Switzerland
Tel: +41 22 999 0000
Fax: +41 22 999 0002
Website: www.iucn.org

SOS Sahel International UK
1 Tolpuddle Street
London N1 0XT, UK
Tel: +44 20 7837 9129
Fax: +44 20 7837 0856

Survival
6 Charterhouse Buildings
London EC1M 7ET, UK
Tel: +44 20 7687 8700
Fax: +44 20 7687 8701
Website: www.survival-international.org

Tourism Concern
Stapleton House
277–281 Holloway Road
London N7 8HN, UK
Tel: +44 20 7133 3330
Fax: +44 20 7133 3331
Website: www.tourismconcern.org

UNCCD Secretariat
PO Box 260129
Haus Carstanjen
D-53153 Bonn, Germany
Tel: + 49 228 815 2800
Fax: + 49 228 815 2898/99
Website: www.unccd.int

UNEP-World Conservation Monitoring Centre

219 Huntingdon Road
Cambridge CB3 0DL, UK
Tel: +44 1223 277314
Fax: +44 1223 277136
Website: www.unep-wcmc.org

The World Heritage Centre
UNESCO
7, place de Fontenoy
75352 Paris 07 SP, France
Tel: +33 145 68 15 71
Fax: +33 145 68 55 70
Website: www.unesco.org/whc

World Wide Fund for Nature
International
Avenue de Mont Blanc
CH-1196 Gland, Switzerland
Tel: +41 2236 49111
Website: www.panda.org

WWF-Australia
PO Box 528
Sydney NSW 2001, Australia
Tel: +61 2 9281 5515
Fax: +61 2 9281 1060
Website: www.wwf.org.au

WWF-UK*
Panda House
Weyside Park
Godalming
Surrey GU7 1XR, UK
Tel: +44 1483 426444
Fax: +44 1483 426409
Website: www.wwf-uk.org

WWF-US*
1250 24th Street N.W.
Washington DC 20037, USA
Website: www.worldwildlife.org

Further reading

Abrahams, A.D. and Parsons, A.J. (eds.) (1994) *Geomorphology of desert environments*. Chapman and Hall, Ltd.

Allan,T. and Warren, A. (1993) *Deserts: the encroaching wilderness*. Published in association with IUCN the World Conservation Union. Mitchell Beazley International Ltd., London

Beckwith, C, and Fisher, A. (1996) *African ark: peoples of the horn*. The Harvill Press, London

Evans, M.I. (compiler) (1994) *Important bird areas in the Middle East*. BirdLife International, Cambridge.

Faber, P. (ed) (1997) *California's wild gardens*. California Native Plant Society, Sacramento, California.

Hassan Hassan and Dregne, H.E. (1997) *Natural habitats and ecosystems management in drylands: an overview*. Environment Department Papers, Natural Habitats and Ecosystems Management Series. Paper No. 51, The World Bank, Washington, DC.

Hutchison, R.A. (ed) (1991) *Fighting for survival: insecurity, people and the environment in the Horn of Africa*. IUCN, Gland, Switzerland, and Cambridge, UK.

Kingdon, J. (1990) *Island Africa. The evolution of Africa's rare animals and plants*. Collins, London.

Latz, P. (1995) *Bushfires and bushtucker. Aboriginal plant use in Central Australia*. IAD Press, Alice Springs.

Mallon, D.P. and Kingswood, S.C. (compilers) (2001) *Antelopes. Part 4: North Africa, the Middle East, and Asia. Global survey and regional action plans*. SSC Antelope Specialist Group. IUCN, Gland, Switzerland, and Cambridge, UK.

Middleton, N. (2001) *Going to extremes*. Channel Four Books.

Nabhan, G. P. (1985) *Gathering the desert*. The University of Arizona Press. Tucson, Arizona.

Oldfield, S.F. (compiler) (1997) *Status survey and conservation action plan. Cactus and succulent plants*. IUCN, Gland, Switzerland, and Cambridge, UK.

Schaller, G.B. (1998) *Wildlife of the Tibetan steppe*. The University of Chicago Press.

Thesiger, W. (1979) *Desert, marsh and mountain. The world of a nomad*. Collins, London.

Van Oosterzee, P. and Morrison, R. (1991) *The Centre. The natural history of Australia's desert regions*. Reed Books Pty Ltd.

Index

Acknowledgements

Thank you to all the people of FFI who have provided information or reviewed sections of the book. In particular, thanks are due to Martin Fisher, Chris Loades, Chris Magin and Simon Mickleburgh. John Hare, of the Wild Camel Protection Foundation, kindly provided information on conservation measures for the wild bactrian camel. I am also most grateful to Greg Leach who provided the information I needed on Australian deserts at a point when my research sources were running dry and to Uwe Schippmann who supplied inspirational stories and pictures of the Namib Desert.

Picture credits

All photographs from the Bruce Coleman Collection with the exception of the following:

Ardea
Pages 28, 30, 31 (top), 39 (right), 40, 44 (bottom), 46, 46–47, 49 (bottom), 60, 64, 66, 67, 68, 74 (left), 74 (right), 75, 80, 81, 83 (bottom), 84, 85, 90, 91, 93, 101 (right), 103, 105, 107, 110, 111, 137, 138

Michael & Patricia Fogden
Pages 12, 19 (right), 41, 51, 100–1, 113, 136

Royal Geographic Society
Pages 14, 27, 31 (bottom), 78, 82–83 (top)

Dr Uwe Schippmann
Page 34 (top)

N. P. Taylor
Page 133